Just Different

Just Different

A Memoir

WAYNE SLEEP

HODDER &
STOUGHTON

First published in Great Britain in 2024 by Hodder & Stoughton Limited
An Hachette UK company

3

Copyright © Wayne Sleep 2024

A CIP catalogue record for this title is available from the British Library

Hardback ISBN 978 1 399 71206 4
ebook ISBN 978 1 399 71208 8

Typeset in Celeste by Palimpsest Book Production Ltd, Falkirk, Stirlingshire

Printed and bound in Great Britain by Clays Ltd, Elcograf S.p.A.

Hodder & Stoughton policy is to use papers that are natural, renewable
and recyclable products and made from wood grown in sustainable forests.
The logging and manufacturing processes are expected to conform to
the environmental regulations of the country of origin.

Hodder & Stoughton Limited
Carmelite House
50 Victoria Embankment
London EC4Y 0DZ

The authorised representative in the EEA is Hachette Ireland,
8 Castlecourt Centre, Dublin 15, D15 XTP3, Ireland
(email: info@hbgi.ie)

www.hodder.co.uk

For my best friend, George.

CONTENTS

Prologue 1
Chapter One – Born Entertainer 5
Chapter Two – First Steps 27
Chapter Three – 'Boy Gives up Rugby for Ballet' 47
Chapter Four – The Presence of Greatness 73
Chapter Five – From Covent Garden to Fire Island 95
Chapter Six – A Meeting of Minds 117
Chapter Seven – Drama Queen 143
Chapter Eight – Dancing to My Own Tune 175
Chapter Nine – 'Fly, Miss Sleep, Fly . . .' 203
Chapter Ten – Uptown Girl 227
Chapter Eleven – Beginnings and Endings 257
Chapter Twelve – Reality and Reinvention 285

Epilogue 313
Acknowledgements 317
Picture Credits 321

PROLOGUE
South Kensington, June 1988

'SO VERY KIND of you to invite me for lunch, Wayne,' said Diana, Princess of Wales, while reclining into my living room sofa and kicking off her shoes. As her slim, elegant feet sank into my cheap, short-pile carpet (the same feet that, three years previously, had memorably stepped in sync with mine at the Opera House), I cringed inside, wishing I'd splashed out on that Persian rug from Harrods after all.

Finding my South Kensington home had been incredibly fortuitous. Since creating my own touring production, *Dash*, I'd yearned to set up my own dance studio and, sure enough, had found a place that ticked all the right boxes. Originally built as stables in Victorian times, it had subsequently been converted into a formal ballroom before becoming a dance school; it was rare in those days to find such a big space with no pillars. Then, not long after I bought the studio, the mews property opposite came on the market, which I immediately snapped up, even though it meant selling my beloved apartment in Covent Garden. Having my house and my studio within yards of each other was just perfect. Both spaces needed tons of work – and a very accommodating bank manager – but I reckoned it was worth it.

The house was located a stone's throw away from Diana's Kensington Palace residence and she'd regularly drive past in her old blue Ford Escort – her 'camouflage car', as she called it – using this quiet cobbled passage as a convenient shortcut to evade the paparazzi. If she ever spotted me outside, amid all the dust, bricks and rubble, she'd toot her horn and wind down her window.

'Not finished yet?' she'd shout, flashing me a smile. 'I'm still waiting for the invitation to your housewarming!'

My kitchen and living room had not yet been renovated, but still, in the summer of 1988, I felt able to ask my friend and former dancing partner over for lunch. I served up trout with almonds – the only thing I could cook reasonably well – followed by a Fortnum & Mason strawberries and cream gateau, both which I served up on a table comprising a sheet of glass perched atop a couple of breeze blocks. Diana didn't bat an eyelid at this makeshift furniture. I think she rather liked the relaxed, slightly chaotic vibe at Chez Sleep – a refreshing change from the ordered formality of the palace, I guess. She even insisted on doing the washing-up afterwards, pulling on a pair of yellow Marigolds like it was a completely normal scenario for The Most Famous Young Woman in the World, who had, just that morning, played a tennis match with Steffi Graf and was thrilled to tell me that she had returned one of her serves.

Our conversations were always laid-back and light-hearted – 'I'll do the jokes, Darling' was a pet phrase of hers – and, as such, she rarely delved deeply into personal matters, other than updating me on the progress of her boys, William and Harry. Whenever we dined at the Groucho Club, or attended

one of my shows, she much preferred to hear my stories about the world of ballet, and from behind the curtain, it being an art form she'd adored since childhood (hence her burning desire to dance at the Opera House). So, I'd regale her with tales from my three decades with the Royal Ballet, working with splendid choreographers like Sir Frederick Ashton and Sir Kenneth MacMillan. I would tell her my stories of appearing alongside superb principals like Margot Fonteyn and Rudolf Nureyev, as well as some about my own show *Dash* and musicals like *Cabaret, High Society* and *Cats* that I'd performed in. Being a dance aficionado, she relished my insight. And if I ever dropped a juicy bit of hearsay into the conversation – a rumoured affair, perhaps, or a diva-like walkout – her blue eyes would flash as if to say *'Go on . . . tell me more'*. Our conversation never petered out – there was always plenty of talking, laughing and gossiping. We just hit it off, pure and simple.

The day after our lunch, I received a handwritten note on Kensington Palace paper saying how much she loved my new 'nest' and telling me how wonderful it must be to have a place of one's own. In the months that followed, she'd often joke about moving into one of the mews' bedrooms, which, she said, would be decorated wall to wall in pastel pink. At least I *think* the Princess was joking. Sometimes her wistful, faraway expression hinted at a yearning for a little bolt-hole, a place of sanctuary, perhaps, where she could escape all the hullaballoo.

I didn't know it back then – in those days, I had neither the time nor inclination to analyse our friendship – but dance wasn't the only thing that bonded us. The benefit of hindsight

has made me realise that, despite our contrasting back-grounds, Diana and I had much in common and were shaped by similar experiences. Above all, both of us had been para-chuted into new worlds at a young age – she into the royal family, me into the Royal Ballet – and, though we had both made efforts to fit in to these rarefied environments, I think she felt like an outsider, like I did. She, a modern girl in an ancient institution. Me, a working-class boy in a cultural colossus. Two people who knew that, to achieve our goals in life, we'd have to challenge convention, defy the norm and dare to be different.

CHAPTER ONE

Born Entertainer

I PERFORMED MY first ever pirouette in the womb. As my mother's due date approached, in the summer of 1948, the midwife discovered I was lying in a breech position and had to deftly spin me around with forceps to prevent me emerging backside first. It wasn't the only pregnancy-related complication my mum had to endure, bless her. The location of my spine had triggered agonising nerve pain throughout her body, the shock of which had caused her thick, wavy brown hair to fall out in clumps.

Following a traumatic birth, I cried constantly for six weeks and refused to take my mother's milk. My Auntie Vera had to express hers instead, which I much preferred for some reason. And on top of that, I was born with a severe squint – 'Is he cross-eyed, Joan?' neighbours would tactlessly ask Mum as they peered into my pram – fortunately in time that rectified itself.

What with all the exhaustion and trauma I created, you wouldn't have blamed my mother for resenting her newborn son. But she didn't. My mother's maternal instincts kicked in from day one and she bonded with me instantly. Once I settled into a routine, I became a good, mild-mannered baby.

Mum had originally planned to call me Wayne Colin after her brother but, fearing that I'd be mocked for having 'WC' as my initials, she rectified this by inserting a 'P' for Philip. 'WPC' had another meaning in Britain, of course – 'woman police constable' – but that was more preferable than the toilet connotations. And as for my birth surname, I gather Pinto has southern European origins and, apparently, can mean 'a lively and restless person'. So the exact opposite of Sleep, funnily enough, a surname I would come to adopt later in my childhood.

What caused Mum most trauma, if truth be told, was having a child out of wedlock. Being an unmarried mother triggered a deep sense of shame that she never quite managed to shake off. She'd met my birth father in the summer of 1947, when she was twenty-five, at Broadreads, a holiday camp in the West Sussex resort of Selsey, where she was working as a waitress and he was the resident big band leader. In his forties, Bob Holland, from Wales, was tall and blond with laser-blue eyes. As fate would have it, he was also a married man who, unbeknown to Mum, was living a double life. The lovebirds bonded over a shared passion for music, meeting up for after-hours trysts in their chalets, where Bob would strum Peggy Lee numbers on the guitar as his girl-friend happily sang along.

Mum had a stunningly beautiful voice. She'd spent most of the Second World War working as a nurse and, while stationed at a burns unit at RAF Hospital Ely, had boosted the morale of injured airmen with her repertoire of songs and arias, her soaring soprano tailor-made for opera. Impressed with her ability – few could hit a top 'C' like Joan Pinto – the

powers-that-be invited Mum to perform a set at their summer and Christmas concerts, introducing her to the troops as 'Our Star'. I feel very proud of my mother when I reflect back on these stories and I remember what a gift she possessed. She was certainly in demand. A senior military man at the base (and a patient of my mother's) was so impressed he asked her to perform 'Ave Maria' in Latin at his wedding. Father McSweeney, a Franciscan Friar, agreed to teach her the Latin and accompanied her on the piano. The doctors in attendance were amazed that my mother had managed to get Father McSweeney on stage, owing to the fact he had no legs.

The Odeon cinema in Plymouth asked my mother to sing during the intervals. Such was her popularity, the cinema's management asked a local music company to press a record of one of her finest renditions, 'Dancing in the Dark', so it could be played when she was absent. First recorded by Bing Crosby in 1931, the song beautifully showcased Mum's rich, powerful voice. There would come a day, sometime in the future, when I'd hear that record for myself.

Mum went straight from nursing to waitressing, which eventually led her to the Broadreads holiday camp. Within weeks of her arrival, she'd fallen madly in love with Bob, and before long he was talking about marrying his 'singing waitress', as he affectionately called her. Bob's pledges and promises kept coming, even when Joan told him she was expecting his child. She'd discovered she was pregnant when she'd moved back to the family home in Plymouth, following the end of the summer season. Although the news came as a huge shock, she was greatly encouraged by her sweetheart's support. He encouraged her to keep the baby, bearing in

mind they'd all be together in the near future. He even came to Plymouth to meet his future in-laws.

However, as the months went by, Bob became increasingly evasive and elusive. Although he wrote to her regularly – her heart leapt when letters postmarked from Broadreads hit the doormat – each one contained a different excuse for being unable to visit: he had a bout of flu, he was working long hours, he'd run out of petrol. My mother wasn't daft and, some time after I was born, sussed out that he was stringing her along and had a wife and family elsewhere. She was devastated. Being an unmarried mother in her mid-twenties had not been in her plans. With a heavy heart, she resigned herself to raising her baby alone.

Announcing her pregnancy to her family was incredibly traumatic for Mum, given the circumstances. Single parents and 'illegitimate' children – I still detest that word – were deemed the lowest of the low in post-war, working-class Britain, and she felt guilty and betrayed that she had been duped into this situation. But to their credit, her mother and three sisters – Ruth, Vera and Sybil – responded with kindness and compassion, and without question or judgement. Some friends and neighbours weren't quite so tolerant, sadly, and would literally turn away as Mum passed by in the street, pulling down her cardigan to conceal her burgeoning baby bump. It was such a huge stigma to carry a 'bastard' child, as people so cruelly referred to us back then.

Joan kept in touch with Bob after I was born via letters, but while he occasionally asked about me in his letters, he never made the effort to meet me or to foster any kind of father-son relationship – there was always an excuse. He did

agree to Mum's request to adopt me, though – a formality that, in Mum's mind, helped to legitimise my existence – but that's where his involvement began and ended. Tellingly, in the smattering of correspondence that followed, he only used my Christian name once, usually referring to me as 'the baby' or 'the boy'. So it came as no surprise to my mother when his communication dried up completely, prior to my first birthday. Decades later, I'd come to read Bob Holland's hand-written letters for myself, since Mum had kept a stash of them in a chest of drawers. Being privy to these notes was both upsetting and illuminating.

'Get those silly notions out of your head, my dear . . . don't say if I don't get my divorce through you'll commit suicide,' he'd scrawled in one, the implication being that, fraught with despair, she'd contemplated taking her own life. Until then, I'd not known the true extent of my mother's anguish, and his words shook me to the core.

As soon as I was old enough to comprehend, my mother told me about my father. I began to notice that my mother would occasionally drop his name into the conversation. She thought this was for the best – she felt so guilty I only had one parent, unlike my friends – but I never paid much attention. Once, she even showed me a faded snapshot of this middle-aged, blond-haired stranger ('This is your dad, Wayne . . .'). Later that afternoon, when my mother had gone shopping, I went into her bedroom, found the photograph, and ceremoniously ripped it apart, leaving the pieces on her dresser. I think she got the message. I felt no connection with this Bob Holland person – how dare he be so mean to my mother! I wanted nothing to do with him.

So, from childhood through to adulthood, I never made any effort to trace my father. Firstly, I didn't want to waste time and energy on someone who'd treated us so badly. Secondly, I was governed by a strong sense of loyalty and allegiance towards my darling mother. I didn't want her thinking that, by trying to find him, I was somehow doubting her parenting skills or trying to fill a gap in my life. That wasn't remotely the case. Mum met all my emotional needs – I received love, support and kindness in abundance – and, throughout my early years, I never felt I was missing out. I never craved a daddy. And besides, Mum and I had such fun together. I have a vivid memory of her singing and dancing while she cooled down my meal at teatime, balancing the dinner plate on the palm of her hand while she waltzed around to a song on the radio.

Although I didn't like being smothered in kisses and cuddles – I've never been a very tactile, touchy-feely person – there was a huge amount of affection between us. As an only child I became quite independent and self-reliant at an early age. Mum used to tell the story of how I fell over quite badly in the street in Plymouth, aged about three, and how a gentleman passer-by dashed over to pick me up.

'Get away from me, I'll do it myself,' I said.

This wilful attitude would follow me right through to adulthood.

When I was a toddler, something quite remarkable happened. A BBC talent scout had seen my mother singing live at the Odeon cinema and offered her a contract to perform in a weekly music programme on national radio.

'This could be your big break, Joan,' she was told. 'Consider it your first step into the entertainment world.'

After careful thought and consideration, my mother turned down this golden opportunity. Firstly, she was worried that her lack of formal training and her limited broadcasting experience would be exposed, leading to personal failure and public humiliation. Along with many lower-class people, she had a deep sense of inferiority and didn't feel she belonged in the highbrow arts scene. Cultural elitism was rife in 1950s Britain – every BBC presenter spoke the Queen's English; you'd rarely hear a regional accent – and it was natural for someone like my mother, hailing from a poor, working-class family from Devon, to fear derision and ridicule.

More profoundly, Mum was convinced that the Corporation would drop her like a ton of bricks if they discovered she was an unmarried single mother. She wasn't prepared to lie about her status – she was a woman of integrity – so, to avoid any potential humiliation, she politely declined the offer.

Looking back, it's impossible to say whether her concerns were misplaced or justified, and whether her decision was in fact the right one. But, as someone who has faced professional snobbery himself, and knows how cruel and condescending the performing arts world can be, I can understand her rationale. It seems she was just trying to protect herself, and to protect her son.

I was surrounded by women in my family. Everywhere I turned there was some 'auntie' or other – my mum's trio of sisters, or her cousin Barbara, or her Aunt Edie, or her Aunt Florrie – and the air was always full of chatter and

laughter. There was a mere smattering of males in the family – notably Colin, my blood uncle, and Bert, who was married to Barbara – but they played little part in my life. In post-war, working-class Plymouth, you'd rarely see the younger males in the Pinto family, since most of them worked extremely long hours at the Devonport dockyards, building and repairing ships and submarines, or they were in the merchant navy. Their wives stayed at home or worked part-time, and generally did the lion's share of the childcare.

While there was a certain 'macho' vibe among my industrious male relatives, sometimes the mask would slip. When I was young, I recall a male relative coming over to our house one night, following a shift at the docks, distraught that his best friend had fallen to his death from a crane. I don't think I'd ever seen a man cry before; the blokes in my family didn't tend to show their feelings. I remember staring at him in bewilderment as the tears tracked down his grimy cheeks, before he upended his chair and ran into another room to sob privately. Until that moment, I'd never seen such an outpouring of emotion from one man to another.

'Poor, poor man,' said my mother, slowly shaking her head. 'He loved his friend very, very much.'

My main role model turned out to be my great-grandfather, William Hortop, who I simply called 'Grandad'. He occupied a hero-like status in our family: the archetypal patriarch. He'd once walked 300 miles from Plymouth to Manchester to find work and, as soon as he arrived, had sent a horse and cart to collect his wife and daughters, all of whom took up jobs in the cotton mills. Before the outbreak of the First World War, he'd also done stints in Devon's slate quarries and tin mines.

My eyes would widen as Grandad told me stories about life as a quarryman, rolling up his shirt sleeves to reveal the shards of grey slate that remained embedded in his forearms, the result of being accidentally blown up by dynamite.

'That blast took my flippin' eye out too, Wayne, and I couldn't fight for my country,' he'd growl, pointing at its glinting glass replacement. 'So take that as a warning. Don't ever work down the mines.'

Four generations of the Pinto family occupied two rented, multi-occupancy houses in Percy Terrace, a street situated in a low-lying, flood-prone part of Plymouth known as 'The Dip'. Me, Mum and Grandad lived at number five, and aunts and cousins were further down the street at number sixteen. My grandmother Emma's husband had been kicked out of the marital home years earlier (relatives would speak in hushed tones about 'that man's *outrageous* behaviour') and she'd duly remarried, to the far less outrageous Harry.

Mum, Grandad and I had a floor to ourselves, with a little bedroom, kitchen and lounge diner. Our domestic life was very, very basic. We had an outside toilet some distance from the house in the back yard, a tin bath in the living area and a gas stove and oven in the kitchen, with a boil-on-the-hob kettle. We didn't have the luxury of a fridge or freezer – just a pantry for food storage – and our most lavish electrical appliance was a Hoover vacuum cleaner. Mum couldn't afford a television.

Our landlord at Percy Terrace rented out the basement to a young married couple, although sometime in the early 1950s the wife mysteriously went missing, prompting local speculation that her husband had 'done her in' and buried her beneath the floorboards. When the bloke from the

basement knocked on our door one night to offer us some freshly baked pumpkin pie, Mum convinced herself it was laced with rat poison.

'Eat that, Wayne, and you'll be six feet under, along with his wife,' she said, holding the parchment-wrapped parcel at arm's length and dropping it into the waste bin.

We never had fancy food at home – tinned fruit cocktail was Mum's special Sunday dessert of choice – so seeing this rare delicacy being binned was hard to bear.

During the day, Mum worked at Fuller's, widely regarded as the finest tea room in Plymouth. Self-conscious about her single-parent status, it seems she liked the anonymity of waitressing. The city's Palace Theatre was only a stone's throw away, so she'd often find herself serving actors of great repute, like John Mills and Peggy Ashcroft, who'd pop in for high tea – coffee and cake – between their matinée and evening shows. My mum loved chatting to these living legends about performing on the stage and screen, maybe with an element of wistfulness, considering her own missed opportunity. She'd have probably dropped her tray of clotted cream scones had anyone told her that, two decades later, her own son would be top of the bill at that very same theatre.

Whenever my mother was working at Fuller's, Grandad would be tasked with looking after me (he was more than able, despite being in his late eighties) and I loved whiling away the time with this wise, witty old man. He'd entertain me by using his long fingernails to bash out skiffle rhythms on saucepan lids – *shersh-ti-ti, shersh-ti-ti* – and by regaling me with tales of his mischievous childhood, spent largely in the woods, on beaches and down the tin mines. He used to

let me watch him shave and I became fascinated by the whole process of soaping up and scraping off. One morning, Mum found me hanging over the kitchen sink, my cheeks and chin covered in blood, having tried out Grandad's razor. I'd cut myself to ribbons and had to be taken straight to Plymouth General to be treated and bandaged.

While money was scarce in our family – there were no trips to Fuller's or the Palace Theatre for us – we still found ways to spend quality time together. Every year, a dozen or so of the Pinto clan would hop on the train and head to the wilds of Dartmoor for our week-long summer holiday, pitching our army surplus tents in a field near Shaugh Bridge. Along with my cousins Robert, Diane and Jackie, I'd spend my days swimming in the stream, exploring the woods or staging fights with dried cow pats. As night fell, my relatives would gather around the campfire to sing a medley of songs, with Mum on lead vocals and Grandad on tin-pan percussion. Sometimes the men would come out dressed in drag, as Old Mother Hubbard in an apron or as Mae West with socks stuffed down a bra, dragging on fags and drawling 'Come up and see me sometime . . .' while us kids screamed with laughter.

Besides this, once or twice per month (unless the weather was particularly foul), the family would gather our rugs, deckchairs and picnic boxes and cross the border into Cornwall. We'd find ourselves a sheltered spot on a secluded beach, where the grownups would sit and chat, and we young 'uns would frolic in the waves and the dunes. The only break in play came when the Cornish pasties, baked fresh that morning and wrapped tightly in tea towels, were lifted out of carrier bags. Each pasty bore our initial, fashioned from

left-over pastry, because we all liked different fillings: D for Diane (without onions). R for Ruth (extra peas).

'Can't beat a proper pasty,' Uncle Colin would say with a grin as we devoured our still-steaming meat-and-potato parcels.

The Pintos liked a good laugh and enjoyed a good knees-up. As was the case with many cash-strapped, post-war families, we had to make our own entertainment and would take turns to stage cheery get-togethers at the weekends, for friends, relatives and neighbours of all ages. Crates of cheap ale for the adults and fizzy pop for the kids would be stacked up in the corner of the room, and platters of sandwiches and cakes would adorn the dining table. Jim, the accordionist from across the road, would provide the music – he some-times let me press the keys – playing *fortissimo* during the sing-alongs and *pianissimo* during the storytelling, the latter provided by our resident dockers who'd spin yarns of sailors, pirates and buccaneers, from Francis Drake to Edward 'Blackbeard' Teach. We children lapped it up.

I loved our Christmas family gatherings, too, but not for the usual reasons. I wasn't bothered about presents – Mum couldn't afford to shower me with gifts in any case – but was utterly obsessed with the burst of light and colour that accompanied the festive season. I was a sucker for twinkling fairy lights, glittery tinsel and flickering lanterns. I used to ogle the luminous displays in Plymouth's shop windows, and late on Christmas Eve would march inside to ask the owners if I could take their paper streamers home, now that they'd finished with them. Back at Percy Terrace, I'd drape myself in my second-hand red, green and gold decor-ations and parade around the place, like a walking Christmas

tree, singing 'Ding Dong Merrily on High' at the top of my voice.

'Wayne's different to the other boys, isn't he?' said Auntie Vera to my mum as I preened and pranced before them.

With my bright blue eyes, my mop of curly brown hair and my wide, toothy grin, I was a cute and cheeky young lad. I had a particularly impish sense of humour, playing pranks and mimicking comedians on the 'wireless', like Wilfred 'Give 'im the money, Mabel' Pickles or Arthur 'Hello, playmates!' Askey. My family were routinely entertained by my early attempts at dancing, too. As a crawling infant, I'd wiggle my bottom to nursery rhymes and – egged on by Mum and Grandad – I'd jig around the house to a radio show called *Uncle Mac's Children's Favourites*. I loved 'The Ugly Duckling' and 'Mommy, Gimme a Drinka Water', both sung by Danny Kaye. The more they laughed, the more it encouraged me.

Even at that tender age, moving my body in time with a rhythm felt innate and instinctive. I'd dance spontaneously to anything that had a beat – a train rattling down a line, a cacophony of church bells, the clopping of horses' hooves – and whenever we staged our family campfire singsongs, I'd reel around the flames like a whirligig, abandoning myself to the melodies and handclaps. To me, dancing felt as natural and as normal as breathing.

Auntie Barbara, my mother's fun-loving cousin, loved watching me in action. She'd tune the radio dial to the BBC Light Programme – the station that broadcast popular music – and would encourage me to tap dance on the kitchen linoleum, teaching me how to do a single-time step.

'Come on, Twinkle Toes, show us your stuff,' she'd say as she sat in our kitchen, puffing on a Woodbine and – as was her wont – warming her feet inside the gas oven. I'd then trip the light fantastic for my audience of one, wielding assorted household utensils (rolling pins, bottle brushes and broom handles) as props. Sometimes I'd use upturned orange crates as makeshift mini stages.

'How was that, Auntie Barbara?' I'd ask at the end of my routine, arms outstretched and ankles crossed in a *ta-daaaaa!* pose.

'Encore, Wayne, encore,' she'd say with a grin, putting out her fag in the ashtray so she could give me a round of applause.

Not every relative was quite so enamoured with my talents, however. During my Auntie Sybil's wedding reception at a Plymouth community centre, in the early 1950s, my urge to dance overwhelmed me. I couldn't resist clambering onto the stage – I was drawn to it, having never seen one at close quarters before – and performed an impromptu song 'n' dance routine to a music hall comedy classic, 'My Baby's Gone Down the Plughole'. I'd even raided the backstage dressing-up box, and was wearing a hat and a wig with plaits. The wedding guests proceeded to clap along and hoot with laughter as this mischievous moppet worked the stage like he was topping the bill at the London Palladium.

As my passion for dance continued, many family members urged Mum to send me to formal classes ('Your Wayne's got something special there, Joan,' friends would say) but she was initially reluctant to do so. Not only was she concerned about cost – she'd have to work more shifts at Fuller's to cover the fees – she also feared that all the detailed form-filling

would reveal my illegitimacy. Her sense of shame and paranoia was ever-present and all-pervading.

She had misgivings about my penchant for dancing, too. Hollywood hotshots like Gene Kelly and Fred Astaire may well have brought their art to the masses but in provincial south-west England, it was still deemed as a pursuit for 'cissies' or 'fairies'. The gender divide was pretty clear cut in fifties' Devon: dancing was for girls and cricket was for boys. Full stop. As someone who already felt stigmatised by society, this preyed on my mother's mind.

She eventually relented, though – my family's constant badgering finally wore her down – and, aged five, I was enrolled at Pat Rouce's Academy of Dance. I was the only boy in the tap and jazz class, but being outnumbered twelve to one didn't bother me in the slightest. Quite the opposite, in fact. I liked bucking the trend and being the centre of attention. I positively enjoyed being different.

'Most boys wouldn't dream of being in a class with twenty girls,' little girls in pink tutus would say as I joined them at the barre.

'Well, I'm a boy and I *love* it,' I'd reply.

Miss Rouce took Mum to one side one evening to tell her that her son was a natural performer; indeed, she'd not taught anyone so talented for a long while. I would quite literally perform some steps with my eyes shut, like a little party piece for my classmates.

My first pair of proper tap shoes had to be ordered from a specialist shop in London. I'd had to wait six weeks for delivery – ooh, the anticipation! – and, when the parcel arrived, the entire family came over to witness the big reveal. I excitedly

tore open the cardboard box only to discover a pair of girl's tap shoes – dainty white things, with bows and ribbons – with a note attached explaining that the boy's style was out of stock. I was terribly upset – I may have been the only boy in the class, but I certainly wasn't going to wear girl's shoes.

'Gene Kelly wouldn't be seen dead in these silly, girly things . . .' I wailed.

'We'll sort it, Wayne, don't you worry . . .' said Mum.

Within days, the offending articles were returned to London and plan B was enacted. My mum popped into Plymouth to purchase a pair of black patent leather shoes – they sported shiny silver buckles, like an olde-worlde sailor's shoe – and, back at home, Grandad hammered some metal segs onto the soles to make them tap-friendly. Panic over. Disaster averted.

Mum's resourcefulness also came in handy when I took part in the end of term concert at Miss Rouce's, for which I'd been given a Grenadier Guard-themed dance to perform. All the parents had to make their child's costume, so a few days before the concert, my mum wondered, 'Where on earth am I going to find a bloomin' bearskin hat?'

'I dunno,' I replied, unhelpfully. 'Buckingham Palace?'

She enlisted the help of Auntie Ruth and set to task, fashioning a cylinder out of cardboard and covering it with remnants of a wartime blackout curtain. Unable to find a suitable chin strap, she went to our bathroom, wrenched off the lavatory chain and used that. No doubt she and Ruth had a good old giggle as they watched me at the concert the following day, marching, stomping and saluting with gusto while wearing a hat made from moth-eaten material and a

rusty loo chain. Meanwhile, back at Percy Terrace, poor old Grandad had to use the toilet over at Grandma Emma's house, albeit temporarily.

I only stayed at Pat Rouce's for a few months. My mother became fed up with trekking across town on the bus every week – it was a couple of miles away – and instead enrolled me at Geraldine Lamb's School of Dance, which was closer but pricier. Though finding the extra money had become less of a problem for my mum, now that she was engaged to be married.

You couldn't really blame my mother for seeking a husband. She was tired of being 'on the shelf' – all three of her sisters had now coupled up – and she was desperate to become a respectable married woman. And, with Grandad not getting any younger, the prospect of having another man in the house with whom to share parenting duties became increasingly appealing.

I wasn't the easiest child to bring up, you see. As I reached school age, I became what's euphemistically known as a 'handful'. While I was a happy kid at home, I was undeniably high-spirited – verging on hyperactive – and, as such, could be incredibly demanding. With me, everything had to be just so. The water in our tin bath had to be the perfect temperature before I let it touch my skin or my hair. I refused to go to sleep in the dark because I was scared of monsters – the light had to remain on until I was fast asleep – and I'd insist on fastidiously folding all my clothes into neat little piles, from my socks to my sweaters. My exasperated mother even coined a nickname for her picky, pernickety son: Fuss Arse.

I was a headstrong little boy who wasn't afraid of standing his ground, even if it meant making a scene. I recall a scene

from later in life when Mum and I were served up a lukewarm bowl of soup in a café. She wouldn't dream of complaining and she continued eating it, as if nothing was amiss. I simply couldn't fathom her mindset. Why was she such a pushover?

'But the soup's *cold*, Mum,' I'd whine. 'You must tell the waiter to bring us another.'

'Keep quiet and eat it up, Wayne,' she'd say under her breath. 'Just let it go.'

But the more she dissuaded me, the more agitated I became. It may have only been a bowl of soup, but my deep sense of rectitude told me this was neither fair nor acceptable, and I'd end up raising my hand, summoning the waiter and embarrassing my mother. It was this kind of wilful stubbornness that would cause me no end of trouble in my professional life, even if, further down the line, this pursuit of perfection even in everyday life also helped me to no end in my career.

So I wasn't the easiest child to handle. As well as my bolshiness, I also suffered with sporadic bouts of sickness. I was prone to nasty abscesses in my ear, which had to be lanced – I'll spare you the details – and I also had terrible problems with my sinuses, which eventually had to be operated on. And that was on top of the car sickness, the bad headaches and the incessant coughs and splutters.

Food-wise, I was unable to tolerate any dairy products. Just the smell of milk, cheese and butter made me feel nauseous, so they weren't allowed to pass my lips. I would have acid attacks due to a lack of protein. It was a standing joke in our house that I'd be the perfect inmate at Dartmoor prison because I could easily survive on a daily diet of dry bread and water. I remember my worried mum buying me bottle after bottle

of Ribena, in an attempt to get some vitamin C into my system. Looking back, I do wonder if my poor childhood nutrition – particularly the lack of calcium, vitamins and minerals – somehow affected my growth. I suppose I'll never know.

So, all things considered, lone parenthood had become a real struggle for my mother, and, at some point, she must have started searching in earnest for a suitable life partner and stepfather. Still only in her early thirties, she was an attractive woman with a good figure, nice hair, a kind heart and a sunny nature – quite the catch, in many respects. And while I don't recall the exact moment that Stanley Sleep entered my life, I can remember the acute feelings of panic and confusion that raced through my mind once I realised something was afoot.

What's this man doing in our house, Mum?

And he's moving in with us, too . . . aren't we happy as we are?

What d'you mean, you're getting married?

When I sussed what was going on, my little world collapsed like a domino rally. I felt betrayed and bewildered. All this talk of 'marriage' and 'moving in' had come completely out of the blue. I wasn't ready or willing to share my mother's love and attention with anyone, let alone this thirty-something stranger. I soon gathered, through eavesdropping on family conversations, that Stan had caught her eye at Fuller's; he was the secretary of the Plymouth Gin Company and would visit the tea rooms in his lunch break. Their chats progressed to dates and soon they were officially 'courting'.

While always smartly dressed in a suit and tie, Stan was unremarkable in appearance: slim, small-ish and with greying hair that made him look older than his years. Personality-wise, he struck me as a rather cold and detached character – in

contrast with Mum's innate cheeriness – and, from my perspective, it was hard to fathom where the attraction lay. Looking back, I think her eagerness to ditch 'Miss' for 'Mrs' had eclipsed any sense of rational judgement, and she may have accepted the first marriage proposal she received. (In fairness to Stan, few men would have considered taking on a woman with baggage, namely me.) Perhaps, though, she should have heeded the warning from Stan's own mother.

'Are you sure you know what you're letting yourself in for, Joan?' she'd said, enigmatically, not long after the two women had first met. 'Why d'you think he's been on the shelf for so long?'

Not exactly the most ringing of endorsements. But Mum carried on, regardless.

Right from the off, I sensed Stan wasn't very fond of me. He showed me scant affection – he seemed devoid of warmth or emotion – and he made me feel like an irritant who just got in his way. I distinctly remember Mum asking him to fasten my Marks & Spencer sandals one morning, only for him to yank them so tightly that the metal buckles dug through my school socks and into my skin. He knew full well how much he was hurting me. I never, ever forgot that. Such moments can linger long in a child's memory.

I was about six years old when they got married. My mum didn't think she merited a white wedding – those guilty waters ran deep – so instead chose to walk down the aisle wearing a three-quarter-length netted purple dress that bore absolutely no resemblance to a conventional bridal gown. Following the ceremony, the newlyweds lined up their friends and family for the customary wedding photographs . . . everyone except

me, that is. Bizarrely, Mum wouldn't allow me to have my picture taken as this would potentially 'out' me as illegitimate. Omitting me from the family photo line-up was effectively an exercise in damage limitation, to prevent anyone digging up my past, connecting the dots and exposing The Unspeakable Truth. Perhaps Mum was being a little over-protective, but she was all too aware of how prejudiced society could be.

Within weeks, Stan had moved the three of us out of Percy Terrace and into a smaller house on nearby Glendower Road. There was no space for Grandad, sadly, who had no option but to move in with his daughter, Winnie, across the city (Mum would come to regret her tacit approval of this hard-hearted decision). I felt utterly bereft without my mate and mentor – I missed his ditsy drumming and his down-the-mine stories – and my dim view of my stepfather became ever darker. This man was an intruder and an interloper, as far as I was concerned – how *dare* he disrupt our happy family life – and a deep resentment began to fester. Mum's decision for Stan to legally adopt me left me cold, as did my new surname.

'I don't want to be Wayne Sleep, Mum,' I said to her one night, as she read me a bedtime story. 'It's a silly name. I much prefer Pinto.'

'Ssshhh, love,' she whispered, afraid that Stan was in earshot. 'It's for the best, son, trust me.'

Around the time of my seventh birthday, Stan dropped the bombshell that we were leaving Plymouth altogether. His head had been turned by his sister, Winnie, who'd relocated to Hartlepool and was forever waxing lyrical about the cheaper cost of living in the north-east. She and her husband Burt had bought themselves a boarding house – there was

a huge demand for B&B accommodation in the town, she said – and it had become a money-spinning goldmine.

The temptation was too much for Stan and my mum, after he had convinced her. Keen to emulate his sister's good fortune, he quit his job at the gin company, withdrew all his savings and bought a boarding house up in Hartlepool. He didn't think twice about uprooting us from Devon, separating us from our family and upping sticks to County Durham. The tears streamed down my face as we made the long journey north, Stan's ancient Austin A40 sagging under the weight of our belongings.

CHAPTER TWO
First Steps

LIKE MY BIRTH city, Hartlepool had a rich seafaring and ship-building history. It was a hub port for consignments of Norwegian wood (yes, like the Beatles' song), huge planks of which were shipped into the docks and seasoned outdoors before being transported further afield. Not long after I arrived in the town, my new cousin Peter – Winnie's son – took me crabbing in the nearby rock pools and I remember gazing at the colossal piles of criss-crossed timbers as they dried on the shoreline.

At one point, we were joined by some rough 'n' ready local lads with their own lines and bait, who immediately made fun of my broad Plymouth accent.

'Eh, don't yer talk funny,' they laughed. 'Yer sound proper posh, like.'

Posh? They couldn't have been further from the truth. My origins were probably just as humble as theirs. It was only our speaking voices that differed.

Stan's hope for a lucrative life in Hartlepool didn't go to plan. Winnie had grossly exaggerated the demand for board and lodgings – we'd arrived to find VACANCIES signs in countless windows – so the rambling Victorian house that

Stan had bought on Friar Terrace, in the district of Old Hartlepool, remained largely empty. As did his bank account.

'She's lured us here under false pretences, Wayne,' I remember my mother whispering to me when Stan was out of the room. 'Taken us for a ride. Anything to get her brother living nearby.'

To keep the proverbial wolf from the door, Auntie Ruth, Uncle Reg and their daughter Karen came up from Plymouth and moved in with us, paying rent to occupy the ground floor while we lived in the basement, which was considerably cheaper than rent in Plymouth. My mother was understandably thrilled to be reunited with her beloved sister, of course, and they both kept the house ticking over while their husbands went out to work. Stan reluctantly took a job making bricks on the night-shift production line at nearby Steetley Magnesium Company. It was physically demanding and mind-numbingly boring, and he'd return home at dawn every day, filthy and fatigued. Performing manual work like this was a demoralising climb-down for someone who'd spent his career sitting at a desk, filling in payment ledgers and balance sheets with his beautifully neat handwriting.

With his ego bruised, my stepfather's mood plummeted even further. He was perpetually downbeat, moping around the house, moaning at his wife and ignoring his pesky stepson. Stan would rather sit in his armchair and read the *Hartlepool Mail* than spend time with me, so I became quite used to creating my own entertainment. I had a piano teacher who lived up the road. I forget her name but she was a fat, elderly spinster who was friendly enough, though a little despondent about my lack of practice (I dared not practise while Stan slept off his night shift). And I loved listening to music on

our ancient wind-up gramophone, a contraption so decrepit it would often go on the blink, forcing me to manually revolve the 78s in order to hear Gracie Fields or Frankie Laine. I carefully cultivated a window box outside my bedroom, too, which Stan had made for me (in one of his nicest gestures), planting night-scented stock to mask the whiff emanating from the outside privy. Even now, the intoxicating smell of stock in bloom can bring all the memories flooding back.

Above all, my favourite pastime was constructing home-made peep shows. I'd carefully cut out characters from my fairy tale anthologies (like Cinderella, or Little Red Riding Hood) and affix them to the base of a cardboard box, arranging the figurines like they were performing on a stage. I'd then make a two-inch circular hole at the top which I'd cover with a yellow cellophane wrapper, before shining a torch through to bathe my theatrical scene in a glowing spotlight. I spent hour upon hour devising elaborate shows, creating my own fantasy world of song and dance, far away from all the slammed doors and sulky silences in Friar Terrace. Sometimes I'd cast myself in a starring role – Prince Charming or the Big Bad Wolf – and would imagine myself entertaining the public on the big stage.

My stepfather resented all forms of fun and jollity. If Mum and I had the temerity to giggle at something on our new rented television set, like *Hancock's Half Hour,* he'd groan loudly, slam down his newspaper, storm out of the lounge and stomp straight upstairs. He never shouted, he'd just leave the room and give us the silent treatment, sometimes for days on end.

'Off he goes again,' Mum would say with a sigh and a shake of the head.

29

I felt sorry for her, I really did. All she'd wanted out of marriage was cuddles, conversation and companionship, yet she'd landed herself with a monosyllabic misery-guts. Weirdly, I felt a bit sorry for my stepfather too. Stan was a petulant man-child who saw me as a rival for his wife's affections but who also knew, deep down, that the mother-son bond was too strong to break. We were inseparable, Mum and I – blood was definitely thicker than water, as the saying goes – and I think he found that hard to stomach. Nothing could change my 'Mummy's boy' status.

All that being said, I wasn't totally blameless for our lack of rapport. Hindsight has made me realise that my own hostility and resentment didn't help matters. Stan may not have been my favourite fella but he wasn't a terrible person – he genuinely cared for my mother, even though he didn't always show it – and, by shutting him out from day one, I don't think I ever gave him much of a chance. Indeed, as I've aged and mellowed, I've started to feel a tad regretful about my attitude towards him. Had I made more effort to adapt to life with a stepfather, and to welcome him into my life, we may well have enjoyed a better relationship.

Occasionally, I'll experience flashbacks to instances when he treated me quite kindly, like when he covered for me after I stole a bottle of juice from a crate outside the Methodist church. When the angry warden knocked at our front door, Stan gave me an alibi – 'My son would do nothing of the sort; he's been at home all day' – despite him having already seen my white t-shirt covered in tell-tale orange stains. And when I once woke up from a nightmare, terrified of the dark and tormented by a German invasion of Hartlepool, my stepfather

came into my bedroom to calm me down. Our relationship was such that he didn't feel able to sit beside me and stroke my hair, but he instead offered me some reassuring words.

'I'd give those bloody Germans what for, don't you worry,' he said, clenching his fist and gnashing his teeth. 'They wouldn't get anywhere near our front door.'

Stan wouldn't be the only person I'd cold-shoulder, though. Burning bridges with people, both personally and professionally, would become something of a habit of mine.

For a special treat – and to have a break from Stan – my mother and I would pay a visit to the ABC Picture House. Unable to watch many films on our bog-standard telly – most of them were shown on the commercial channel, ITV, which meant us buying an extra aerial that we couldn't afford – we'd instead get our fix at the 'flicks'. Being rather prudish, Mum wouldn't countenance any films featuring big-boobed, bottle-blonde divas like Marilyn Monroe and Jayne Mansfield (nor that pelvis-pumping Elvis Presley), but there were plenty of other movies and musicals to enjoy. I loved the cinema's sense of drama – the expectant hum in the auditorium, the gradual opening of the purple velvet curtain – and, for that precious couple of hours, I'd allow myself to escape into another world.

The films I looked forward to most, however, were the big-screen Technicolor musicals, especially those starring my all-time dance hero Gene Kelly. Mum and I must have watched *On the Town, An American in Paris* and *Singin' in the Rain* dozens of times; on each occasion, I was so gripped by this mini-maestro I could hardly take my eyes off that silver screen. He was mesmeric. In contrast with Fred Astaire, his tall and graceful

rival, Kelly was strong and stocky and moved with such power and dynamism. Whenever I watched him, something stirred deep within me – a recognition, a connection, a yearning.

Singin' in the Rain – the story of a promising young dancer's attempt to crack Broadway – was my favourite by far. I remember watching, open-mouthed, as he performed the legendary five-minute sequence that saw him tap-dancing down the street mid-downpour, niftily spinning his umbrella. As my fellow cinemagoers erupted into spontaneous applause at Kelly's sheer brilliance, I leaned over to my mother.

'That'll be me one day, Mum,' I whispered into her ear. 'Wouldn't it be great to be like him one day, Mum?'

'Well, let's just see about that, Wayne,' she said, with typical matter-of-factness. 'Don't be getting ahead of yourself, now.'

I twirled around every single lamppost as we made our way home to Friar Terrace that night.

When we'd first arrived in Hartlepool, I'd insisted upon continuing my dance classes. Even at the age of eight, I was full of drive and determination, eager to learn new steps and acquire fresh skills. I wasn't the sort of kid who needed a timely shove from a pushy parent – I had more than enough motivation myself – so Mum simply filled in the forms while Stan paid the fees. Despite our strained relationship, he never begrudged me anything, financially speaking. I was genuinely grateful for this. Money was tight in those days and there were plenty of other things he could have spent it on, like clothes for my mother or nice things for the house. That said, I don't think he was enamoured with the idea of his stepson attending dance classes at the weekend while

his friends' lads played rugby or football. And while my mother never dissuaded me, she didn't exactly go out of her way to encourage me, either. She just let me get on with it, maybe hoping it was a passing phase that would soon be replaced with a more boyish hobby, like fishing or building model aeroplanes. I did all those pursuits but I soon lost interest.

I had the choice of two dance schools in Hartlepool: Freda Compton's – a slick, glitzy set-up that often swept the board in local tournaments – or Muriel Carr's, a more sedate, traditional establishment that valued convention over competition. I opted for the latter, prompted by some sage advice from a clued-up neighbour.

'If Wayne wants the best training, Joan, send him to Miss Carr's place,' she'd said to Mum over the fence one day. 'She may not have sparkly costumes and flashy choreography, but she does things properly, all by the book.'

Muriel Carr's School of Dance, which specialised in modern musical, tap and ballet for girls, wasn't the flashiest of venues. Located above a Halford's bicycle shop in Lynn Street, the large, draughty studio with cracked windows and peeling walls was reached via a rickety wrought iron staircase. There was an ancient upright piano in one corner and a portable gas fire in the other. My new teacher was in her thirties, a dark-haired, bespectacled woman with a schoolmistress-like demeanour.

'Well, *hello*, Wayne,' she smiled when I arrived for my first class, shaking my hand and ushering me inside. 'How divine to meet you and how *wonderful* to have another young man joining us.'

Occasionally, a middle-aged, smartly-dressed pianist called Billy Hands – who had a half a finger missing, much to my

33

childish amusement – would turn up to class to silently observe proceedings. He would help Miss Carr to decide which musical theatre pieces we'd all be performing at the regional song and dance contests, alongside other schools in the area. They both earmarked me for a tournament in nearby Middlesbrough, in the under-twelves tap category, vying against other dancers from South Shields, Sunderland and Newcastle-upon-Tyne.

The competition was staged in a suburban Methodist church hall in the town centre. Mum came along to support me, as did Miss Carr, and they watched me perform a sprightly routine to 'Five Foot Two, Eyes of Blue', the popular American ditty. Its title was quite apt, in hindsight, five foot two being the precise height I'd reach in adulthood. Not that my stature was ever an issue in my younger years, because I was no smaller than many other lads of my age.

And I positively oozed with confidence, too. Many kids in these contests would flee the stage in tears, running to their mothers, unable to cope with the pressure. But I was utterly fearless and took it all in my stride.

At the end of the two-week long competition, I was awarded the silver cup for the highest mark in song and dance for under twelves and shared the first place cup for the highest mark in the competition across all under eighteens. However, sadly I wasn't there that day. Mum and I had just missed the bus to Middlesborough and so had turned back home, rather than wait for the next one. My mother had seemed quite down at that time and I hadn't wanted to push it by insisting we got the next one.

So it was Miss Carr who informed me that I had won, and also what the adjudicator had said when awarding the prize

34

to me *in absentia*: 'I must insist that he learns ballet. He has *marvellous* turnout, quite marvellous.' She said I reminded her of Danny Kaye.

'Turnout', I discovered, is a technical term to describe the extent to which your leg rotate at the hips, allowing the feet to point outward at ninety degrees, Charlie Chaplin style. A dancer with this level of flexibility – such as me, apparently – has a particularly poised way of standing, walking and dancing that lends itself perfectly to ballet.

However, my mother was not on board with the competition judge's pronouncement. Until this point, she'd tolerated my passion for dancing but she had never once factored ballet into the equation. As far as she was concerned, this was a bridge too far.

I could almost read her mind. *What would people think? How would my family react? What would the neighbours say?*

'Well, Vaslav Nijinsky would probably beg to differ,' said Miss Carr, referring to the darling of the Ballets Russes.

Decades later, while being interviewed for an afternoon TV programme – footage I still treasure to this day – Mum outlined her misgivings at that time.

'There was nothing wrong with Wayne being a song and dance man, y'see,' she explained in her soft Plymouth lilt, 'but when it came to ballet I just thought, *No way*. I didn't want him to do it. I was being ignorant, I suppose. I kept saying no but his teacher told me he *had* to learn it.'

Indeed, following a few weeks of gentle persuasion, Miss Carr succeeded in changing my mother's mind. She explained that a grounding in ballet was essential if I were to progress as a dancer, as I'd be taught how to jump, spin and leap

35

properly, along with other fundamental moves and manoeuvres. Learning classical ballet would also complement other forms of popular dance, such as jazz, tap, modern and contemporary.

Shortly afterwards, the Royal Academy of Dance's boys' ballet syllabus landed on Miss Carr's doormat with a thud. To be quite honest, I can't say I was hugely enthusiastic about learning this brand new discipline. It had always been my dream to become a song and dance man – like my hero Gene Kelly – and to perform in Hollywood and on Broadway. Not only that, the handful of ballets I'd seen on television hadn't chimed with me at all. They seemed incredibly staid and stuffy, and were largely dominated by women in tutus, with the few male participants consigned to fleeting cameos. I'd always imagined myself basking in the spotlight rather than waiting in the wings. But then again, I wasn't going to look a gift horse in the mouth. I'd been told by a dance judge that I possessed a rare talent. I'd never been a very academic child, so I might as well try and excel in something else.

Miss Carr had never taught ballet to a young boy but, credit to her, was prepared to push the envelope with her star pupil. First of all, she sat me down and gave me a potted history, telling me how ballet had been around for centuries and how dancers of this specialism underwent years of dedicated training in order to achieve perfection. Then, week after week she gave me one-to-one grade two lessons (I was allowed to skip grade one), following the curriculum to a T, using that weighty syllabus as a guide. I was taken through all the various steps, positions and techniques with painstaking precision. Miss Carr taught me how to do a demi-plié and grand plié,

and how to perfect the port de bras – the carriage of the head and arms – to ensure both are positioned perfectly. Much to her delight, I took to the half-turns and full spins like a natural. It was a pivotal time in my life, in more ways than one.

I may have been top of the class at Muriel Carr's dance school but this certainly wasn't the case at Baltic Street Junior School in Old Hartlepool. While I had a thirst for knowledge and a fertile imagination – I was a very curious and inquisitive child – I found classwork extremely difficult and coped badly in lessons. Reading was my big problem. I just couldn't get to grips with it. If I concentrated hard, I was able to recognise individual words and short sentences, but my mind went haywire when faced with paragraphs and pages. I found it so hard to absorb anything. Lines and columns appeared muddled and jumbled, separated by moving whorls of blank space. Sometimes it looked like rivers were flowing through the text.

Trying to decipher everything made me feel queasy, and my frustration and embarrassment would make me want to give up. I was so keen to learn about the wonders of history, science and literature, yet this debilitating problem held me back at every stage. Whenever I flagged up my reading issues to my teachers they just ignored me (and making myself heard in a forty-strong class was no mean feat). My mother didn't really question my substandard grades, either. Back then, working-class parents like mine had neither the courage nor confidence to question authority. There was far too much deference to their 'betters', which meant they wouldn't dream of marching up to the head teacher's office and knocking on their door. So, as a result, I was dismissed as a 'slow learner'.

A rather unkind and unsympathetic label, especially for a child who was desperate to discover more about the world. It's only through the process of writing this book, almost seventy years later, that I realise I probably suffered with dyslexia as a child and am likely suffering with it now. But, despite these suspicions, I've never sought a medical diagnosis. Receiving the official confirmation that I've missed out on decades of knowledge and education might just break my heart.

So, with academia beyond my reach at Baltic Street juniors, I lost interest in lessons and learning, and – because I could hardly decipher my textbooks, or the blackboard – would spend most of the time messing about in class, practising my dance steps or daydreaming about performing. I was no teacher's pet. One particular mistress could barely hide her dislike of me and would humiliate me by purposely forgetting my name.

'Morning Arthur,' she'd sneer whenever I entered the classroom.

'But my name's Wayne, Miss,' I'd reply.

Afternoon, Arthur,' she'd repeat the next day, with added malice.

'I've already told you, Miss, it's Wayne . . .'

Years after I left school, I suddenly twigged what this teacher was playing at. Arthur Sleep sounds like 'half asleep'. I'm sure she was very proud of her private joke, which probably tickled a fair few ribs in the staff room, too. But what a heartless way to treat a kid who needed support in the classroom, not scorn. Thank goodness that wouldn't happen nowadays. Looking back, I think you were always at a disadvantage at Baltic Juniors if you were working class. If you were the child of a

bank manager or a local councillor, you were treated like gold. If you were like me, the son of a brick worker and a housewife, you were simply not acknowledged.

In the school playground, I was often given a rough ride by some – not all – fellow pupils, who'd aim insults like 'fairy' and 'nancy' at me when they discovered I attended Muriel Carr's place. Male dancers were routinely mocked in those days, of course. Society regarded them as figures of fun. All you had to do was switch on your TV to see comedians like Benny Hill prancing around in pink tights and tutus, all pursed lips and limp wrists ('Oooh, me Nutcrackers . . .' he'd say, landing clumsily post-pirouette). I fully appreciated it was just for laughs – I'm sure my mother and I would have giggled at these skits ourselves – but these portrayals undeniably helped to perpetrate a stereotype that all male dancers were fey and effeminate, and thus ripe for ridicule. Dancing was for cissies.

Not that I let my tormentors get the better of me. I was pretty resilient – I think I inherited my chutzpah from Grandad – and would keenly stand up for myself. Occasionally, a gang of boys would encircle me in the playground or the toilets, prodding and jostling me before demanding I perform for them . . . or else. I'd either flounce off back to the classroom ('I'm not a dancing bear, you know') or, just to shut them up, would unleash my pièce de resistance: a perfect side-splits (cue gasps of 'blooming heck, Sleep, that's not normal . . . '). Humouring them was the best response, I soon learned, and after a while they stopped cornering me. I never made any close male friends at Baltic Juniors, however. I thought the boy's playground was filthy – full of spit, snot and fighting – and I much preferred playing chase and hopscotch with

Linda McNamara in the girls' yard. And, being a very fast runner, I was a whiz with a skipping rope.

Back home at Friar Terrace, I sensed a change in the air. For weeks, I'd noticed lots of nudges, winks and whispers around the house – exchanged between Mum and Stan, or Mum and Ruth – and it felt like a big secret was being harboured. Then, one night in February 1958, I heard a cacophony of noise coming from my parents' bedroom, like a wild animal howling in distress. Petrified, I leaped out of bed and raced into the landing, only to be stopped in my tracks by Auntie Ruth carrying a kettle of boiling water.

'Don't worry, Wayne,' she said, soothingly. 'Your mum's having a baby. Everything's OK. Go back to bed. You can meet your brother or sister in the morning.'

'What did you say?' I asked, rubbing my eyes in disbelief. 'A *baby*?'

I'd had no clue my mother was pregnant; I'd noticed her tummy getting bigger but hadn't twigged.

Looking back, I do wonder why she chose to shield me from the situation, rather than sharing it. When I first clapped eyes on baby Joanne in her cradle (her name was a nifty amalgamation of 'Jo' from Joan, 'An' from Stan and 'Ne' from Wayne), I felt consumed with brotherly love and comforted to have a sibling by my side. It's a feeling that's never left me, I'm pleased to say. My baby sister grew up into a beautiful person and has become a constant presence in my life. I worship the ground she walks on.

As one family member arrived, however, another one departed. Around the time of Joanne's birth, news arrived from Devon that poor Grandad had died. I vividly remember Auntie

Ruth bursting into tears as she read the words in the telegram and the sisters collapsing into each other's arms. Stan wisely made himself scarce that day, aware that my mother had never really forgiven him for callously shunting the old man out of the family home in Plymouth. I despaired that I would never see him again, and that night dreamed about Grandad playing skiffle on a saucepan while I danced on the linoleum.

In 1959, I tackled the dreaded eleven-plus exam, a tough aptitude test which dictated whether a pupil would progress to a grammar school with the clever crowd or to a secondary setting with the rest of my cohort. I don't think my parents or my teachers held much hope that I'd make the grade – which I didn't, as it transpired – but, on the strength of a decent maths result, I did pretty well to bag myself a place at the well-regarded, all-boys West Hartlepool Technical College. Its practical and non-academic curriculum suited me just fine. I became quite skilled at technical drawing – my intricate diagrams of cathode ray tubes and internal combustion engines were a work of art – and in woodwork class I made my own theatre (shock, horror!) which sadly ended up being chucked onto the open fire, as kindling, after Mum accidentally leaned on it while she was vacuuming. She and Auntie Ruth had fallen about in hysterics when Mum had realised I'd used chewing gum to hold it together.

The Tech – a Gothic-looking building with towering turrets and wrought iron gates – was like another world. A true 'school of hard knocks', it was the sort of place where groups of lads would smoke and fight in the playground, with any resultant punishment taking the form of the strap in the

principal's office. I was often summoned there – usually for poor time-keeping – and I can testify that those lashes to the bottom hurt like hell.

I knew full well I'd get plenty of stick about my dancing at an all-male college, so – to try to counteract any 'pansy' barbs, I did the manliest thing possible and joined the rugby team. I was a natural hooker, being fast and nimble, and became adept at stealing the ball in the scrum and tapping it back through the props' legs. I received the occasional on-pitch jibe from a macho rugger boy but it was often him, not me, who ended up looking foolish.

'Oi, Sleep, where's your tutu?'

'You borrowed it, remember?'

Ironically enough, my dancing prowess often attracted more female attention than my rugby pursuits. Every year, students from the girls' tech across town would join us for our Christmas concert where I'd perform, with customary relish, one of my grade two ballet pieces. My favourite by far was the 'Sailor's Hornpipe', a lively nautical jig that required oodles of strength and stamina. However, all I could hear during my performance was cries of 'You little poof', 'You little pretty boy' coming from the more vocal boys in the school. The headmaster was livid.

'Right, STOP what you're doing, Sleep,' he said, as the music came to a sudden halt. 'Now, I want you to dance it again but this time there'll be silence in the hall.'

I did as he asked and this time I got an encore. *That put those bullies in their place,* I thought to myself. *I'm not going to be a victim.*

Afterwards, dozens of girls flocked around me, fluttering

their eyelashes and showering me with compliments about my moves and my muscles.

'You're well in there, Sleepy,' my good friend Stephen Gretton would say, with a knowing wink.

'Am I?' I'd reply, indifferently, unmoved by all this attention.

Unlike many boys at the Tech, I wasn't a girl-obsessed 'skirt-chaser'. That's not to say I wasn't fascinated by the opposite sex, though. Whenever I was backstage at dance shows or contests, I'd secretly peep through the curtain at teenage ballerinas as they changed into their costumes, gazing in wonderment at their pert breasts and peachy bottoms. I was intrigued, more than anything. The women in my family were extremely buttoned-up – quite literally, you never saw any bare flesh on display at Friar Terrace – and, until my pre-show prying, I'd not realised how different boys' and girls' bodies were.

Enjoying the company of boys and men held a certain appeal, there's no denying that, and when I was eleven years old, I joined my local Church Army. I was no stranger to religion. While Mum wasn't a practising Christian back then – being an unmarried mother had made her feel somehow unworthy, I think – she'd taught me to say my prayers at night when I was a toddler. When I was about nine years old, she encouraged me to sing in the choir at St Hilda's, which I loved nearly as much as flouncing around in a red cassock and white ruff. One afternoon, the Church Army – an evangelical Christian group – happened to pay a week-long visit to our congregation. They played a slide show about John Bunyan's *Pilgrim's Progress* before organising a sing-along of rousing tunes that, thrillingly, were more like pop songs than old hymns.

The session was led by a couple of young men in their twenties, Noel Proctor and Ken Storey. Something about their cheery, upbeat demeanour greatly chimed with me, and I also thought they looked very smart in their slate-grey Church Army uniform, with its military-style shiny brass buttons. I signed up on the spot.

I relished learning the Christian scriptures and won a leather-bound Bible for winning a competition by reciting twenty-one verses from memory (I found recitation and rote learning much easier than staring at whirling words). I must have made a good first impression with Noel and Ken because they invited me to caravan around the colliery towns of County Durham with them, spreading the Lord's word in Washington and saving souls for Christ in Consett. My mother was more than happy for me to join them. These men of God were trustworthy by default, being upstanding members of the faith community. Her parental instincts weren't wrong, as it happened – Noel and Ken were unfailingly kind, decent and responsible – but her unquestioning consent reflected the attitudes of the day. In the late 1950s, there was no such thing as background checks or duty of care, and no one thought twice about a schoolboy spending a weekend alone with two adult Church Army members. It was all perfectly normal.

Our little roadshow comprised two or three caravans of devotees who visited a network of community centres across the region. Noel's tenor voice would accompany Ken's acoustic guitar as they led the repertoire of songs of

44

worship. I loved joining in with my favourite, 'He Walks With Me'.

And He walks with me
And He talks with me
And He tells me I am his own
And the joy we share
As we tarry there
None other has ever known

What impressed me most about the Church Army was the ardent singing and preaching, as well as the drama of people lining up to be 'saved' by Noel and Ken. The theatricality of it all dovetailed perfectly with my desire to entertain. We missionaries were performers, the congregation our audience, the church hall our stage and a full house every night. The Army's ethos of friendship and fellowship struck a chord with me, too. I may not have realised or acknowledged it at the time, but my distant relationship with Stan, the death of my beloved grandad – and, subconsciously, the absence of my birth father – had left a man-sized gap in my life that Noel and Ken undoubtedly helped to fill.

The Church Army played an important part in my life, arming me with a degree of confidence and independence which would stand me in good stead for the future. Because further down the line, over 300 miles away, lay an even bigger adventure.

CHAPTER THREE

'Boy Gives Up Rugby for Ballet'

BREAKING INTO THE world of classical ballet can be incredibly difficult for youngsters from deprived backgrounds. Not only is it an expensive pursuit – equipment, costumes, competition fees – there's also an air of elitism that implies it's not for 'people like us'. Indeed, it's this inequity that prompted me to set up my own charity, The Wayne Sleep Foundation, which over the past twenty-five years has provided support to students across the performing arts, particularly those who are unable to pay for accommodation or tuition.

It's an issue I feel very passionate about, having lived that experience myself back in the late 1950s. At the age of eleven, I was awarded a regional scholarship to the Royal Academy of Dance, which proved to be a godsend for a kid from a poor household. It was Muriel Carr who'd initially put me forward for the audition. Passing it with ease, I was then able to attend twice-weekly ballet classes at the RAD in Newcastle-upon-Tyne, in tandem with my regular Saturday morning sessions in Hartlepool. Without this scholarship, there's no way I could have accessed these special ballet classes. The expensive fees would have been well beyond the means of the Sleep family.

Attending these elite lessons in the big city, taught by qualified ballet teachers, felt like a significant step up the ballet ladder. And, soon enough, I began to set my sights even higher. Even at that tender age, I began to feel a gravitational pull towards London, home of the big shows and the bright lights. One day, a fellow Royal Academy classmate – a lad from Sunderland, Peter O'Brien – informed me that a West End theatre was holding auditions for the leading role in *Oliver!*

Convinced I stood a chance, I pleaded with Mum to let me go – I was all set to pack my bags, travel down south and live my best life in the gold-paved streets of London – but she was having none of it. She couldn't possibly allow her little boy to stay in the big city all alone, she said. What on earth would people think? I sulked incessantly for a whole week.

'You probably wouldn't have got the part of Oliver anyway, Wayne love,' said Auntie Ruth in an effort to console me. 'That cheeky face of yours is far more Artful Dodger.'

London came calling again a few weeks' later, however. Auntie Barbara had drawn Mum's attention to a newspaper advert asking for young people, male and female, to apply for two Leverhulme scholarships at the prestigious Royal Ballet School in Richmond. The successful candidates would have their fees covered, their accommodation provided and, in line with the national curriculum, a full academic programme taught alongside classical ballet lessons. I dare say Mum saw this as a more preferable option than my *Oliver!* plans, and it prompted a conversation with my dance teacher.

'Is it worth Wayne applying? D'you think he'd be good enough?'

'Oh yes, Mrs Sleep. He'd be up against some stiff competition, but I'm sure he'd have an excellent chance.'

Mum then asked Miss Carr why she'd not alerted us to this prominent scholarship herself. Her reply still befuddles me to this day. Apparently, she didn't want the other parents to become jealous of my success, which might lead them to withdraw their children from her classes out of spite. How very British. That would have never been the case in America.

A few weekends later, in July 1960, Mum and I were on a London-bound sleeper train en route to the big audition. She was keen for me to have some shut-eye beforehand, but couldn't afford a hotel stop-over, so this seemed like a decent compromise. Not that either of us slept much that night, as we were both pretty nervous. But once we arrived at King's Cross Station and freshened ourselves up, we were ready to discover what lay in store at the Royal Ballet School.

The audition began at 9am sharp, at the upper school in Barons Court. Three hundred boys and girls were lined up and ready to go, pristine in their tights and leotards. By 4.30pm, that number had been whittled down to a final seven, including me. My confidence had grown as the day had progressed and to get down to the final seven would have been enough for me. So I threw caution to the wind and decided to enjoy myself, even if it was to be the last moment.

We'd spent the day completing a series of ballet-related tasks which was followed by a sit-down written test. The essay I wrote about 'My Home Town' wouldn't have troubled the Pulitzer Prize – my word-blindness didn't help matters, of course – but I gave it my best shot, scrawling a few paragraphs about the eighteenth-century seafaring tale that gave

49

rise to Hartlepudlians being nicknamed 'monkey-hangers' (it's a long story . . . feel free to google).

Meanwhile, my mum was being interviewed by a ballet school panel who asked her about my upbringing and quizzed her about her household finances. She felt way out of her comfort zone – she was by no means a typical theatre mother – so found it an incredibly daunting and intimidating experience. She looked emotionally drained when I caught up with her later.

'I hope I didn't put my foot in it . . .'

'I'm sure you were fine, Mum.'

As the day drew to a close, a panel of ten distinguished-looking people came to judge the finalists. I didn't realise it then, of course, but among their number were ballet legends like Ursula Moreton, the director of the school, and Dame Ninette De Valois, the director of the Company itself, along with top teacher Errol Addison and principal dancer Nadia Nerina. When Dame Ninette walked in, everybody stood to attention. Wearing a smart two-piece suit with her hair wrapped in an elegant turban, she cut an impressively regal figure. Dame Ninette would become a wonderful friend and mentor who would change the whole course of my life.

The day ended with a routine orthopaedic examination which included the so-called 'frog test'. This entailed lying on my back and splaying out my knees to the side so the surgeon could assess my hip flexibility for that all-important 'turnout'. With so much money at stake, the Leverhulme scholarship governors needed all candidates to undergo these vital checks.

'That's you done, young man,' he said, once I'd been given a good poke and prod. 'I'll see you at Great Ormond Street tomorrow for the wrist x-ray.'

I shot him a puzzled look. *Wrist x-ray?* Neither Mum nor I had been given any prior warning. The surgeon explained that by x-raying the wrist, you could get a good indication of how tall someone might become in adulthood, as it was one of the first joints in the human body to fully develop. In those days, the minimum height for male dancers in the Royal Ballet Company was five feet seven inches – principal dancers were expected to be taller than their female partners – so anyone with an iffy wrist test result might not gain admission to the school. Falling at this first hurdle meant a ballet career could end before it started.

'But I can't be there tomorrow morning,' I said to the physio, biting my lip, worried this missed appointment would scupper my chances. 'We've got to catch the train back to Hartlepool in a few hours.'

The physio told me to leave it with him; he'd try to sort out an alternative plan, perhaps at a hospital nearer home.

As things transpired, the x-ray never materialised – I'm not exactly sure why – but a few weeks later, I received a letter offering me a Leverhulme scholarship, to commence the following January. I remember gingerly opening the envelope at the breakfast table and whooping with joy when I slowly read out its contents. With the benefit of hindsight, my missed appointment turned out to be a huge stroke of luck. Failing the wrist test – a more-than-likely probability – would have indicated that I wasn't going to hit the requisite height. The school might well have invested their time and energy in a taller dancer who'd better fit their mould.

I'd later find out that my audition had been so impressive

that the school had felt compelled to give me an unconditional place. They'd taken a significant gamble, it seems, perhaps crossing their fingers I'd reach the required height. Two years later, I'd finally undergo the wrist test, which did indeed point towards the lower end of the height scale, between five foot two and five foot five. But by then, I'd totally justified my place at the school through talent alone.

My acceptance letter came as bittersweet news for my mother. On the one hand, she was delighted I'd made the grade. On the other hand, she couldn't bear the thought of me flying the nest and leaving her alone with Stan. As well as being her son, I was her friend and confidant. But she put on the bravest of faces, knowing full well how much this scholarship meant to me.

'People should always follow their dreams, my love, and I'll never get in the way of yours,' she said, somewhat wistfully, perhaps alluding to her own dashed hopes of being a singer. 'But I think I'd still prefer you to become a doctor.'

Within days of my good tidings, a reporter for the *Daily Express* came knocking, asking if he could write about my decision to swap the rugby scrum for the Royal Ballet. This angle wasn't strictly accurate, of course – why let the truth get in the way of a good story – but I was happy enough to go along with it. Even at the age of twelve, I knew good PR when I saw it. Under the strapline 'Boy Gives Up Rugby for Ballet' the newspaper printed a small piece alongside a photograph of me diving for a leather ball, wearing boots that hadn't seen any action for quite some time. Mum carefully snipped out the article and put it in a cuttings box for safekeeping. Within a few years, that box would be full to the brim.

As my scholarship start-date loomed, I persuaded Mum to buy a pair of tickets for the Royal Ballet Company's touring production of *Sleeping Beauty*, as the production was visiting Newcastle-upon-Tyne. Now that I was joining their ranks – well, the school, at least – I was curious to see them in action. While I'd watched a lot of musicals at the cinema and a couple of ballets on television, I'd never seen a real-life performance before. I could hardly wait.

'I'm afraid it'll have to be the cheap seats, Wayne,' said Mum as she gave me the cash to go and buy the tickets.

'Doesn't matter,' I replied. 'Just being there is good enough for me.'

A few weeks later, we were sitting up in the gods at the Theatre Royal. My spine tingled as the orchestra struck up Tchaikovsky's overture, the velvet curtain rising to reveal the palatial setting for the opening scene: the christening cere-mony of Princess Aurora. It came as a revelation to watch real-life performers on stage and to recognise the ballet steps I'd learned in class. It wasn't just the dancing that enthralled me, though, it was the whole spectacle: the lighting, the costumes, the colour. It was like watching a three-dimensional version of the cardboard peep show I'd created as a kid. My childhood fantasy had suddenly become real.

'My goodness, this is so beautiful,' whispered Mum as the Lilac Fairy deftly leapt across the stage, moving in perfect sync with the music.

'I know,' I smiled, thrilled to share this amazing experience with her.

We only managed to see the first two acts, sadly, because we had to leave early to catch the last train to Hartlepool.

This meant I didn't get the chance to witness the male solos in Act Three – in this version of *Sleeping Beauty*, the men only had supporting roles until that point – but I'd seen enough to realise that my destiny lay before me. I belonged on a stage.

Many twelve-year-olds might have felt hugely anxious at the prospect of departing the family home for a new life at a new school, 300 miles away. But not me. I had no qualms or misgivings whatsoever, and couldn't wait to start this brand new chapter. I loved my mother very much, and would no doubt miss her presence, but I was happy to cut those apron strings and go it alone. I like to think I was channelling the strong-willed spirit of my beloved grandad, and his journey from the slate mines of Devon to the cotton mills of Cheadle, when he'd seized the opportunity to make a better life for himself.

My mother almost fainted when she saw the exhaustive list of clothes and equipment required for my first term at ballet school. Tights, leotards, ballet shoes, school uniform, Wellington boots and house shoes . . . even bath towels and bed sheets. And not forgetting the extra-large bottle of methylated spirits (to harden my feet and prevent blisters) and a first aid kit stuffed with medication. Luckily, as I'd approached my teens I'd become a lot less sickly – fewer sinus and abscess issues – but still needed supplies on hand as a precaution.

Since our local council had turned down Mum's application for a grant to cover the £80 cost of all the equipment – an astronomical amount in those days – she had to scrimp, save and borrow, asking Stan and other family members to help

her foot the bill. Shortly after my final day at Hartlepool Tech, Mum and I paid a visit to Barkers of Kensington (the only department store to stock the regulation outfits) and returned north laden with bags of gear. Everything had to be labelled, too. My poor Mum spent hours sat down in front of the TV with a needle and thread, painstakingly stitching W. SLEEP into each item.

January arrived soon enough. Stan drove Mum and me down to London in the old Austin, heading south of the city to White Lodge in Richmond Park, where the lower school was based. This eighteenth-century hunting lodge had been built for King George II – it later became a regular haunt of Queen Victoria's – and had been occupied by the Royal Ballet since 1955. As schools go, it was a hugely impressive building – all Palladian columns and Doric archways – and the surrounding gardens, with their glistening ponds and mani-cured lawns, were absolutely stunning. As someone who hailed from an industrial town, and from a grey-stone terrace with an outside loo, it felt like I'd walked straight into a fairy tale.

As the three of us were shown around the lodge by the housemaster, I could see my parents' eyes widening. They'd never witnessed such grandeur. But Mum, bless her, was more bothered about my future prospects than the fancy décor.

'This is all very nice,' she said, surveying the surroundings, 'but do any ballet dancers actually go on to make a decent living?'

'They do indeed, Mrs Sleep,' replied the housemaster with a grin. 'They often come back to visit me, to show off their shiny new cars.'

While Mum seemed somewhat heartened by this – she

needed reassurance that such a big move was worthwhile – it still didn't stop her dissolving into tears when the time came for our farewell hug. Stan offered me a stiff handshake and a stilted smile, while I gave him a look as if to say, 'You'd better be nice to her while I'm gone'. I felt a slight pang as I watched our car trundle off into the distance, but not enough to make me want to jump back in with them.

There was a temporary bed shortage in the ballet school's boys' dormitory, so in my first term I had to lodge with a middle-aged couple, Mr and Mrs Withers, in the quiet suburb of East Sheen. Along with the other day pupils, I was collected each morning by a big black van and taken to White Lodge. We only had one ballet class scheduled per day, disappointingly, since the rest was devoted to academic teaching. In order to secure grant funding from the Greater London Council, the lower school was obliged to align itself with the national curriculum, which meant laying on lots of class work – far too much for my liking. I just wanted to dance all day long.

For the next three years I achieved the bare minimum, academically, but that was always going to be the case with my reading difficulties. This was frustrating for me, of course, because I knew deep down that I was no dunce and was just as smart as my classmates. But I just accepted it, like I'd done at Baltic Street Juniors and West Hartlepool Tech, and nothing was ever flagged by the teachers. The formal curriculum just didn't suit me, and I ended up dropping half my subjects, but succeeded in obtaining three O-levels, in Art, History and English Literature. They were the only subjects

that interested me. I particularly loved studying Shakespeare, especially when the teacher walked around the classroom with a book in her hand, reciting that wonderful prose with its olde-worlde language. *A Midsummer Night's Dream* was one of my favourites, yet I had no idea back then that, as a professional, I'd be cast as Puck in the ballet, play and opera.

> *If we shadows have offended*
> *Think but this, and all is mended*
> *That you have but slumber'd here*
> *While these visions did appear*

Our daily ballet class – or 'class' as it was simply referred to – took place in the salon. Once used as a royal banqueting room, it had a huge mirror on one wall and an oak barre across the length of another. It was light and airy, with very high ceilings, and through the windows lay stunning views of Richmond Park. The pianist would be situated in the corner, sitting patiently at an upright piano, and the teacher – often holding a cane, to thud on the floor to keep time – would pace around the room, barking out their instructions. The salon became my second home. I relished learning new skills and techniques, from practising grand pliés at the barre – a full knee bend – to perfecting entrechats from standing start. The latter, which involves deftly crossing and uncrossing the legs during a vertical jump, would become one of my trademark steps.

As well as the ballet fundamentals, we were also taught abstract, interpretive dance exercises – called Dalcroze – which encouraged us to pretend to escape from a box, for instance, or to escape from a cocoon, or to 'glue' our left leg

to the floor. The point was to syncopate your brain with your body, turning a mental concept into a creative expression. It was about expressing emotion, like you would in mime. Our classes were gruelling and exhausting – every muscle would be worked and every sinew stretched – but that was always going to be the case in such an elite environment.

The class of '61 comprised twenty-two pupils, of whom just four others were male. The vast majority were fee-paying students from middle- or upper-class backgrounds, the offspring of doctors and lawyers. But despite being a working-class boy with a completely different upbringing, I never felt like an inferior being. Very rarely did I detect disdain from students or teachers. Within the confines of the salon, we were all equals; the Royal Ballet School was a meritocracy, and rightly so. To earn your place, you had to have exceptional ability. There were no strings to pull or favours to ask, regardless of who Daddy was or how much cash he had in his coffers. Admissions were strictly dependent on talent, which I had in spades.

Our quintet of boys got on famously from the outset. One of them, Graham Powell, I clicked with straight away. Even now, sixty years later, I still count him as one of the finest human beings I've ever met. With the body of a Greek god and the mind of a Roman philosopher, Graham was simply glorious in every way. He was one of those disarmingly talented and inventive people who could turn their hand to anything, from painting to poetry. But he wore his genius lightly – he was remarkably down-to-earth and self-deprecating – and this made me admire him even more.

'Here, Wayne, I've done this for you,' he once said in art class, nonchalantly handing over a beautifully observed pencil

drawing of me which could have easily graced the walls of a Bond Street art gallery.

As well as our passion for dance, Graham and I had something else in common: we fancied boys more than girls. I found this out in passing. When I was in the lower school, I received a lot of female attention from the first and second formers – they would beg me to take them for afternoon tea in Richmond or East Sheen – but I'd often use the excuse that I was focusing on dancing, not dating. A group of girls once sent me a communal '*Dear Wayne . . .*' love letter, praising my ballet skills, my blue eyes and my curly hair. I thought it best not to reply, though, because I neither wanted to mislead nor encourage. Leading them a merry dance would be wrong, I surmised.

I discussed this awkward situation with Graham one afternoon while we were taking a stroll around Richmond Park. As we passed by Pen Ponds, with its pretty tree-clad island, I revealed the truth of the matter. There was no fear or apprehension on my part. I just wanted to be honest with my best friend.

'The thing is, Graham, girls just don't float my boat,' I said.

'Funny you should say that,' he replied, 'because they don't float mine, either.'

Before this conversation with Graham, I'd kept my feelings about boys to myself. But when Graham and I realised we were like-minded, we began to experiment a little, in secret. After dark, we'd mess about in the dormitory together, sneaking into each other's bed, having a furtive fumble beneath the sheets, giving each other a quick hand job. We enjoyed fooling around together. We didn't feel remotely guilty or sinful, and there was certainly no hidden turmoil or inner torment for

either of us. It was a bit of fun between two curious teenagers, no more and no less. There was a strong romantic attraction between us, and a great respect for each other's talent. As we were always first in the class, there was a silent competition between us – although it never got in the way of our attachment, and that's how it would remain.

My first male celebrity crush was Dr Kildare, portrayed by actor Richard Chamberlain. After supper, I used to rush over to the television room at White Lodge to get my weekly fix of the medical drama, all the way from America, and became rather infatuated. Not only was Kildare devastatingly handsome, he also healed the sick and saved people's lives. What more could you want from a man, for goodness' sake? When I was thirteen, I decided to pen a letter to my showbiz hero. I spent hours perfecting the wording and handwriting before popping it into an envelope addressed to 'Richard Chamberlain, Actor, c/o Hollywood, America.'

'Dear Mr Chamberlain,' I wrote. 'I'm a great fan of yours, and watch Dr Kildare in our TV room whenever I can. I really love the way James treats the patients at Blair General Hospital. Would you possibly consider adopting me? Love and best wishes, Wayne Sleep, Royal Ballet School, White Lodge, Richmond Park, London, England, Great Britain.'

I never received a reply, surprisingly enough, so I had to shelve my plans of living the LA dream with my actor sugar daddy. To compensate, I bought the *Dr Kildare* theme tune on vinyl and, much to the irritation of my fellow students, played it incessantly on our communal record player.

As my classmates and I progressed through school, we realised only the crème de la crème of eighteen-year-olds would

go on to graduate to the Royal Ballet Company, so we were keen to perfect the fastest spins, the longest leaps and the highest elevation. One of my favourite ballet teachers, Joan Lawson, would even etch marks onto the wall to record the height of our leaps, to make things extra-competitive. In terms of talent, Graham and I definitely had the edge over the other pupils – he was a superb dancer and my closest rival – and in class, we'd subconsciously push each other to the limit.

In retrospect, I realise we were at a disadvantage, teaching-wise, until Joan Lawson came along in my final year at White Lodge. Her contemporaries, in my opinion, seemed to be just acting the part; many of them had retired early due to injury and almost fell into their roles. But Miss Lawson was a fabulous teacher; the real deal. Her personality was as outlandish as her dress sense.

'We're bringing in a teacher who's quite eccentric,' Ursula Moreton, the head of the school, told us one morning.

You don't say. In waltzed this woman wearing a floor-length dress tucked into her bloomers – so she could demonstrate steps properly – who placed an alarm clock on the piano so she could time the session with precision (pupils at the school she had previously taught at had a habit of tampering with the hands on the wall clock to curtail lessons).

But everyone fell in love with Miss Lawson, particularly when she demonstrated mime, a specialism of hers. Her expressive Eastern European folk stories not only made us laugh – she'd put her scarf around her head and pretend to dig beetroots – but also helped us to hone our own theatrical skills. She was the first to teach us about physiology – how to develop your inner core and to breathe from your back rather than

your diaphragm – which helped us to make sense of the way our bodies worked. She also very cleverly introduced us to the history of classical ballet through demonstrations ('this is why Vaslav Nijinsky's entrechat became the stuff of legend . . . this is how Margot Fonteyn pioneered this step . . .') and I lapped it up. I loved learning about Nijinsky in particular. Small and sturdy, he became famed for his sensational leaps and his sensitive interpretation, and was regarded as a virtuoso in its truest sense: a unique artiste with outstanding talent and technical ability. I would have daydream upon daydream of emulating him one day.

I didn't warm to all my teachers, though. One, Louis Ressiga, had a very short fuse and angrily reported me to senior staff for lazily putting rubber bands around my shoe instead of carefully sewing in some elastic. Another, Donald Britten – a principal in the Royal Ballet touring company – was a brilliant virtuoso dancer-cum-coach who'd teach me many of the roles I'd one day inherit. Like Miss Lawson, he was a pioneer – I remember him showing us a chart of the body, pointing out all the muscles and ligaments – but he and I would often rub each other up the wrong way. We could both be a bit moody – I blame my teenage hormones – and would often lock horns in class. Indeed, when I met him in later life, he told me he knew I was in a bad mood if I flounced out of the salon without shutting the door behind me.

Dame Ninette De Valois formed the first ballet school in 1926 – incredible to think that it will soon be 100 years old. She was appointed director of the Royal Ballet School in 1963, replacing Ursula Moreton. One of the most influential figures in the history of dance, both on stage and off, Dame Ninette

was born Edris Stannus in Ireland before changing her name in her twenties while performing with the Ballets Russes. As a choreographer, she went on to establish the prestigious Sadler's Wells Ballet in London, which evolved into the Royal Ballet Company. Then, in order to provide the organisation with a hotbed of talent, she set up the school to coach and nurture young dancers. Renowned and respected for her vision and innovation – and her dogged pursuit of excellence – she was known simply as 'Madam' by everyone in the ballet world.

Our first meeting, when I was thirteen, was remarkable, but for all the wrong reasons. Madam had visited the salon one morning to observe class – we were all totally star-struck – and midway through the session had asked me to demonstrate a pirouette, under her very close scrutiny. That day, my age-old sinus problems had reared up again, however, and, as I eagerly executed a double turn, a huge globule shot out of my nostril and landed – splat! – squarely on Madam's black patent shoe. I was mortified. My cheeks burned as my classmates sniggered behind me. Sarah Payne, my teacher, handed me a handkerchief and I wiped off the slime as best I could.

'Oh, don't worry about it, you silly boy. Get back to class,' said Madam.

Fortunately, the twinkle in her eye suggested amusement rather than anger. Indeed, I think something clicked between us that morning. Dame Ninette would later admit she'd been rather charmed by my impish streak, something of a rarity in the prim and proper world of ballet. Madam, I found out, was very fond of naughty boys.

* * *

While I was loving life at the ballet school, things weren't so wonderful for my parents. They had moved back to Plymouth in the early 1960s, around the time that Joanne was due to start nursery school. Stan's money-making enterprise hadn't worked out as planned and Mum wasn't enjoying life up north. Not only was she missing me dreadfully – she'd cry buckets whenever Burl Ives's 'A Little Bitty Tear' came on the radio because it reminded her of me – she'd also become very homesick for her native Devon. She'd sing that song to me whenever I came home, not only to make me feel a little guilty, but also to exercise her vocal cords. I think she must have missed singing.

I'd sometimes pack my little suitcase and go and stay for the weekend (when Stan could afford my train fare) but, unknown to my mother, this was more out of duty than devotion. While it was nice to catch up with the family goings-on – my aunts and uncles would always drop by to say hello – I always felt slightly disengaged whenever I was in the Sleep household, with Stan harrumphing around the place and Mum tending to the needs of my toddling sister. In truth, I felt far more content living in leafy Richmond, where I could enjoy my new-found independence.

Some weekends, if all my classmates had gone back home, I'd find myself rattling around in the boys' dormitory alone. This never bothered me, though, because I really enjoyed my own company; having grown up as an only child for the first ten years of my life, I was quite accustomed to solitude. At White Lodge, I'd spend hours exploring the beautifully tended gardens and would often find myself gravitating to a lush patch of lawn in front of the hunting lodge. There, I'd lie down flat, eyes tightly shut, visualising myself as a

tiny little speck upon Planet Earth's curve. Connecting with something so vast and permanent gave me comfort. My future often felt uncertain at the school – there was no guarantee I'd progress to the Company, no matter how well I performed – and being at one with Mother Nature seemed to ease these worries.

There came a point at which I sought more solace in the great outdoors than in my religious faith. Ever since I'd arrived in London, I'd felt myself slowly losing interest. I was no longer active in the Church Army – there were no local meetings – and my efforts to set up a Scripture Union at White Lodge had been scorned by my fellow students. I had also heard them giggling as I held prayers in the dormitory. As a consequence, I began to question some of the Holy Bible's teachings – maybe the Feeding of the Five Thousand *was* far-fetched, as my classmates had said. I still went to All Saints Church each Sunday with the rest of school, walking through Richmond Park to get there, but I didn't feel I needed it in my life any more. Dancing had become my new religion.

Nevertheless, I continued to receive letters from my Church Army mentor, Noel Proctor. One exhorted me to 'keep close to the Lord all the time, that you might not fall to any of the temptations that will naturally come your way'. Another warned me that 'now that you are away from the fellowship of other people who have accepted Christ the Saviour, you may find it difficult to stand alone'. It was kind of him to keep in touch, but his words no longer resonated so deeply. The 'temptations' reference made me feel a little confused, too, because it made me wonder whether my dormitory dalliances with Graham were wrong. Because they didn't feel very wrong to me.

Occasionally, I spent my free weekends at the Earl's Court apartment of an elegant, erudite fifty-something, Joan de Robeck, who I credit for introducing me to a whole new world of arts and culture. She was the legal guardian of my fellow pupil, Nicholas Bramble, who'd taken me to visit her one Friday evening when I was left alone in the dormirtory. We'd listen to *Friday Night is Music Night* on her Roberts radio, never imagining that I would appear on that very show one day. Miss de Robeck and I immediately hit it off, chatting over a cup of Earl Grey. I'd never had tea or coffee at this point, so this seemed incredibly exotic, although its faintly medicinal aftertaste did make me wonder if I was being poisoned. I'd always had a fertile imagination. I also used to fixate on her false teeth, which often became dislodged and clacked like castanets.

Miss de Robeck took me under her wing – I think she felt sorry for me, all alone in the dorm – and whisked me off to her favourite museums, like the British Museum or the Wallace Collection. She taught me that this thing called 'culture' was something to be accessed by everybody, regardless of their status or background. And in terms of cultural offerings, London was the place to be.

'You have as much right to enjoy this as anyone, Wayne, dear,' she'd say, as we marvelled at the beauty of Frans Hals' 'The Laughing Cavalier'.

She also invited me along to a variety of West End plays, mainly very safe, English ones, that I usually fell asleep in, though I adored the thrill of live performance and the buzz of Theatreland. And if that wasn't exciting enough, Miss de Robeck would then treat me to an aftershow hamburger at the famous Golden Egg on Earl's Court Road, one of London's

original fast-food restaurants. Her kindness knew no bounds. She even wrote chatty letters to my mother to reassure her I was being well looked-after, although Mum didn't take too kindly to them. She didn't like the idea of being 'substituted' by some posh, rich woman in London who saw more of her son than she did.

In the winter of 1962, one outing with Joan became a life-changing experience. Unusually, she asked me to choose our entertainment – her previous choice, a Noel Coward-style saga, *The Reluctant Peer*, had been a little underwhelming – and, for a change, I opted for a film. The musical *West Side Story* had just premiered on stage in the UK, having wowed audiences in America, and the film was showing at the Astoria on Tottenham Court Road. This adaptation of Shakespeare's *Romeo and Juliet*, starring Natalie Wood and Richard Beymer, was enthralling from start to finish. I was utterly captivated by Jerome Robbins's choreography, a dazzling fusion of dance and gymnastics that managed to blend the grace of ballet with the energy of jazz. Miss de Robeck wasn't a fan, though. Maybe it was a generational thing.

The sequences involving the Sharks and the Jets – leaping across building sites, pirouetting through parking lots – made me want to tear through the cinema screen and jump onto the mean streets of Manhattan. I'd never seen male dancers who looked and moved that way. Rippling with muscles and glistening with sweat, these guys exuded swagger, bravado and attitude. Coincidentally, sitting beside Miss de Robeck and I that night was one of my teachers at White Lodge, Errol Addison, who had also been on the panel that had admitted me to the school.

'Now that's *proper* dancing for you, laddie,' he said, turning around and winking as the end credits rolled.

'It certainly is, Sir,' I replied. 'I'd give anything to perform like that.'

And, as if I needed any more motivation to graduate to the Company, he then told me that George Chakiris, who played the role of Bernardo, had studied the fundamentals of classical ballet at the American School of Dance.

As luck would have it, I was able to rub shoulders with some world-famous dancers in July 1963, when I was asked to perform with the renowned Bolshoi Ballet. The Moscow-based company had mounted a grand tour of the West and, while based at Covent Garden, had chosen a dozen pupils from White Lodge to take part in a production called *School of Ballet*. While staying in London, the Bolshoi dancers were confined to their hotel, for fear of defection. I was told that the only dancer allowed out happened to be having a relationship with the daughter of Soviet Union president, Leonid Brezhnev.

The whole thing was thrilling. Not only was I sharing a stage with the finest ballet dancers in the world, including the maestro Vladimir Vasiliev, I was also playing to an audience at the famous Royal Opera House. What a magical venue. This beautiful nineteenth-century amphitheatre is one of the largest in London (it can seat over 2,000 people, including the VIPs in the lavish royal box) and boasts a wondrously ornate domed ceiling.

I thought that the backstage area had a really special atmosphere, a constant hubbub of dancers warming up their muscles or dashing off for a costume change. It also had its own distinctive aroma: a heady mix of Pan-Stik make-up,

hairspray, Russian cigarettes and rosin, the pine-smelling substance used to add traction to the stage floor. Every night, I'd peep out from the wings to watch Vasiliev in action, marvelling at his sensual, almost brutish approach to ballet. Like most Russian dancers, he stomped, he stamped and he strutted. The English way, with its emphasis on effortless elegance, precision and the beauty of line, was much more genteel and refined. No prizes for guessing which style I favoured. *That's the way I want to dance,* I remember thinking to myself.

And little did I know that, a few years later, I'd be sharing a stage with Rudolf Nureyev, the most famous Russian dancer of all.

I was about seventeen when I realised I'd stopped growing. My male and female peers had begun to shoot up and tower over me – Peter O'Brien and Alan Hooper soon hit six foot – and my longed-for growth spurt never materialised. Marooned at just five-foot-two, I felt completely miserable. Vanity wasn't the issue. I was happy enough with my appearance and was often told I was handsome (although not by Mum, perhaps to dampen any ego I might have).

'Mum, am I good looking?' I remember once asking her.

'Well, you're no Clark Gable,' came her reply.

Of primary concern to me was my career progression. My lack of inches would probably dent my chances of graduating to the Royal Ballet Company and, even if I succeeded, my choice of roles would be limited. No self-respecting *Swan Lake* choreographer would partner a five-foot-two Prince Siegfried with a five-foot-eight Princess Odette. Although I often came first in my end of year assessment, in all likelihood, I'd be

consigned to character roles or the *corps de ballet*. And there was no guarantee I'd get a place, anyway. The Royal Ballet Company was all about business, not benevolence.

My height issues became a source of amusement to some people at White Lodge. The other lads in the dormitory would lark about in the evening, calling me 'midget' or 'shorty', and pinning me down on the bed by my ankles and shoulders to stretch me, or hoisting me up to the door lintels so I could hang from them by my fingertips to supposedly lengthen my limbs. In class, the taller boys would lean on me as if I was a table, just for laughs. It was more a case of horseplay than harassment. If anything, I was a willing participant, hoping these ruses might have the desired effect. The dorm culture at White Lodge was pretty merciless – nobody seemed to give a stuff about hurt feelings back then – and we were all subjected to ribbing of some sort. I just went along with it. To me, it was no big deal.

I was more annoyed by those teachers who chose to have a sly dig. Being fully grown adults, you'd have perhaps expected them to show a little more tact and sensitivity.

'We'll have to put you on the rack, Sleep,' one of them grinned as I practised a *pas de deux* with Lesley Collier, my eyes barely level with her collarbone.

'Have you ever considered sleeping in horse manure?' another quipped. 'Might add a couple of inches.'

Idiots . . . I'll bloody show you . . . I'd mutter under my breath. Their sideswipes became motivational tools, spurring me on to increase my strength and stamina to compensate for my lack of height. By my final term, I was as strong as an ox and could lift the tallest girl in the school with one hand. *Have some of this, you doubters . . .*

But there were occasions when my resolve weakened. At one point, I felt so desperate about my predicament that I seriously contemplated taking growth hormones. I'd read in a magazine that some small male dancers had taken hormones to make them grow but they hadn't perfected the science of it. We talked about it in the upper school dressing room one night and I wondered aloud whether hormones might be the solution for me. To my horror, one of my classmate confidantes must have tipped off Dame Ninette, who promptly hauled me into her office.

'Now, Sleep, what's this story I hear about you wanting to take a pill?' said Madam, sharply (she always used my surname back then). She then told me about a young dancer she knew who'd taken such medication, only to shoot up to a massive six foot four, which effectively ruined his career. I wasn't sure I believed her – it sounded like a tall story, if you'll pardon the pun – but I promised Madam that I'd shelve my foolish notions, keep working hard and stay focused.

'You'll just have to spin twice as fast and jump twice as high as everyone else. Now, get on with it.'

Dame Ninette was one of the shrewdest people I ever met. I would never disobey Madam. And her words of advice would linger for a long time, following me through my career. Wherever I performed, from London to Los Angeles, I'd aim to spin twice as fast and jump twice as high. To keep my place in this distinguished Company, with its array of world-class dancers, there was simply no other option.

CHAPTER FOUR

The Presence of Greatness

THE PERIOD BETWEEN the early 1960s and the late 1970s is widely regarded by many as the golden era of the Royal Ballet. But it's only now, looking back, that I realise how lucky I was to be a scholarship student in those glory days, to observe at close quarters some of the finest principals and partnerships to have ever graced Covent Garden. Just a small selection of their names reads like a who's who of classical ballet: Anthony Dowell and Antoinette Sibley; Lynn Seymour and Christopher Gable; Svetlana Beriosova and Donald MacLeary; and, of course, Dame Margot Fonteyn and Rudolf Nureyev – the most famous duo of them all.

When I was a fourth former, around the age of fifteen, my White Lodge classmates and I would be shuttled over to Barons Court in west London to be taught with our upper school counterparts. The Royal Ballet Company had class in the same building, too, as well as rehearsals. Their studio doors had little port-holes that, if you were feeling daring and devilish, you could peer through to try to catch sight of a big-name dancer. This prying was frowned upon, especially if top secret choreography was being developed. The powers-that-be were very protective over their new steps and sequences.

Very occasionally, if the star principal or choreographer was in a good mood, we'd be invited into studio rehearsals. Having the opportunity to watch these ballet legends, to study their skills and techniques, was pivotal to my development as a dancer. Indeed, I learned as much from these observational sessions as I did from my formal lessons.

In 1962, Barons Court was abuzz with news of the arrival of 24-year-old Rudolf Nureyev, just a year after his headline-grabbing defection to the West from the Soviet Union. Dame Ninette had invited this charismatic young dancer to London as a guest artiste, to partner Margot Fonteyn – then the world's most famous ballerina – in a new production of *Giselle*. What a masterstroke that was by Madam. You wouldn't have put those two together in casting. By then, Fonteyn was in her early forties and on the verge of retiring, but the arrival of this youthful Russian upstart suddenly breathed new life into her career. She and Rudi clicked almost immediately, and the rest was history.

In the spring of 1962, I was lucky enough to witness Rudolf and Margot rehearsing *Giselle* at the Royal Opera House. Occasionally, groups of White Lodge students were allowed to watch dress rehearsals from up in the gods, as long as we sat nice and still in our seats and didn't rustle our lunchtime sandwiches too loudly. Often joining us for these special treats were the Friends of Covent Garden, a group of wealthy donors who, as a reward for their financial support, would enjoy certain perks and privileges, like Q&As with our big-name dancers and VIP tickets for the annual Christmas party-cum-performance attended by royalty. Like them, I was so excited at the prospect of seeing

this talented young dancer for the very first time with my very own eyes.

'That's him, that's him,' I nudged my fellow classmates when I caught sight of the Russian, striding onto the stage to perform his warm-up. Even that alone was mesmerising. Most dancers chose to do their stretching exercises behind the scenes, but not Rudolf. I could barely take my eyes off him as he went through the motions, holding onto the proscenium arch to perform his barre work, and then coming centre stage to do his forward bends. His body was taut and his face was stern. He looked like a god.

The performance itself was magical. I'd watched other dress rehearsals at Covent Garden before but nothing quite so enchanting as this. Nureyev and Fonteyn were perfect partners, her grace and elegance acting as the ideal foil for his brawn and passion. Together, they would go on to add a new sheen and sparkle to *Giselle*, arguably one of the finest ballets in the classical repertoire. At the Covent Garden premiere, this magnificent new duo would receive over twenty curtain calls. Their *Romeo and Juliet* in 1965 earned them forty-three.

The move across to the upper school when I was sixteen brought with it plenty of benefits. For starters, it marked the end of my academic studies – hallelujah! – which meant my entire timetable was devoted to broadening my range and ability, dance-wise. We were taught technical skills, such as how to artfully and tactfully place our hands on our partner's body during a pas de deux. We were also given a grounding in other disciplines – including Russian and Eastern Europe

character dance – and were taught some popular elements of the Royal Ballet repertoire, step by step. So, using *Swan Lake* as an example, the girls might learn the Dance of the Cygnets and the boys might learn the Prince's Solo.

We were also given classical ballet-style mime acting lessons – which I loved – where we'd learn how to add drama to a movement with a simple head-tilt or a hand gesture. We were taught that ballet was essentially storytelling without words and, if done properly, was an art form that could transcend language. There were only a few classical ballet dancers in my day who were able to act the part and dance it brilliantly, and when you mastered them both it caused a sensation. I like to think I was a member of that elite group.

Company directors and choreographers would periodically pop into the studio to observe us and would sometimes be invited to coach us for an afternoon (we called this room 'the goldfish bowl' because much of it was glass, and you always felt you were being watched). The directors would weigh us up and double-check our progress, earmarking any potential Covent Garden performers. We would see them giving each other the side-eye, as if to say 'he's pretty special', or 'she's rather good'. Indeed, the director of the Company Sir Frederick Ashton once walked past me in the studio and, as he did so, grabbed my head – gently, mind – and said, 'Grow, Sleep, grow,' like he was somehow willing me to gain a few inches. The message was crystal clear: *you may be good enough for the Company one day, young man; you're just not tall enough . . .*

Yet again, I feared my lack of height would scupper my prospects. Being the best in class and coming first in tests wasn't good enough – ballet (and life) could be so damned

unfair – though all I could do was make the most of the talent I had. Knowing that taller and less talented dancers had a better chance of progressing to the Company made me work even harder on my technique. I just had to become head and shoulders above the rest – metaphorically speaking, of course.

My life outside the studio had its problems, too. When students left the confines of White Lodge, it was their responsibility to find replacement accommodation. This created an issue for me, since the funding obtained through my Leverhulme scholarship had now stopped. An award from Plymouth Council paid for my place at the upper school, and I was granted a £5-per-week living allowance to cover food, travel and accommodation. I moved to the YMCA hostel on Tottenham Court Road with my classmate Alan Hooper, where we shared a poky, musty room and a particularly rank communal bathroom used by the whole floor. Being a fastidious 'fuss-arse' (as my mother used to say), I'd regularly arm myself with a bottle of Dettol, scrubbing all manner of substances from the bath, bowl and basin. It wasn't until I was much older that I was told what often went on behind those locked doors.

My YMCA rent cost me 30 shillings per week, and my daily travel to and from Barons Court amounted to one shilling and sixpence. This meant I could hardly afford to eat. More often than not, my daily food consumption comprised just one solitary Mars Bar and, following a strenuous ballet class one morning, a few weeks into my new term at upper school, I became light-headed and almost passed out. My teacher rescued me just in time and, concerned about my health, whisked me straight to Madam's office.

'What's the matter, Sleep? Didn't you eat breakfast?' she said.

'I can't really afford it. I only get five pounds per week,' I answered.

'Goodness, why on earth didn't you tell us?'

'I thought everyone was in the same position, Madam . . .'

It turned out that my fellow students received much more generous grants. So, with typical practicality, Madam organised for the upper school bursar to access a benevolent fund that topped up my weekly allowance by £2. On a professional level, Madam was a tough cookie. On a personal level, she was unfailingly kind and humane. That two quid made all the difference. I no longer had to worry about making ends meet. In fact, that is the richest I've ever felt in my life.

Not long after, I found a part-time job as a dresser for a production of *Oliver!* at the New Theatre on St Martin's Lane. It wasn't as exciting as it sounds. I had imagined the backstage area to be opulent and luxurious (similar to the theatre's front of house, with its velour seats, velvet curtains and satin swags), but the reality was very different. The stone floors were icy cold under foot and the walls were stained a greyish yellow from all the actors' cigarette smoke. It was very basic and sparse, not remotely like the sparkly peep-show theatres I used to make as a kid.

I worked with two actors – one played Mr Bumble, the other Dr Grimwig. I'd liaise with the wardrobe mistress to ensure the actors changed quickly into their freshly ironed costumes and, after their performance, climbed carefully out of their sweaty gear, which I'd rush back to wardrobe to get laundered. It was a slog of a job – the actor playing Mr Bumble was about thirty stone, so de-robing him was like

wrestling with a rhino – but those extra pound notes in my pocket made it all worthwhile.

I also received a pound per show for working as an extra in various Covent Garden performances – both opera and ballet – starring in roles such as 'Spear Holder' and 'Carrier of the Prince's Cushion'. I stood still for so long my feet would go numb and I'd feel myself swaying, but I relished this unique vantage point because it allowed me to watch the performances unfold and gauge the audience reaction. There were downsides to this moonlighting, though, including having to wear mangy, moth-eaten Roman centurion costumes that probably hadn't been washed since the war. Believe me, the performing arts weren't always glitzy and glamorous.

The students at Barons Court were a very mixed bag. Lots of young protégés had joined from provincial dance schools – Sheffield, Manchester or Birmingham – or from Commonwealth countries like Australia, Canada and New Zealand. And, compared with our mollycoddled crowd from White Lodge, many of the additional intake seemed far more sassy and worldly-wise. Among them was a minority of boys, maybe a dozen or so, whose outrageous behaviour I found both funny and fascinating. I'd watch intently as they flounced and cavorted around the canteen, exaggerating each mannerism and gesticulation. When they sat down to talk it was like listening to a bunch of gossipy, garrulous women, their voices rising, their vowels stretching, their chatter full of *ooohs, aaaahs* and *you don't says* . . .

They even gave each other feminine names, so Peter was 'Petula', Michael was 'Mandy', Brian was 'Brenda', and so on.

Something about their carefree attitude struck a chord and I felt incredibly drawn to them. Life was a hoot for these boys. If they weren't playfully lampooning others, they were laughing like drains at themselves. I'd come to realise that this performative flamboyance, commonly (but not always) adopted by gays, had its own name: *camp*.

I soon found myself gravitating towards this clique of dancers and, keen to fit in, began to mimic their traits and behaviours. I subconsciously found myself channelling my mother and aunties, too – as a kid, I'd often been privy to their nudge-nudge, wink-wink conflabs – as well as the jokers I'd watched on TV and film, like *Carry On* stars Kenneth Williams and Frankie Howerd. Camp, I discovered, came naturally to me. But I only put on this act when I was within the confines of Barons Court; I wouldn't have dreamed of doing so in the wider world.

'Well, fancy that, look at Wendy!' cooed one of my new buddies, when I first joined in with all the frivolity. 'He's one of us . . .'

'Ooh, you don't say, Brenda sweetheart . . .'

Inevitably, perhaps, my gravitation towards the camp crew invited speculation about my sexual orientation. Graham was the only classmate who knew I preferred men but, soon enough, others began to drop hints and raise eyebrows. Bizarrely enough, when I was asked for the first time if I was 'gay' – by a female dancer – I had no idea what the word signified in that context. I genuinely thought it meant 'happy' (the only such definition that had been used in the Sleep household, after all) and had to request an explainer. This slang term may well have been used in certain London circles for some time, but up until then it had eluded me.

In response to pointed 'are you gay?' questions, I'd shrug my shoulders in a vague, non-committal, *who knows?* kind of way. I was quite happy to keep people guessing. And a part of me didn't want to upset the girls at Barons Court, a few of whom I knew would be disappointed that I was effectively flexing my muscles in the other market. By maintaining an air of ambiguity – having a foot in both camps, as it were – I could still entertain the idea of plausibly dating a woman one day, albeit as a decoy to hide my true feelings. Back then, many gay men found themselves contemplating this unfortunate scenario.

In addition to all this, from a professional perspective, as a performer with ambitions, I believed it was in my interest to keep my cards close to my chest. I was afraid that my career would be ruined in an instant if people knew I was gay. Much of the British public viewed homosexuality as debauched and disgraceful, sadly. I'd heard stories of theatre-goers refusing to watch 'one of them' on a West End stage, and rumours of theatre producers fearing the associated financial and reputational damage. So I kept schtum, as did many of my colleagues. During my time at the Royal Ballet, I never witnessed anyone coming out. It wasn't common practice and it wasn't the right climate.

I wasn't willing to open up to my family, either. The Pinto/Sleep clan were pretty narrow-minded in that respect – they still talked of poofs and Nancy boys – and I sensed they'd not only react with horror but would happily ostracise me too. Above all else, though, I knew this truth-bomb would have a catastrophic effect upon my mother. Giving birth to an illegitimate child in the first place had caused her no end

of shame and embarrassment, but being forced to admit she had a 'pansy' for a son would've broken her heart. So, for as long as Mum lived, I never once brought up the subject and, difficult though it was, never officially came out in public, so as to protect her.

There would come a time, when I was in my mid-twenties, when she probably realised I was gay – and *she* knew that *I* knew that *she* knew I was gay – but it was never, ever spoken about. We both deftly sidestepped the issue. The decision to shield my mother from any unnecessary grief or upset was something I never once regretted. As my good friend George Lawson later said to me: 'Mother always knows.'

I was in my late teens when I had my first grown-up gay experience. I met a young man in the YMCA coffee bar – he was a university student – and something just clicked. With his tall, dark looks and his impeccable manners, he felt like quite the catch. And while I don't remember his name – and we only saw each other a few times – I do remember the intense attraction between us. My stomach did a hundred pirouettes when he walked into the room.

My beau and I spent lots of time together in the hostel (by then, Alan and I had our own rooms, giving me much more privacy), and we even managed a getaway weekend in Torquay, zooming down to the south-west coast on his scooter. In common with most male couples, we had to pretend we were 'just good friends' – such a drag – which meant booking separate rooms in our B&B and carefully avoiding any public displays of affection. It just wasn't worth the risk. Gay-bashing was commonplace in every town and city, and terrified the life out of me.

While I was extremely fond of my boyfriend, it soon became obvious that he was more interested in the physical side of our relationship than the emotional. As a dyed-in-the-wool romantic, who often daydreamed about finding true love, this was incredibly disappointing for me, and I let my true feelings be known. My other half eventually tired of me – perhaps I became too needy – and when he started to turn out his light when I knocked on the door, I realised we were history. But while our courtship was short lived, I considered it an important milestone. I finally realised I was capable of falling in love with another man and that I was designed to do so. This was no passing phase.

I began to attract more male attention back at Barons Court, too, including that of the most famous ballet dancer of his generation. Being an upper school student meant that, much to my delight, I'd sometimes find myself in the same studio as Rudolf Nureyev, warming up and practising my steps in close proximity. As a guest artist, he wasn't there as often as the other male principals, like Anthony Dowell and Christopher Gable, so it was a rare treat whenever he was in the building.

Like many of us, Rudolf wasn't 'out' to the wider world – spurious rumours of flings with Margot would occasionally emerge in the tabloids – but everyone at the Royal Ballet knew he preferred men. Within the confines of Barons Court and Covent Garden, he flaunted his sexuality, preening around like a peacock and regularly trying his luck with his fellow dancers. He'd flirt outrageously, even with the straight guys, but it was always done in jest by him and taken as a joke by us. There was nothing sleazy or sinister; it was just Rudi being Rudi. Indeed, being the subject of his affections was often taken as

a compliment – the very height of flattery – and most people either lapped it up or laughed it off. In retrospect, I can see that he probably got away with so much because of who he was. Others of lesser status may not have been so well tolerated.

It was waiting in the wings at the Opera House, during Act Two of a performance of *Giselle*, when Rudolf made a pass at me. He'd just come off stage following his solo, and I remember sensing a presence behind me, and then feeling a pair of arms encircling my waist and a hand creeping towards my belt. When I turned around, I saw Rudi there, with a big grin on his face. I quickly darted out of the way, performing a nifty petit jeté that even he'd have been proud of. When he realised I wasn't playing ball, as it were, he just winked, shrugged his shoulders and strode off in the opposite direction. I was more worried that the performers on stage might have spied what was going on, and thus gained the wrong impression, but, in reality, the glare from the spotlights wouldn't have allowed this.

Luckily, I found it quite easy to spurn Rudi's cheeky advances, which would happen from time to time. I was among the tiny minority not drawn to him in the slightest, physically or emotionally. Others were reduced to jelly by his macho swagger and his chiselled features, but, looks-wise, he did nothing for me.

Though I loved him dearly, I was green with envy when my pal Graham was asked to join the Company following his first year at upper school. Most students were invited in their second year, with only the crème de la crème meriting an early call-up. My dismay was largely born of frustration. I knew

I was as talented as Graham – if not more – and suspected I was, yet again, falling victim to the ballet world's obsession with perfectly proportioned physiques. I was good enough, just not tall enough, and I was starting to worry that I'd struggle to even get into any old dance company, let alone the Royal Ballet Company. However, with Madam's advice ringing in my ears ('spin faster . . . jump higher!'), I pulled up my tights, strapped on my pumps and put my best foot forward.

Ironically enough, it was my lack of height that gave me my big breakthrough. Sir Frederick Ashton's new idea for the 1965 revival of *Cinderella* – a festive institution first performed at Sadler's Wells in the 1940s – was that in the ballroom scene, the Ugly Sisters would have as suitors the small, squat Napoleon and the tall, handsome Duke of Wellington. It was an innovation introduced to keep the show fresh for that year's audience and meant that Sir Fred required a diminutive dancer to play the light-hearted Napoleon Bonaparte cameo. Sir Fred reprised his uproarious Ugly Sisters' double act with Robert Helpmann, a brilliantly versatile dancer and actor. I first met this legend of a performer in a backstage corridor, bumping into him and Sir Fred as they tottered around in their flamboyant finery.

'What d'you think of Wayne, then?' asked the latter, having perhaps tipped off his friend about my potential as a dancer.

'Too tall,' replied Helpmann, quick as a flash. Ha-flipping-ha.

Three years later, he'd famously play the role of the callous and creepy Child Catcher in *Chitty Chitty Bang Bang*. He told a great story about his young godson who, shortly after the film's release, was handed a telephone receiver by his parents because 'nice Uncle Robert' wanted a word.

'LOLLIPOPS, KIDDIWINKIES!' Helpmann snarled down the line, in character, leaving the poor kid traumatised for days. The adults had all colluded together, the rotten bastards.

I was asked to perform Napoleon three times per week at Covent Garden and I relished every second. I'd worked hard to create a suitably pompous caricature with a deadpan expression, and got the biggest adrenalin rush when I heard peals of laughter echoing around the auditorium. I had no idea I was going to get a reaction like that for such a small scene. Following his solo, Sir Fred would allow me to lift him high, or to catch him in my arms, both of which I could do with ease (I knew my pas de deux training with the tall girls would come in handy one day). Unusually, at the end of the solo, he'd grab my arm and pull me to the front of the stage for a 'call', as he'd realised that by me lifting him, we had won over Sir Robert's solo, which had in the past always received the greater applause. This opportunity to bow to the audience and be bathed in applause wasn't afforded to everyone, let alone a student, and I was flattered beyond belief.

Is this really happening? I remember thinking to myself as I held aloft this ballet icon.

'Don't you dare bloody drop me, Sleep,' he'd often hiss under his breath.

While *Cinderella* allowed me to showcase my virtuoso talents to Covent Garden's top brass, it was the role of the Blue Boy in Ashton's *Les Patineurs* that essentially sealed my place in the Company. Brimming with spins, turns and entrechats, it was the ideal dance for someone with my energy and athleticism and played perfectly to my strengths. I revelled in its finale, which, while the velvet curtain was

lowered, saw me spinning for a minute beneath a flurry of fake snow. When the curtain slowly rose again I was still under the same spotlight, spinning continuously on centre stage until the music stopped. The Opera House audience adored it – as did one influential dance critic, it transpired.

'A seventeen-year-old boy, making his debut in one of our most famous leading roles, not only equals but surpasses all his predecessors,' wrote John Percival in *Dance & Dancers* magazine. 'What a pleasant change to find a young man so mettlesome and so un-stereotyped. I would guess that we are in for some fun . . .'

My first proper review in our industry publication and it was a decent one. I was beyond thrilled.

The occasion was made extra-special by Mum being among the audience that afternoon, along with Auntie Ruth. Classical ballet wasn't Stan's cup of tea (neither was his stepson, to be fair) so his non-attendance came as no surprise. In fact, I don't ever recall him showing any interest in my dancing or asking me how I was getting on. But it was lovely to perform in front of my mother. After all, she was the person who'd witnessed my entire dancing journey, from Pat Rouce's to Muriel Carr's, and from the Teesside & Durham Tournament to the Royal Ballet School audition. And now here I was, performing on stage at Covent Garden. Mum wasn't the effusive type, so I didn't expect any gushing praise or flattery, but I could sense her underlying pride as she and her sister caught up with me afterwards. Indeed, their hugs, kisses and teary eyes spoke volumes.

It was a few weeks' later, while sitting at her kitchen table in Plymouth, that my mother opened a letter formally inviting

her son to join the Royal Ballet Company as a professional dancer. I still wonder whether, amid her joy and happiness, she felt a little pang of sadness that I'd succeeded in the world of high culture when she perhaps had not. I'll never know.

Following a six-week probation period with the Company, my weekly salary rose from nine pounds to fifteen guineas (probably about £300 in today's money). I celebrated by blowing my entire pay packet on a pair of Russell & Bromley shoes – beautiful, soft brown leather slip-ons, with a faux-gold bar across the front. With no money left in my kitty, I spent the rest of the week existing on a diet of bread and jam. I didn't dare tell Mum, of course. Being a life-long thrifty person, she'd have been appalled at such extravagance. For me, though, my purchase was well worth the sacrifice. I'd become obsessed with fashion, spending my spare time trawling the vintage market in High Street Kensington or the designer boutiques of Chelsea and Soho.

Carnaby Street and the King's Road were at the very heart of Swinging Sixties' London. The shops that lined the pavements were honeypots for famous actors, musicians and broadcasters. I remember excitedly spotting Dusty Springfield and Marianne Faithfull shopping in the Biba boutique, and rubbing shoulders with a very dapper Noel Edmonds (then an up-and-coming radio DJ) in the exclusive Just Men store. On a Saturday morning, Mercedes convertibles would cruise around the area, crammed with beautiful people waving and whooping at any pedestrians who caught their eye. In sixties' Soho, it was almost impossible to distinguish between the gays and the straights because everyone

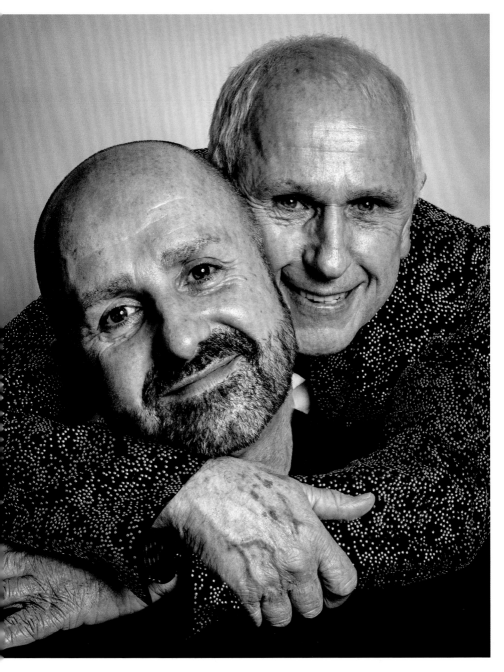

With my husband, José Bergera, the love of my life.

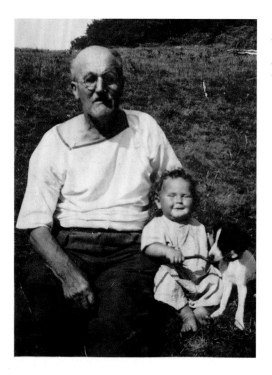

With my great-grandfather camping on Dartmoor and Whisky the dog.

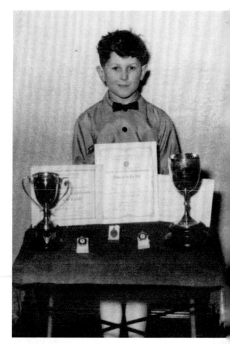

Aged 8, a two minute solo, and look what I got!

With Joanne and my mother at Christmas. A rare occasion when the whole family came together.

Inspired by Greek statues. It took us ages to untwine!

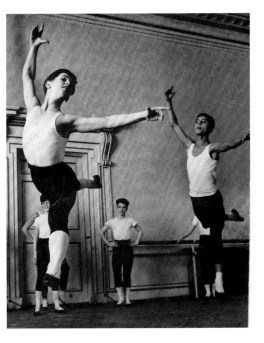

Aged 13 at White Lodge. Just after I had won my scholarship to the Royal Ballet School in Richmond Park. Always aiming higher.

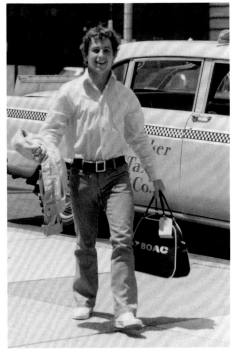

My first visit to New York with the Royal Ballet.

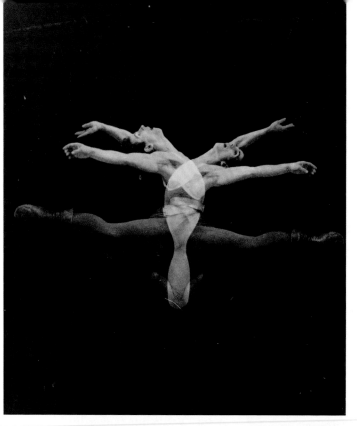

Experimenting with new techniques and always finding a different way to present myself.

My one and only modelling job. Clive stood me on a box because I was too small!

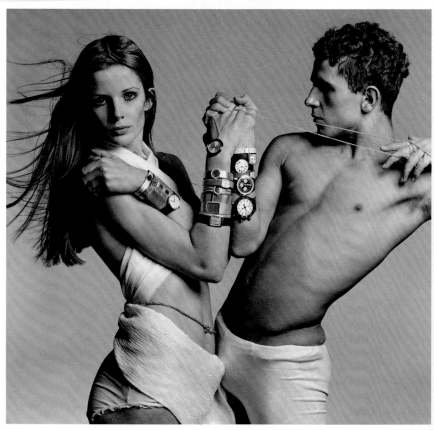

Posing for the *Evening Standard* before flying to New York, with principal dancer, Deanne Bergsma.

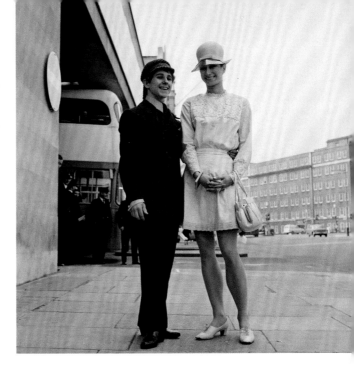

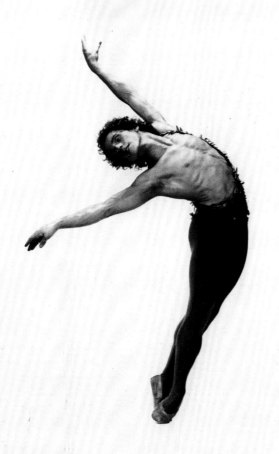

I was known as one of the best 'Pucks' in the business!

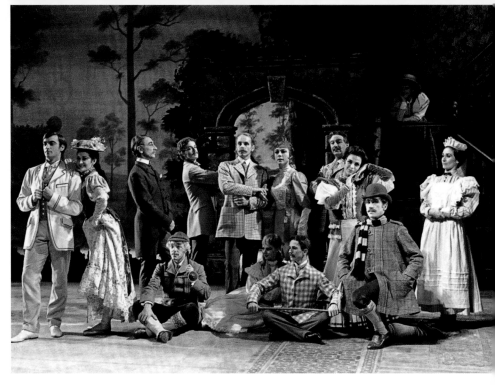

My first solo role, created by Sir Frederick Ashton, playing GRS in
Enigma Variations, half-dog, half-man.

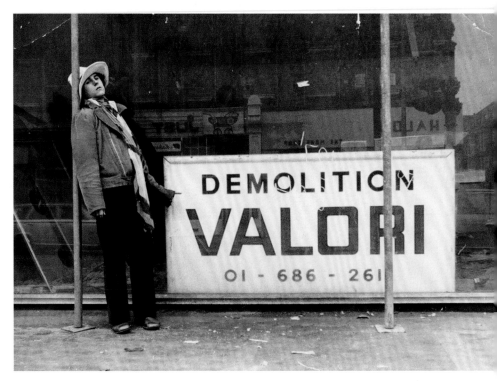

This is how I felt when I heard that the Royal Ballet were considering releasing me.

I was the first classical dancer to guest and choreograph for London Contemporary Dance. Pictured here in *David and Goliath* which I co-choreographed with Robert North.

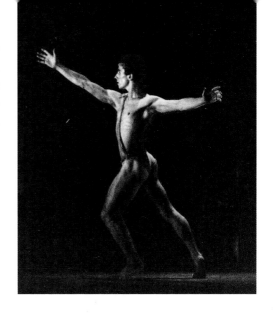

Plastered again! At David Hockney's house in Malibu, hiding from the press before the next season.

David Hockney's double portrait 'George Lawson and Wayne Sleep' arrives, finally finished, at the Tate Britain. I am pictured here with George.

Strangled by Sean Connery – I'll never relive that moment!
In the film *The Great Train Robbery*.

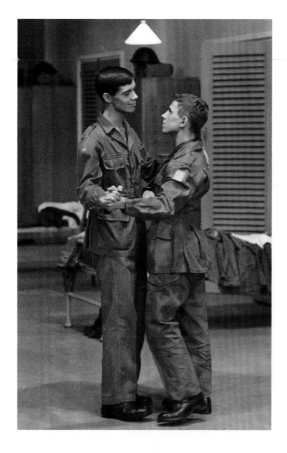

Acting as a gay soldier in the film *The Virgin Soldiers*, pictured here with Gregory Phillips. I had to do a lot of research for the role.

dressed flamboyantly, rocking their butt-hugging flares and their see-through voile shirts.

With money in my pocket, I developed a very expensive taste in designer clothes. I preferred to spend two months saving up for an Ossie Clark silk shirt rather than buying three or four cheapo garments for the same price. The 'dandy style' was my preferred look lots of foppish frills and floppy hats – and many an afternoon would find me strutting my stuff through the streets of London, showing off my new attire.

I frequented nearby Berwick Street market, too, taking photographs of this humming hive of activity (it was a renowned red-light district, too). I'd always wanted a proper, extra-curricular hobby – I needed a break from the intensity of ballet – and had bought myself a second-hand camera from Gordon Henson, a friend I'd met at the YMCA. Aged around eighty, and most probably gay (I was far too polite to beg the question), Gordon was a fascinating character. Sporting a bow tie, a smoking jacket and a skewwhiff toupee, he'd hold court in the bar, trying to flog job lots he'd bought in various London auction houses, while sniffing snuff from a little tin box. One day, he'd be armed with watches, the next day, umbrellas, and, on a good day, second-hand gadgets like radios and cameras.

'Got a beautiful second-hand Zeiss Ikon here for you, Wayne, darling, in *mint* condition.'

'I'll give you two guineas for it, Gordon . . .'

Sometimes, he and I would go to Berwick Street together on a Friday or Saturday night, just before sunset, when the fading light softly illuminated the market. While I took shots of the fruit and veg stalls with my camera – quite the novelty,

since I'd never had my own as a child – Gordon would chat to the sex workers who loitered under the streetlamps, trying to offload some jewellery he'd bought that day. He and I would then treat ourselves to a bowl of spaghetti Bolognese at the Pollo Bar in Old Compton Street, notable for being one of the few places in London where you could grab a late-night bite to eat (back then, most places closed in the early evening). A portion of homemade Italian pasta and a glass of Asti spumante was quite the luxury in those days.

Gordon was fabulous company. A former music hall entertainer – a song and dance man of some repute, apparently – he told vivid, colourful stories about the comedians, pantomime dames and end-of-the-pier acts he'd encountered over the years (one day, I'd come across similar characters myself, while pursuing my own career in the world of variety and panto).

It was Gordon who sold me my first portable record player, a pre-owned Dansette. Whenever I got down in the dumps (usually about my failure to grow into a six-foot Adonis), I'd give my favourite LP a spin: *Judy Garland – Live at Carnegie Hall*. I played it over and over again, and learned every lyric off by heart. And whenever I felt like throwing the towel in during class – quite often, as it happened – I'd hum 'I Got Rhythm' in my head, even if the piano in the corner of the salon was playing Tchaikovsky. I didn't know at the time, but I would later go on tour with Judy's daughter, Lorna Luft, touring the major concert halls in the UK, using her mother's arrangements from Carnegie Hall that she herself had used all those years before.

* * *

One evening on Berwick Street, while photographing the fruit and veg market stalls, I was approached by a well-spoken woman in her sixties. A Royal Ballet regular, she'd recognised me from my graduation performance. As we chatted, I just happened to mention that I was looking for another place to live. I'd moved out of the YMCA into a room off Harrow Road but was having trouble settling. I immediately noticed her eyes lighting up.

'I've got a spare room in my flat, Wayne,' she trilled. 'It's lovely and airy. You'd be more than welcome to stay awhile.'

It wasn't until I moved in with all my belongings – essentially my Dansette and my designer gear – that I began to suspect that Diana might have an ulterior motive. Her spacious apartment on Irving Street, near Leicester Square, turned out to be a shrine to Rudolf Nureyev, with hundreds of photographs and newspaper cuttings adorning her kitchen wall, and a stack of *Dancing Times* magazines and Royal Opera House programmes piled up on the carpet.

Whenever I returned home from Covent Garden, she'd pepper me with questions ('How was Rudi in class today? What was he rehearsing? Did he speak to you? What was he wearing?') and it became abundantly clear that she'd developed some kind of obsession. I think she was hoping that, in return for my board and lodging, I'd bring Nureyev back to the flat one afternoon for tea, cake and – in her dreams, most likely – a quick smooch and a squeeze.

Diana wouldn't be the first 'woman of a certain age' to fetishise my Russian colleague. As his fame grew, he attracted a dedicated band of well-to-do groupies who attended each one of his performances – matinees and evenings – and who lusted over his every plié and pirouette. Any ballet with

Rudolf would sell out within days – sometimes hours – but Sergeant Martin, our indomitable, ex-army front of house, would always hold back a few tickets for the Rudolf Appreciation Society so they didn't miss out.

'Look at 'em all!' I remember one dancer saying backstage as he noticed the familiar faces filing into the auditorium. 'There won't be a dry seat in the house . . .'

The ladies would also queue up outside the stage door afterwards to meet their idol, and would often be allowed into the vestibule, one by one, to get their programmes signed by him. Sometimes they'd accost me as I exited the theatre, seeking answers to a barrage of bizarre Rudi-related questions.

'Is it true that he puts cotton wool balls and a soup spoon down the front of his jockstrap?' I was once asked by one panting pensioner.

'Don't be so ridiculous,' I replied, making a mental note to ask him myself.

Like Joan de Robeck before her, Diana Roberts would write to my mother, believing she was doing her a great service because I hardly kept in contact. Referring to herself as 'Wayne's London Mum', however, went down like the proverbial lead balloon, as did her encyclopaedic knowledge of my tour dates and performance schedules.

'She's not your mother, I am,' I'd be told during one of my rare visits to Plymouth. 'Do you not think I take priority?'

'Of course you do, Mum,' I'd reply, feeling a slight pang of guilt. She and I both realised that our worlds were becoming further apart by the day.

* * *

I still saw a lot of my pal Graham, even though, since leaving the school, he had been recruited to the Royal Ballet's touring company, which operated as a separate entity to ours. Whenever he was in town, he'd visit me at Diana's place on Irving Street. He was still as gorgeous as ever, the handsome devil – all olive skin and blond curls – but our friendship continued to be platonic rather than romantic. When my landlady was out for the day, we'd go crazy in her flat, downing cheap wine and dancing around naked to Françoise Hardy's *Tous les Garçons et les Filles*, or, during an obsession with all things Russian, the Soviet Union national anthem. My taste in music was eclectic, to say the least. I loved the Beatles as much as I loved Beethoven.

Until I joined the Company, I'd never been much of a drinker – the Sleep family were virtually teetotal, so there was rarely alcohol in our house – but Graham was a party-loving wild child and would often lead me astray at the weekend. Once, he even turned up with some mystery white pills he'd brought back from Barcelona, assuring me they'd only give me a high if I washed them down with half a bottle of scotch. God knows what was in them – they could have easily killed me; same with the liquor – but devil-may-care teenagers didn't worry about such consequences.

During one such day of debauchery, Diana came home earlier than expected and was greeted in the hallway by the pair of us, in the buff and rather merry.

'Get to your bedroom, and get yourselves dressed!' she chuckled, shielding her eyes with her crocodile handbag as we shrieked with laughter.

'Don't you want to watch us dancing, Diana?' I'd say,

93

grabbing my friend's waist and pulling him close. 'We've choreographed a new pas de deux . . .'

'No dear, I'll miss *Peyton Place*,' she said, fleeing to her lounge to watch her favourite soap opera, while Graham and I collapsed on the floor in a fit of giggles. 'I'd rather watch *Peyton Place*' would become our new catchphrase, deployed whenever we were distinctly unimpressed with something or other.

The following day's comedown hangover was invariably horrendous. Graham often suffered more than me, on these occasions, though, experiencing severe headaches and heavy nosebleeds that would linger for days. These troubling symptoms should have acted as a red flag, of course, not that either of us realised it at the time. We were having far too much fun to give it much thought. Two ballet boys, living life to the full.

CHAPTER FIVE

From Covent Garden
to Fire Island

AFTER SEEING THE Royal Ballet Company rehearse during my time at the White Lodge, my one aim when I graduated was to be part of this wonderful company. Every lower and upper school student dreamed of doing so, since it was widely regarded as the best of its kind in the world, boasting the very best directors, choreographers, designers and – of course – the finest dancers. With the likes of Fonteyn and Nureyev in our midst, no other company could compare. For many of my contemporaries, it was the Royal Ballet or nothing. Anything else felt like some kind of failure, even though, with their training, they could easily get places in other companies around the world.

As things turned out, however, my first year as a professional proved frustrating. Most of the new intake went straight into a production's corps de ballet, which improved their technique, kept their strength and gave them opportunities to work with new choreographers, learning new styles. Whereas I, with only an hour and fifteen minute class every morning (this would often be the only thing in my schedule), found my toned muscles starting to become less defined, and my strength weakening. I had been used

to two-hour classes at the Royal Ballet School, followed by rehearsals, pas de deus, repertoire classes. I realised I had to do something about it. It was my height, *quelle surprise*, that was the issue. No choreographer worth their salt wanted a five-foot-two dancer ruining the symmetry and uniformity of their line-up.

As a result, I'd often find myself relegated to spear-holding or tray-carrying. Being surplus to requirements, and feeling way down the pecking order, was completely demoralising for me. It wasn't technique that was holding me back, it was biology. I'd always thought if you were good, you'd succeed, and I felt a real sense of injustice. I thought if you were the best, you'd win. But the cruel thing about ballet is that aesthetics matters just as much as ability, and looking the part matters as much as being a brilliant dancer. There were days when I felt totally defeated and deflated. It was as if my stellar graduation performance had faded into insignificance.

But I had to keep any negative feelings and emotions to myself, and put on a cheerful façade – as a first year, having accepted a place in the Company, you couldn't be seen to be looking miserable sitting in a corner, it would look as if you were ungrateful. Back home in my Irving Street bedroom, I'd try to escape reality by dimming the lights, sitting beside my little gas fire and cranking up my Dansette record player. For an hour or so, I'd wallow in *Judy at Carnegie Hall,* using the sound of the adulatory applause to lift my sagging spirits.

Helping to break the tedium was the Company's six-week tour of central and eastern Europe in Autumn 1966. Our connecting flight to Luxembourg was the first time I'd ever

been aboard an aeroplane. I loved every second of being up among the clouds.

We spent six weeks performing our repertoire in countries like Romania, Poland, Bulgaria and Czechoslovakia, where the art of ballet had been revered for hundreds of years. All the towns and cities we visited boasted magnificently opulent opera houses, complete with high-tech moving sets and mechanical stages. This all came as a surprise to me. I'd mistakenly assumed that Iron Curtain countries were behind the times compared with Britain, but in most cases the opposite was true. Cultural pursuits were given higher priority in Warsaw than in London, it seemed. Artists were respected as much as scientists and politicians. The audiences over there were incredibly know-ledgeable and appreciative, and were a joy to perform before.

We Brits weren't popular in all quarters, however. I remember being harangued by elderly locals as we walked around the city of Prague, at a time when there were rumours of a Soviet invasion.

'Where were you after the war?' they asked, spotting our Royal Ballet bags and insignias. 'We *needed* you . . .'

My trip also prompted a fascination with Communism, even though I was no political animal (that's still the case to this day). When I returned to London I headed straight to the Eastern Bloc traders on Oxford Street, where I bought high-collared shirts and leather army boots. I purchased the Russian national anthem on vinyl, too. As it blared out from the Dansette I'd down a shot of slivovitz, the famous Slavic plum brandy. Workers of the world unite!

* * *

The following spring, I was on the move again, for a three-month tour of the United States. The prospect of touring America filled me with glee. At the age of eighteen, I was more than ready to broaden my horizons and discover more of the world. Since arriving in London, I'd been surrounded by dancers from relatively privileged backgrounds, who were used to going on expensive holidays abroad. The longest journey I'd ever made with my parents was Plymouth to Hartlepool in Stan's old banger.

The Company's American tours were usually a biannual affair and had financial as well as cultural benefits. Performing to sell-out audiences from New York to San Francisco was not only a great way to show the Royal Ballet repertoire, it was also a sure-fire means of generating income. Not that all the profits were ploughed straight back into the Company, though. Cash injections were needed elsewhere. The old Royal Opera House building was falling apart, from backstage to front of house, and each year, vital repairs had to be undertaken to keep the place open for business. Moreover, the Covent Garden coffers had to be suitably swollen in order to meet the fees of guest stars (like Maria Callas), whose pay demands far exceeded those of their ballet counterparts. So our American tours were essentially bankrolling the opera.

Stepping onto the tarmac at JFK airport in New York was one of those moments I'll never forget, since it led to my first brush with fame. I was all togged up in my King's Road finery: a black double-breasted jacket with matching bell-bottomed trousers, teamed with Cuban heels and a tasselled hat. I thought I was really on trend with all the latest fashion. Indeed, as ambassadors of the Company, we were required to dress smartly

at all times. Every male dancer was told to keep his hair short, for example (that didn't last; I loved my curly mop) and we were banned from wearing jeans, inside and outside the opera houses. My sartorial style had even been noted by Margot Fonteyn, who jokily mentioned it to Rudolf Nureyev – he was a trendsetter – while we were backstage at Covent Garden.

'Oh, be careful Rudolf . . . Wayne Sleep wears hats, too,' she'd said, nodding in my direction. I don't think it was only my trendy fashion that she was alluding to but the fact that I had talent, too.

My dandy-style garb clearly attracted the attention of the JFK airport photographer, too, because as I headed to the terminal, he singled me out and asked me to strike a pose with another dancer, Deanne Bergsma. As his shutter clicked, I felt the wrath of half-a-dozen male soloists. It was unusual for someone in the corps to be photographed among the principals. The following day, the photograph (with a namecheck for Deanne and me) featured prominently in the *London Evening Standard*.

Back then, British artistes had so much cachet in America. Our country was the world's cultural hub, of course – from the Beatles and the Stones to David Bailey and Mary Quant – and the Union Jack was a symbol of prestige. As members of the esteemed Royal Ballet Company, we were treated like superstars. Staff at Macy's and Bloomingdales, for instance, showered us with discount cards and free samples when they heard our British accents and spied the RBC logo on our shoulder bags.

'Are you with the Royal bal-*aaaay*?' They'd ask. 'Could you pass me a two-dollar voucher from under the counter, honey?'

She didn't need to know I was a mere underling, did she?

99

The contrast between America and England couldn't have been more stark. At home, I was always careful to conceal any trace of my employer, for fear of being shouted at or beaten up. On the streets of London, the Royal Ballet insignia was a sure sign of a 'poof'. On the streets of New York, it was a badge of honour.

The pay packets were larger over there, too. In order to stay in line with US Equity rates, our wages doubled while we were Stateside. I heard that one dancer took tins of food with him to eat in the hotel room so he could save some money; the huge wad he amassed enabled him to put down a deposit for a new house back in London. But I wasn't so sensible, of course. I spent all my extra funds on a stack of albums from Sam Goody's record shop and brought back over a hundred records rather than investing in bricks and mortar.

Our overtime payments were juicy, too, because wherever the Royal Ballet performed, we received standing ovations, which led to countless curtain calls. American audiences adored us. We were a company of characters, all of whom brought unique elements to the ballet, and there was always a clamour to see those starry partnerships like Fonteyn and Nureyev, and Sibley and Dowell. Some aficionados would watch the same ballet numerous times, just to see it performed by different casts. I was thrilled to bits when my US stage debut – the Napoleon cameo in *Cinderella* – earned me a special mention in the *New York Times*. Their dance critic, Clive Barnes, was a famously forthright writer whose scathing reviews had been known to close a show. Unbeknown to me, however, it turned out he was already an admirer of mine, having seen me on stage at Covent Garden.

'Mr Sleep, the star of last year's Royal Ballet School graduation performance, is a wonderful performer,' he wrote. 'New York will – not this season but in years to come – see much more of him, and his debut should be properly noted.'

Seeing that accolade in black and white put a real spring in my step, physically and metaphorically. Soon, Sir Fred would cast me as Puck in *The Dream* – alongside Sibley and Dowell – and in *Sleeping Beauty*'s Bluebird pas de deux with Lesley Collier. Finally, I felt I'd moved up a notch.

I was still basking in the afterglow of Barnes's praise when disaster struck. During rehearsals, while practising the Mandolin Dance for *Romeo and Juliet*, I landed awkwardly after a grand jeté and felt my ankle give way. The pain was excruciating. Our designated doctor diagnosed a bad sprain, stuck me in a plaster cast (the worst possible course of action, in hindsight) and told me I'd be unable to dance for weeks, if not months. My US tour, from east coast to west, was effectively over before it had started. I was absolutely devastated. If I had not been put in plaster, the sprain would have healed in a few weeks, under the supervision of our physiotherapist. Unfortunately, it was not to be. Ironically, almost twenty years later, I'd suffer exactly the same injury, but with the right 'RICE' treatment – rest, ice, compression and elevation – was back on stage within ten days.

Much to my dismay, I'd later learn that many other dancers had suffered a similar fate at the same venue. The studio flooring had been so poorly designed, with wood laid directly onto concrete, that sprains and stress fractures had become commonplace (my colleague Brian Shaw snapped his Achilles

tendon during that same tour). If I'd expected any sympathy or compassion from my Company bosses, though, I'd have been mistaken. Assistant artistic director Michael Somes took particular umbrage, blaming the injury on my own recklessness and ordering me to keep away from rehearsals while I recuperated. But the temptation of first night parties throughout the tour was too much to resist.

I grabbed a wad of dollars, crept out of my hotel and, without saying a word to my superiors, hailed a taxi to the airport and took a seaplane to Fire Island, beloved by the Big Apple's hedonists and high-flyers. A Company colleague had been offered an expenses-paid VIP overnighter by a group of well-heeled ballet buffs but, with compulsory rehearsals to attend, he'd suggested I take his place. Despite being on crutches, and subject to a curfew, there was no way I was turning this down. I'd heard plenty of wild and wonderful stories about Fire Island, courtesy of friends who'd visited themselves, and I was totally up for it.

Because Fire Island flouted the state's strict homosexuality laws – and the cops turned a blind eye, for whatever reason – the Pines and Cherry Grove areas had built a reputation as a gay paradise. As well as its out-and-proud clientele, it was also frequented by many closeted bisexuals, homosexuals and transsexuals who, unable to be their authentic selves back home, could release their shackles at Fire Island. I was incredibly curious (and excited) to see the place for myself. Until then, I'd never experienced any kind of gay scene whatsoever. Back in London, my social life largely revolved around West End bistros and restaurants, places where you could get a decent steak Diane or coq au vin. More often

than not, I went out in a group. Sitting at a table for two with another young man, whether a boyfriend or a platonic pal, was not always a good idea, unless you wanted to elicit glares from waiters or whispers from diners.

I never contemplated visiting pubs or bars, gay or otherwise. I doubt I'd have been served in any case – I looked so young – but dark and dingy drinking dens, with their warm beer and their pork scratchings, just weren't my cup of tea (and still aren't, quite frankly). And I was also alarmed by rumours of police raiding pubs like The Coleherne and the Vauxhall Tavern, with men being arrested for just embracing each other or dancing together. Even after the passing of the Sexual Offences Act in 1967 – which decriminalised private and consensual homosexual activity – it still felt very dangerous to be a gay man in the capital. I'd always proceeded with caution by sticking to Soho's café culture.

Fire Island posed no such threat, of course, and I was more than ready to sample the place, even with my ankle in plaster. Upon my arrival, on a warm April afternoon, my genial hosts showed me to my accommodation – a chic timber chalet in The Pines, the classiest enclave – and gave me carte blanche. I took full advantage. Parties by the pool. Barbecues on the beach. Cabaret in the nightclub. And, joy of joys, cocktails in the café bar. Freshly made mojitos, Manhattans and Harvey Wallbangers were all the rage in New York, while Brits were still supping Cinzano and Campari. I credit Fire Island for kick-starting my life-long love of cocktails; there's nothing nicer than a shaken-not-stirred Margarita on a hot summer's day.

Fire Island was a honeypot for artists and artistes across the whole spectrum of sexuality. It was swarming with stars

who would come together on their days off from their Broadway shows – I had a fabulous lunch with renowned tap dancer Tommy Tune – and there was none of the cynicism and pessimism that we Brits seemed to specialise in. Everyone I met was keen to hear all about the Royal Ballet experience. As someone who'd spent years hiding his homosexuality from the rest of society, relaxing outdoors with like-minded people felt wildly liberating. It was a trip I'd never forget.

Back in New York City, I hit the bright lights of Broadway, if only as a spectator. I couldn't wait to see whatever I could get tickets for. There happened to be standing tickets available for *Mame* at the Winter Garden Theatre, starring Angela Lansbury. Her performance in the title role was spellbinding. She came on stage sporting a short blonde quiff and wearing a gold lamé suit, and, after tooting a bugle fanfare, slid down a banister and launched into her opening number, 'It's Today'. I was rapt. I'd seen plenty of West End musicals, but nothing quite so slick and sophisticated as this. I was particularly taken with the orchestra, which performed with wonderful energy and exuded more sound and reverberation than any of its British counterparts. As soon as the overture started I will filled with excitement.

Afterwards, as I queued outside the stage door to get Miss Lansbury's autograph, I'd have guffawed at anyone who'd have told me that, one day, I'd be dining out with this fine woman in London.

On the first day back in September, I was told by one of the Company: 'You're in big trouble, Sleep.'

Shortly afterwards, Madam asked me to meet her for lunch at her house in Barnes, not far from Richmond Park.

'So, Sleep, what are we to do with you?' she asked, her eyes narrowing.

'What do you mean, Madam?' I replied, playing the innocent.

It transpired that a conversation I'd had with a so-called friend, in which I'd talked about the sexual openness of Fire Island, had been repeated to his dance journalist neighbour. This malicious gossip-monger had promptly phoned Madam's office at White Lodge, informing her of a deviant in her midst.

'I was only jesting, Madam!' I protested, explaining that I'd done nothing untoward at Fire Island or indeed at any point in America. If she didn't know I was gay before lunch, she certainly did now.

'I do hope you're telling the truth, Sleep,' she said. 'I don't want you to become a pathological liar.'

'You have my word, I promise,' I said, making a mental note to look up 'pathological' in my Collins English Dictionary.

And, with that, Madam reached to her bookshelf and passed me a small, paperback. The *Bhagavad Gita*, she told me, was a spiritual Hindu text, renowned for its wise words and verses, that had helped her navigate life's challenges. Her inference was, of course, that it might offer her spirited protégé some useful guidance. It was a lovely thing to do; looking back, I think Madam was the only person at the Royal Ballet who genuinely cared for my wellbeing. I politely thanked her for the kind gift and promised to peruse it when I got back home. Not that I did. The *Bhagavad Gita* would gather dust on my bookshelf for over fifty years, until curiosity prompted me to open its pages and broaden my mind.

In the autumn of 1967, and with my ankle on the mend, I rejoined my classes and rehearsals at Covent Garden. Not that

my injury had received a great deal of care and attention. In those days, our physiotherapy and rehabilitation provision was pretty basic, largely comprising a few token manipulations and, if you were lucky, some basic ultrasound. Neither did we receive any guidance about diet and nutrition. We were just told to fuel up in the grotty Royal Ballet canteen, run by a formidable Irish-Italian woman called Mrs Sartini, who'd dish out full English breakfasts and fish and chips lunches through a hatch.

It was around this time that I started to notice a significant decline in my physical fitness. My dodgy diet didn't help matters – there was more chance of me growing outwards than upwards – but neither did my daily schedule. As a student at White Lodge, I'd been allocated two hours of formal ballet classes per day, which kept me lithe, lissom and as fit as a fiddle. However, when I moved across to Covent Garden, this was reduced by forty-five minutes, in order to free up more time for afternoon rehearsals. But since I was taking on occasional understudy duties, or small virtuoso parts, only minimal practice time was required. And even when I was on the performance roster, my appearances could be sporadic. Sharing a venue with the Royal Opera limited the Company to three performances per week, so if three different casts were asked to perform in rotation I might only be required for one show.

The lack of activity severely impacted my fitness. My hallmark strength, stamina and energy levels slumped dramatically. My limbs felt heavy, my muscles felt lax and I could sense my weight starting to creep up. While rehearsing the Bluebird role in *Sleeping Beauty* – a demanding routine featuring my trademark leaps and entrechats – I struggled to get across the room in a single diagonal. I was going downhill fast.

I can't go on like this, I remember thinking to myself. *Something's got to change . . .*

Within days, I'd signed up for afternoon classes at the Dance Centre, an exclusive studio based on Floral Street. As it was just a stone's throw away from the Royal Opera House, I had to go to great lengths to ensure I wasn't spotted by Company colleagues. Attending outside classes was strictly forbidden – it was viewed as an act of treachery, a pollution of 'the brand' – and had this leaked out, I'd have been severely reprimanded. But to me, it was a risk worth taking. Moonlighting at the Dance Centre would help me get back in shape.

The teachers there represented a veritable who's who of the dance world. I started out having ballet classes with Maria Fay and these extra-curricular sessions with her restored my strength and my fitness, and raised my spirits. To protect my weak ankle, I was shown how to cushion my landings properly. To improve my technique, I was taught how to work with my muscles, not against them. I was by far the best dancer in the room – a fact, not a boast – and when I executed the à la seconde pirouettes, there was spontaneous applause. This type of reaction would have been frowned upon at the Royal Ballet, of course – the *height* of vulgarity, darling – but in this studio there was no such restraint. They were merely showing their admiration and appreciation.

Spending time in the centre stirred up other emotions, too. Dabbling in other genres rekindled my childhood love of modern jazz – I hadn't enjoyed jazz so much since Muriel Carr's. I went on to learn jazz with Matt Mattox, a Broadway stalwart who had starred in the Hollywood version of *Seven Brides for Seven Brothers.* And I was taught modern dance

by the legendary Robert Cohan, a ground-breaking choreographer who, in 1967, formed the London Contemporary Dance Theatre. It was an honour and a privilege to share a space with such luminaries.

For the first time since joining the Royal Ballet, I found myself wondering if my future might actually lie outside the classical world.

The Dance Centre also acted as a diversion from other issues. Back at the Company, a culture of bullying had begun to fester, chiefly propagated by Michael Somes (with whom I'd clashed in New York). There was no denying the man had been a marvellous dancer in his day – he'd partnered Margot Fonteyn around the world for two decades – but following his retirement due to injury in the early 1960s, had turned into a rather embittered character who ruled with a rod of iron.

'You'd better perform this like you've rehearsed it, Sleep,' he'd demand of me in the studio. 'Into the corner for another run-through – NOW!'

Once he made me repeat a solo so many times that I threw up in front of him. I'm sure there was method in his madness – he recognised my talent and wanted to stretch me as a dancer – but on many occasions he overstepped the mark. There was a fine line between encouragement and intimidation, with a danger of the latter affecting your protégé's performance and defeating the whole object.

Somes could get physical, too, as I found out to my cost. I'd been backstage at Covent Garden, limbering up for a performance, when I must have said or done something to offend him. He once came up to me and said, 'Sleep, you

had better do it my way, or else,' and proceeded to grab a handful of my hair and drag me across the floor with my curls clenched tightly in his fist. I'd never felt humiliation like it. Half an hour later, I was facing that evening's audience, my smile painted on, stripped of confidence.

At that point in time, reporting someone wasn't an option. He was the assistant director with the power, and I could have lost my job. In fact, I don't know anyone who complained about his conduct. They didn't dare, I suppose, for fear of damaging Somes's career (or their own). And, unlike at the Ballet School, there was much less accountability within the Company – no local authority, no parent governors – so people like him could act with impunity. Had he been reported to his superiors, he'd have probably claimed he was acting in our best interest. Challenging us. Motivating us. Dishing out some tough love. As I grew older and more confident, I'd eventually summon the strength to stand up to Somes. He left me alone when I had the temerity to push back and walk away. Like most bullies, he only got a thrill by preying on the defenceless and newcomers.

There were other behind-the-scenes pressures at Covent Garden. The relentless pursuit of perfection, so pervasive in classical ballet society, turned many dancers into nervous wrecks. Choreographers and directors demanded the crème de la crème of talent for their productions – only those with the right blend of artistry and athleticism would pass muster – which put us under constant scrutiny. As we went through the motions in class or rehearsals, they analysed our posture, our placement and our deportment. We were on a tightrope that never let up.

These remarks could gladden one dancer's soul and darken another's. I think my skin was thicker than most, though. Having been frequently taunted about my height and been passed up for roles due to my stature alone, I'd become quite hardened to criticism. Over the years, I'd learned not to take any unkind comments to heart or dwell on them for days. If anything, they fired me up.

But dancers at the Royal Ballet were taught never to be satisfied. In our world, the quest for excellence always included room for improvement. In class, we practised and practised until a step was perfectly mastered, sometimes at the expense of our bloodied and blistered feet. We fixated on the floor-to-ceiling mirror for hours on end, inspecting the dégagé, the line of one's body. To an outsider – a non-dancer, perhaps – this might have looked like a bunch of narcissists posing, preening and admiring their reflection. In reality, it was anything but. More often than not, the mirror was used as a correction tool, not a vanity aid. Only by close analysis of our body mechanics could we hone and refine our arcs, angles and alignments.

In many ways, fitting the mould was even harder for the women in the Company. There was a much bigger talent pool of ballerinas – they probably outnumbered us by four to one – so the competition and rivalry was intense. Not a day went by without seeing a girl bursting into tears in class or in a corridor, having been told they had put on weight or failed to lose it when instructed to. If they didn't lose weight when told to, they might be dismissed. The system could be abominably cruel and cut-throat.

Many of my colleagues, male and female, went to extreme lengths to keep in shape and stay in contention. At school,

I remember some embarking on drastic diets that left them virtually skeletal and liable to fainting and light-headedness. In the Company, the vast majority would smoke, many in an attempt to keep their weight down. They also smoked in rehearsals, which surprised me. As did the pianist, Hilda Gaunt, who always had a fag in her mouth while bashing out Prokofiev. (I was one of the few exceptions. Long car journeys with my parents smoking horrible-smelling roll-ups put me off for life.) And there was even one very famous but naive ballerina in America who was offered cocaine before performances without knowing what she was snorting. She just thought it was some kind of magic pep-up powder, like snuff, and hoovered it up like nobody's business. Unsurprisingly, she developed a serious addiction.

A few colleagues even resorted to surgery. Through my career, I knew of ballerinas who underwent breast reduction operations because they thought they looked top heavy and male dancers who had their noses reshaped or their ears pinned back in a quest to look more handsome. But some of them took it too far, with tragic consequences. My dear friend Paul Clarke was a case in point. A brilliantly talented dancer, he was in the year above me at White Lodge and rose to the rank of Royal Ballet principal before continuing his stellar career with the London Festival Ballet. Fabulous inside and out, Paul was universally admired and adored. But in common with so many beautiful people, he was never satisfied with his appearance and would obsess about his non-existent flaws.

'Have you seen the size of my forehead, Wayne?' he'd say, angling a hand-held mirror towards his face.

'Don't know what you're talking about, love,' I'd reply. All I saw was a gorgeous, blond Adonis.

In 1973, just after Ken Russell had cast him as Nijinsky in his *Valentino* biopic, Paul decided his jawline protruded too much and would be magnified on the silver screen. After he had his jaw done, it was noticeable that his teeth needed some work. His lover, who was a dentist, said, 'Let's go downstairs to the surgery and I can fix that in no time. I'll have to put you out, and there won't be any nurses.' This was the day before he was due to start rehearsals. After the procedure, his dentist boyfriend said, 'Go on upstairs for a nap, I'll clean up.' When he later went into the bedroom to check on Paul, he found him dead on the bed. The deal was that he would give up dentistry, in order for it not to be reported to the press.

I knew that because of my height, I would have to prove myself every time I took on a role from somebody else and improve it. So if my counterpart performed five pirouettes, I'd perform six. If another mastered three entrechats, I'd master four. If a colleague received one curtain call, I'd aim to receive two. Eventually, this persistence paid off. Impressed by my technique and tenacity, Sir Fred began to create bespoke solo roles that complemented my style and my skills. He knew I'd had my fill of cameos of young children and old people.

Sir Fred always wore a smart suit and tie to rehearsals. His trademark choreography was so perfect and so precise, with a remarkably subtle attention to detail. To add extra depth and drama to the ballet, and to help build a rapport with the audience, he'd add delicately nuanced embellishments. So a step might close with a knowing flourish of the hand or an expressive tilt of the chin, as if to say 'What d'you think about that?' The man was a maestro and I adored him.

Sir Frederick was about to choreograph a new ballet to Richard Rodney Bennett's 'Jazz Calendar'. It was the first time that a jazz score had been used at the Opera House. It was to be a one-act show based on the children's nursery rhyme 'Monday's Child is Fair of Face', and would feature a modern, abstract set designed by Derek Jarman, then a rising star from the Slade School of Fine Art.

Sir Fred decided that for Saturday's Child he would have eight boys from the Company, and choreographed a scene from a ballet class. He singled me out to be the boy who was late (I wondered what he'd heard), so I would arrive sheepishly, after they'd started their barre work. I would take off my towel and throw it into the wings, the teacher gesturing with his stick that I should join the others at the barre. A few moments later, he let the other boys carry on and on my own, I came forward and executed a number of very fast spins, which often got a round of applause.

I'm not sure if the ballet-jazz fusion quite worked but the visuals were absolutely stunning. Mine was a short and sweet solo, but a solo all the same. Those split seconds when I was airborne, defying gravity, gave me a buzz that I couldn't get anywhere else. I was performing centre stage. I was demonstrating my talent. I was entertaining the audience.

And then, joy of joys, that same year, Sir Frederick cast me as Puck in his latest production of *The Dream*, his celebrated adaptation of the Shakespeare play. I'd previously understudied the role, but this time I was put straight into the first cast – the top tier of performers – alongside ballet legends like Anthony Dowell (Oberon), Antoinette Sibley (Titania) and Alexander Grant (Bottom). This elite ensemble was often

dubbed the Dream Team – our performances attracted superb reviews – and the Company would subsequently tour the production around the world to great acclaim.

A small, sprightly and mischievous little creature, Puck was the perfect part for me. I infused him with energy and spirit, and had him springing from burrows and leaping out of bushes, re-enacting my own childhood exploits in the woodlands of Devon and Cornwall. Looking back, there was no other role at Covent Garden I relished more. It felt like I was born to play it. The question I am always asked is: *What is your favourite role?* And I suppose it must be Puck in *A Midsummer Night's Dream.* I've performed Puck in the ballet, Puck in the opera, and Puck in the play. In fact, I became known as one of the best 'Pucks' in the business.

In the spring of 1968, Rudolf Nureyev staged a revival of *The Nutcracker* for the Royal Ballet, casting himself as the Prince, alongside Merle Park as Clara, the young girl. I took on the role of the Nutcracker, a toy that comes to life on Christmas Eve and wages a battle with the evil Mouse King. It was an absolute privilege to take the stage in this dreamlike production ('the best *Nutcracker* England ever had', according to Dame Ninette) with Nureyev's dazzlingly complex choreography acting as the perfect foil for that famous Tchaikovsky score. I was very happy with the way I brought my role to life, but it was the mesmerising Nureyev–Park pairing that drew the most rapturous response from the Covent Garden faithful. Their grand pas de deux, including some death-defying lifts, was utterly breathtaking.

In rehearsals, however, things didn't run so smoothly.

Nureyev was under extreme pressure, not only to direct a money-spinning hit for Covent Garden but also to safeguard his reputation as an elite artiste, as he was both choreographing the performance and taking the leading part. The weight of expectation made him incredibly tetchy and touchy. If something wasn't to his liking, he'd fly into a volcanic rage, berating the long-suffering production crew about the music, the lighting, the costumes, the scenery. During one particularly fraught dress rehearsal in front of an audience, he went totally berserk, smashing up a fibreglass horse's head that bore no resemblance to the original design, sending him into a rage. The whole cast had to run for cover as the splinters flew across the room.

I upset Rudolf while rehearsing the ballet's Pastorale variation, which I'd perform on stage with Carol Hill and Lesley Collier. But I loved the stirring choreography, which was peppered with athletic jumps, spins and entrechats. Rudolf still wasn't happy, however. According to him, I wasn't paying enough attention to the smaller steps, the intricate link-ups that preceded the acrobatics. Rudolf watched you like a hawk. He didn't miss a trick.

'Your double-tours are perfect, Wayne, but in between you are so goddamned *LAZY*!' he'd yell, gesticulating wildly. 'Your feet are all over the place. Galosh . . . galosh . . . *GALOSH*!'

I had no idea what 'galosh' meant (maybe that was no bad thing) but I took Rudi's words to heart. He was spot on, after all – my ego much preferred the dynamic moves to the fluff in between.

Initially, the *Nutcracker* cast found Nureyev's meltdowns quite terrifying. However, as time went by, we learned to

expect them – his psychodramas became par for the course – and our alarm turned into amusement.

Rudolf would have temper tantrums during actual shows, too. I recall being on stage while he raged behind the scenes, trying my best to remain focused on my steps as various props were hurled from the wings and the backcloth billowed with a flurry of kicks and punches. Steaming with fury, fuelled by adrenalin and testosterone, Rudi would then re-appear on stage to deliver yet another exquisite, panther-like performance. He almost single-handedly changed attitudes and opinions towards male dancers. Thanks to his influence, we were no longer seen as mere props for ballerinas and were at last encouraged to take centre stage.

Thank you, Rudolph, for putting male dancers on the map, at last. Hooray!

CHAPTER SIX
A Meeting of Minds

MY PASSION FOR fine art was fired up in my mid-teens, thanks in no small part to the headmistress at White Lodge. Lady Agnew of Lochnaw was an exceedingly cultured but eccentric forty-something who, each Friday morning, would take a handful of dance students (usually the less academic among us who'd dropped a couple of O-level subjects) to an art gallery of her choosing. She'd cram us into her Citroen 2CV before driving us haphazardly through the streets of London, jumping red lights and honking at cyclists as we sniggered on the back seat.

Lady Agnew took great pleasure in introducing us to different styles and movements. One week, we'd visit a pop art exhibition at Tate Britain, the next week a sculpture installation at the National Gallery. She was so clued up about artists, from impressionists to surrealists, that other visitors would assume she was an expert tour guide and would tag along with our group as she critiqued each piece and detailed its history.

I remember her once steering me towards a stunning Modigliani portrait of a woman.

'Goodness gracious, she's your double, Wayne,' she cooed. 'The hair, the eyes, the wistful expression . . . you'd have been the artist's dream sitter, darling.'

My teenage self would never have imagined that five or so years later, I'd be sitting for – and befriending – one of the finest British artists of his generation. One fateful day in 1968, twenty minutes into our morning ballet class, in walked a man in his thirties with a shock of bleached white hair and thick-rimmed black specs, accompanied by a young, slender, dark-haired woman. He sat down in the far corner, took out a sketchpad and pencil and began to sketch, closely observing Rudolf Nureyev. The woman scribbled away, too. This raised a few eyebrows, since it was highly unusual for anyone else to watch class or rehearsals unless they were invited by Sir Fred. Indeed, choreographers were notoriously secretive – especially if they were rehearsing a new piece – and would often block out the little windows in the studio doors so no one could peer in (principal dancers could be similarly guarded). I couldn't help but wonder why this chap had been brought in by Sir Fred. He very occasionally invited in trusted film-makers and photographers, but I'd never seen an artist.

He cut a quirky figure, with his bright green suit and mismatching shoes and socks. I'd never seen anyone quite like him; he looked like a piece of art himself. His presence was great for my pirouettes, too, since it gave me something bright to focus on when I was 'spotting'. This technique involves concentrating on a fixed spot while starting the spin – for me, usually an exit sign in the studio – before whipping your head and body around and back again.

'Who's that, Rudi?' I whispered as we rested at the barre.

'You don't know?' he replied. 'It's David Hockney.'

I kicked myself for not recognising him.

I also noticed a tanned young man with honey-coloured hair lingering in the studio doorway, sporting an Ossie Clark snakeskin jacket. I felt I had to go and say hello in between exercises; he was too handsome not to. I complimented him on his jacket – I'd always coveted that item, with its funky diagonal zip – and he introduced himself as Peter Schlesinger, David's lover. The couple had met at the University of California's school of art (where David was teaching and Peter was studying) and had recently moved into a Notting Hill flat with a spacious studio in which David could create his distinctive paintings. Schlesinger was a talented artist himself, I'd soon learn, though not in the same league as his partner. He had enrolled in the Slade School of Fine Art.

'I wanted to come and sketch, too,' he said, in his Los Angeles drawl, 'but two's company, three's a crowd, it seems.'

'Oh, that's a shame,' I replied, wishing I could have used this beautiful boy for my spotting.

Once class had finished, I made a beeline for Hockney and was immediately taken with his friendly manner and his soft Bradford accent. His companion was Lindy Guinness (otherwise known as the Marchioness of Dufferin and Ava). She had, I learned, taken up painting, and her husband owned the Kasmin Gallery. Before I knew it, Peter was inviting me to their home in Holland Park as he said he was very keen to sketch me – and I willingly accepted. Unlike my classmates, I wasn't rehearsing that day since I was too small for whichever ballet was being performed. There were times when my height played to my advantage.

Lindy lived in a large house on Holland Villas Road. As I entered the ornate drawing room, who should I see draped on a throne-like chair, smoking a cigarette, but Sir Frederick Ashton who, unbeknown to me, had also been asked over to pose.

'Hello, Sleep.'

'Hello, Sir Fred.'

Lindy, David and Peter all began sketching away, the latter concentrating on me. David then proposed that I should sit at Sir Fred's feet, to signify our master-and-apprentice relationship. I posed in clothes first, but then it was suggested that I should disrobe. It all felt perfectly natural. There was no coercion. I felt totally comfortable with my nakedness, as did Sir Fred. He chatted and smoked the whole time, as if having a member of his corps de ballet starkers at his feet was a daily occurrence.

Being Hockney's muse was quite the experience. It felt wonderful to be part of his process – there's nothing better than watching a maestro at work, whether it's on a stage or behind an easel – and I felt like I'd stepped into a whole new world of modern art. And, significantly, Lindy's soiree marked the start of a great friendship between David and me. It turned out we had lots in common. We were kindred spirits. We'd both embarked upon our own pioneering journeys in our respective artistic fields, breaking a few moulds as we did so (and opening doors for others along the way). And with our working-class backgrounds, provincial accents and no-nonsense attitudes, we definitely got up the establishment's noses. As my career progressed, I was keen to innovate, as was he. We greatly appreciated each other's talents – David loved coming

to my performances as much I as I loved going to his exhibitions – but, by the same token, we were both quick to lampoon and poke fun at ourselves. Not only is Hockney a brilliant artist – one of the best who's ever lived, in my opinion, he is a genuinely nice human being.

We shared another thing in common, too: we both preferred men. But David was more 'out' in public while I was still 'in'. His sexuality was common knowledge among friends, family and colleagues – he'd never had to come out, as such – and since he wasn't a member of the 'entertainment' fraternity, the press didn't see him as fair game. Reporters didn't give a hoot about artists or designers being homosexual; it wasn't deemed sensational and didn't merit an exclusive. Painters like Hockney were hidden away in a studio, not performing on the stage. He even had the confidence and conviction to paint wonderfully joyful depictions of gay life, such as a piece titled 'Domestic Scene, Los Angeles' which featured one young man soaping the back of another. I couldn't help but admire that fearlessness.

David would often urge me to reveal my 'true self' to my family, just like he'd done with his folks back in Bradford. When he nudged me to come out and be counted alongside him and several other well-known celebrities, I said, 'No, I can't upset my mother.'

'Oh, I see what you mean,' he'd reply. 'Well, never mind.'

I'd go on to explain that I didn't care a jot what the public thought about my sexuality. In fact, I was far more worried about their opinion of me as a dancer. Indeed, it would have been much easier for me to come out in the dance and theatrical world because there were so many of us. I used to

pity the gay engineers, bank clerks and shop-workers who'd have found it much harder than me.

As a classical ballet dancer of many years, I could identify with Hockney's high-intensity work practices. He was continuously finding new ways to experiment with his art and spent many hours in solitude, perfecting his craft.

Hockney was incredibly busy, but he was the same in the studio as he was with friends: an incredibly warm and welcoming person. I became a regular attendee at his informal supper parties at Powis Terrace, where he and Peter would cook a cassoulet, and a dozen or so friends would sit around his kitchen table and have fun. The door was always open to David's studio and we were welcome to see his latest works. Invitees would often include David's trusty assistant, Mo – along with his boyfriend – and his designer friends Ossie Clark, Celia Birtwell and Manolo Blahnik, who lived nearby. David would also host an afternoon tea at his place each Saturday at four o'clock. It became one of the hottest diary dates in town. He'd despatch Peter to buy cakes from Patisserie Valerie.

I was introduced to Ossie and his wife Celia, down-to-earth Lancastrians, through David, and we all became friends. I adored his ethereal designs, so he'd often invite me over to his renowned Chelsea boutique, Quorum, to observe his tailors in the cutting room, stitching exquisite creations. It was a high-fashion brand at the time and the chicest place to buy clothes. I'd also be invited to the designer's catwalk shows, a procession of stunning male and female models that included Ossie's muse, Gala Mitchell, whose quirky elegance was the perfect fit for his brand.

Out and about with David, at exhibitions and his gallery

openings – or when he was my guest at Opera House first nights – I'd find myself in deep conversation with friends of his, like Cecil Beaton, Stephen Spender, Lucien Freud and Howard Hodgkin. The generation who would individually make their mark in the arts scene. We were all shining lights in our own artistic fields. I was glad to be among so many pioneers, and I felt a certain affinity with them, pushing the boundaries. I could still be shy in the presence of greatness, however. In the early 1970s, Noel Coward came to the first night of *The Grand Tour* at Sadler's Wells. Our resident publicist introduced all six principals but (quite rudely, I thought) chose not to include those of us in the corps de ballet. I was standing right by the great man's shoulder so could have easily offered a handshake and introduced myself, but I didn't. I'm still kicking myself.

In the late sixties, most of my evenings out were quite civilised. I wasn't much of a party animal, certainly during the working week, because I had to stay in peak condition for class. Maintaining high levels of energy and enthusiasm was compulsory at the Royal Ballet. Our schedule was incredibly gruelling. During an average season, you'd typically commence class at 10.15am, on the dot, at Barons Court. This said, sometimes we would have a 9.30am warm-up at the Opera House, followed by a dress rehearsal at 10.30am on stage. Following this, at 2pm some of us would have to take a tube back to Barons Court, for a 2.30pm rehearsal where we would rehearse the next season's repertoire till 4pm. After a short break, we would then have to catch the tube back to Covent Garden to warm up again for that evening's performance, finishing around 10pm.

After the ballet, most of my colleagues would head back to their flats to watch TV and wash their jockstraps, in readiness for the same routine the following morning. But, with my adrenalin rushing and my stomach grumbling, I'd occasionally make a beeline for a restaurant, usually San Lorenzo in Knightsbridge, because the owner adored me and plied me with free food and wine (in those days, restaurants were the only places where you could get decent wine; it was virtually non-existent in pubs). I'd be totally wired after performing high-voltage roles and enjoying the company of friends was, for me, the best way to wind down.

Following a Saturday night performance, however, I'd let my hair down and hit a club. Peter Schlesinger and I would often head over to Yours or Mine, a gay club on Kensington High Street, often with my Royal Ballet colleague Graham Powell and others in tow. It was among a handful of underground venues where we could socialise in relative peace and safety. My three companions were tall, blond and beautiful – total man-magnets – and would invariably be lured onto the dance floor for some bump and grind. I'd usually end up propping up the bar, alone, wishing (yet again) that I was a few inches taller.

I lived a rather nomadic existence in the late sixties, moving from one rented room to another. I found living in shared accommodation quite cramped, so I would often relocate to a new place, cramming my clothes into a couple of suitcases and boxing up my prized possessions (my Zeiss camera, my Dansette and my stack of 33s and 45s).

I even landed at David's flat for a few weeks once, crashing on a put-me-up bed in his studio while in between digs.

I'd wake up to a heady aroma of oil, paper and pencils and, as I surveyed the precious artworks surrounding me, I'd find myself giggling at the absurdity of it all. Each morning, David would turf me out at eight o'clock so he could have his breakfast in peace before picking up his paintbrushes. And while I got on famously with him and Peter, it didn't take long for them to drop large hints.

'Have you found anywhere yet, Wayne?' they'd ask across the dinner table, with barely concealed impatience.

After my time with David, for a while I had a room in Brian Master's house (author of Dennis Nilsen's biography), just off Brook Green, who I introduced to David, and he introduced me to creatives including Penelope Keith, and other leading actors. My first proper self-contained flat was a bijou place in Mason's Yard, just behind the famous Fortnum & Mason department store. It cost me a fortune (£16 per week, which amounted to half my salary), but I considered it money well spent for the independence alone. I zhuzhed it up with some boho-chic furniture and accessories from Portobello market, kick-starting an enduring love affair with interior design. For the first time in my life, I had a place of my own where I could entertain friends. Among them was Karl Bowen, an American art student (and scion of the wealthy Kellogg family) who was so enamoured with my abode that he offered to flat-sit when I was on tour with the Company. Sometimes, this thoughtful young man would fill the living room with fresh, fragrant flowers to greet me on my return, or leave me a huge chunk of marijuana on the kitchen work top (which I'd invariably donate to others, as I didn't smoke it).

It was only a few years later that I discovered that Karl had been using my beloved flat as his personal boudoir, entertaining a series of pick-ups from the public toilet behind Fortnum's, known in the trade as the 'cruisy loo'. God only knows how many of them creased my Egyptian cotton bedsheets. My naivety knew no bounds in those days. No wonder Karl had lavished me with dope and delphiniums.

Unlike my friend, in those days, I wasn't much into hanging around loos, or cottaging, as we called it, in search of a brief encounter. Not only did I find it a little distasteful – the pong put me off, for starters – I also had a deep-rooted fear of being spotted by a Company colleague or nabbed by the police. Any public exposure would have put paid to my ballet career and would have condemned me to eternal shame and damnation. But many other homosexual men did visit the cruisy loo, and others dotted around central London, which was naturally their prerogative. I was once told a story of an Opera House grandee embarking upon a cottaging encounter in the infamous Waterloo station lavatories. Unaccustomed to public loo etiquette, he was surprised to see a note – etched on scratchy Izal toilet paper – being shoved through the gap between the stall and the floor.

'What do you like?' it asked, scrawled in pencil. He reached for the pen in his top pocket.

'Maria Callas in *Tosca*,' he wrote, before folding it neatly and passing it back.

But it was a risky business. Police were known to deploy undercover, plain-clothed officers to entrap men soliciting for sex, who then might be arrested, charged and ultimately jailed, with their full names and addresses often printed in newspapers. I can only imagine the lives and livelihoods

that were ruined as a result. I also heard stories of officers going rogue in Piccadilly Circus, bundling the 'offender' into a police van and demanding sexual favours in return for a let-off. Blackmail and extortion were commonplace, too. 'Plead guilty and give me the £30 fine, or you'll be headlines in the newspaper' was the general gist of it.

My friend Graham Powell had the misfortune of being caught 'importuning for immoral purposes' in the toilets adjacent to the Garrick theatre. Graham's timing wasn't ideal, since he was due to perform with the Opera Ballet Company that night at Covent Garden. Flanked by two constables, he was frogmarched into Bow Street police station, which just happened to be located opposite the Opera House's front door. Romayne Grigorova, the ballet's choreographer, had been alerted to his predicament and could only watch, horri-fied, standing at the stage door, as her principal dancer was dragged in the arms of two officers up the cop-shop steps with just an hour remaining before curtain up.

'Don't worry, Romayne, darling,' shouted Graham, as he glanced over his shoulder. 'I'll be back for the half!'

And he was, but not before receiving a fine and a finger-wag from the boys in blue.

Just before the turn of the decade, Karl Bowen had persuaded me to move into his new place, a huge top-floor flat on Shaftesbury Avenue, slap bang in the middle of theatreland. My bedroom formed part of a turret, its many windows offering a panoramic view of the beautiful city I felt proud to call home. Karl insisted it would be cool to daub the curved walls and the circular floor in brilliant white paint, upon which – in true boho style – he inscribed

various pithy and profound quotations. My friend was fond of throwing parties at the flat and once persuaded me to invite Rudolf Nureyev to his birthday bash. Rudi duly obliged but arrived about half an hour early and spent most of the time sitting on a sofa, alone. None of Karl's pals dared go over and speak to him – they were totally star-struck – and Rudolf didn't appear to have the social skills or savoir faire to interact with anyone. He left after only half an hour and, as he slipped out, I remember thinking he cut a rather lonely figure. A worldwide sensation who couldn't mix with normal people.

As I continued life in swinging sixties' London, my family ties began to slacken. My trips home became pretty sporadic, maybe once or twice a year at most. Devon seemed like another world to me – a behind-the-times backwater – and I felt far more content and comfortable in the capital. Whenever I had pangs of guilt, I'd invite family members to first performances at Covent Garden, promising to treat them to a meal and a sightseeing trip as well.

The presence of a couple of homophobic aunties and uncles in Plymouth didn't fill me with much pleasure, which was another reason for my increasing reluctance to visit. Whenever I saw them, I'd get little digs in my direction. Many people (although not my mother) assumed ballet dancers were 'queer', which, in those days, held lowest-of-the-low status. A couple of relatives were a little resentful of my success, I gather, and knew that the prim and proper Joan would be distraught if I turned out to be 'one of them'. During family gatherings, they'd make a point of slyly criticising my city and my contemporaries, in what felt like a deliberate attempt

to bring her down a peg or two. At least our kids aren't poofs and living in that cesspit called London, was the insinuation.

If these gibes affected Mum, she didn't show it. She'd often counter with a reference to my muscular physique, as if to prove my masculinity.

'Feel his thigh muscles!' she'd say, grabbing my leg.

'Mother!' I'd reply, batting her hand away.

My relatives' narrow-mindedness would often test my patience.

'Eh, Wayne, is that Nureyev a poof?' I remember an aunt once asking me, conspiratorially, while Mum was in the room.

'I really wouldn't know, Auntie. That's his business,' I'd snap. 'D'you not want to ask me what he's like as a dancer?'

Answer there came none, but I was never in any doubt about her feelings around homosexuals. I just had to button my lip.

To throw my family off the scent – and, more importantly, to protect my mother – I even got myself a girlfriend. For a year or so, my pal Graham and I went through an experimental stage, stretching the limits of our sexuality by having liaisons with women. Sexual fluidity was no big deal in the late 1960s, and we thought we may as well give it a whirl. Graham memorably had sex with a young lady on the roof terrace of my digs in Leicester Square, eliciting a round of applause from some nearby builders and scaffolders. One night, at a friend's country cottage, I found myself in bed with a renowned ballerina, a thirty-something divorcée who'd wrongly assumed I was straight. I wriggled out of performing the deed itself, much to her chagrin, and made a swift exit.

At least occasions like these settled the issue of my sexual orientation by confirming what I'd known all along: I much

preferred men. Not that this stopped me from using a girl as a decoy in order to mask my true feelings. The person in question was a housemate of mine, Jill, a professional musician who played with a prestigious London orchestra. I'd moved into a maisonette in Montagu Square, in Marylebone, where my dancer friend David Gayle had a room. The place was owned by Eileen, a well-to-do former actress, whose pet dog – Charlie the chihuahua – was extremely fond of dry humping my ankle. When I first moved in, I immediately stripped off the Regency-style striped wallpaper and replaced it with tin foil (Eileen was horrified, justifiably so), upon which I plastered posters of movie icons like Jean Simmons, Ingrid Bergman and Natalie Wood.

Jill the musician, a slender, sophisticated brunette, lived in the room upstairs. We'd often bump into each other as we waited to use the payphone on the landing and soon struck up a friendship. And, to my shame, I quickly singled her out for a courtship of convenience. I invited over to my room one night, on the pretext that I wanted to sketch her, and we ended up on the floor together. It was a mechanical and perfunctory experience – my earth didn't move, put it that way – but it was a means to an end. Finally, I had a bona fide girlfriend to show off to the Sleep family. Terrible, I know. In hindsight, it was a shabby thing to do.

Taking Jill to Plymouth for Christmas had the desired effect. Mum thought she was divine – she showed her off to all the neighbours – and my relatives desisted with their 'poofs-and-queers' jibes. But Jill and I were never destined to last the distance. A few months' later, I called time on our relationship, doling out the lame excuse of needing to focus

on my career. It was pretty callous behaviour on my part. The poor girl must have felt very confused and upset. But, unbeknown to me, she wreaked her revenge. Following the death of my mother in the mid-1990s, I discovered a note she'd received from Jill, written in the aftermath of our fun together. It must have been stashed away in a drawer for over thirty years, never once to be spoken of.

'I'm so sorry I shan't be seeing you again, Mrs Sleep,' she wrote, 'but I'm afraid Wayne seems to prefer the company of older men these days.'

I did indeed, including a chap who would change my life forever.

I first glimpsed George Lawson in the Regent's Park apartment owned by John Kasmin, a renowned art dealer whose gallery often exhibited David Hockney's work (a sharp and astute operator, Kasmin had talent-spotted David at the Royal Academy of Art's graduate exhibition). A Friday night party was in full swing, but sitting alone in the corner of the room, holding a book in one hand and a glass of red wine in the other, was a balding, studious-looking gentleman. Wearing a dapper suit, and seemingly oblivious to those partying around him, he cut a rather incongruous figure.

Intrigued, I asked David who this fellow was. He said George was a tour de force in the world of twentieth-century first editions – he worked from a shop on Savile Row – and that he was a firm friend of Kasmin's. Hockney must have noticed a flicker of emotion as we spoke (his matchmaking antennae sensed something, he'd later claim) and the following week, he invited me to dinner at Quo Vadis in Soho.

We were to be joined by someone who very much wanted to meet me, I was told.

I arrived to find George already sitting there, scrutinising the wine menu through a monocle, immaculately dressed in a grey flannel suit with a hand-tied dicky bow.

Oh, I remember him – the shy guy from the party who sat in the corner, I said to myself, slightly concerned about how this dinner *à trois* would play out.

The first surprise of the evening came when I discovered George's age: he was only twenty-six, just four years older than me. The second surprise came when I realised, somewhere between hors d'oeuvres and dessert, that I was rather taken with this eccentric individual. Perhaps it was his enquiring mind and his sharp intellect, or his perfect manners and his bone-dry wit, but I found him extraordinarily charming. And he seemed rather enamoured with me, too, peppering me with questions about the world of classical ballet. David – our resident cupid – had a knowing look on his face as my new friend and I chatted intently.

George and I saw each other a few times after our 'date' – I'd often pop into his shop to say hello – but it took an unfortunate incident to finally bring us together. During Christmas 1968, Karl went to stay with friends in New York, giving me free rein of the apartment. Following a night out, however, I opened the front door to find two burglars unplugging my record player. Startled, they jumped up and attempted to bundle me into the bathroom, but I somehow managed to wriggle free and scamper out of the building. Being small and nimble had its plus points sometimes. The intruders fled in my wake, with a holdall stuffed with designer clothes. Scoundrels. I took

comfort in the fact they'd find it impossible to flog my extra-small gear, unless they knew anyone as small as me.

In a state of distress, I called George from a phone box in Shaftesbury Avenue. I told him I was too traumatised to go back to the flat I shared with Karl, as the robbers still had the keys and may have come back, so I asked if I could stay with him for a few days in his tiny Wigmore Place flat, just behind Harley Street. And I never moved out.

As partners and housemates, George and I both loved London life. Neither of us was rolling in cash – my beau had frittered away a substantial family inheritance – but every spare shilling and pound was spent on the latest fashions, theatre-going or eating out. Most evenings saw us dining in nice restaurants – neither of us was a keen cook (in fact, George didn't have a kitchen) – but we'd only frequent places that didn't frown upon a party of men eating together. We'd had a bad experience of that once with David and Peter, where a granite-faced waiter had made his feelings only too clear.

'Somebody's birthday?' he'd sneered, as if that was the only reason for us dining together.

'No, dear, just four boys having fun,' I'd replied, with a giggle and a *more wine, Vicar?* wink. He'd sped off towards the kitchen.

To avoid similar situations, George and I would head for the cosmopolitan triangle of Soho, Mayfair and Piccadilly, or the open-minded suburbs of Hampstead and Richmond. On my birthday, George would take me to Au Savarin on Charlotte Street, where I'd choose veal or steak Diane and sip my favourite Champs-Élysées cocktail (fresh strawberries

mashed with Cointreau and topped with champagne –
magnifique!). George was a connoisseur of fine wines and
we'd team our dessert with a bottle of Château d'Yquem,
arguably the finest sweet wine in the world. At seventy
pounds a pop it was a remarkably pricy indulgence, but we
reckoned we were worth it. At Christmas, we'd treat ourselves
to a crate of vintage Vosne-Romanée, a ridiculously expensive
burgundy. Unthinkable now, considering the cost of fine
wine these days.

George once rang the Ritz to book a table, with hilarious
consequences. The person who took the call must have
been hard of hearing or battling with a crackly phone line
because he somehow mistook 'George Lawson' for 'Lord
Nelson'. Much to our bemusement, upon arrival at the
restaurant, we received VIP treatment like we'd never
known before.

'Lord Nelson, so delighted to have you join us,' smarmed
the maître d' as he ushered George and me to the best table
in the room, at which a top-notch bottle of champagne
awaited us. Once we'd both twigged what had happened, we
surreptitiously glanced at each other as if to say, *Oh, this is
going to be fun . . .*

With his dickie bow, monocle and immaculate three-piece
suit, George certainly looked the part, but I'm sure a fair few
eyebrows were raised at the admiral of the fleet's curly haired,
Cuban-heeled companion. He and I proceeded to sample one
of the best five-course cordon bleu meals we'd ever tasted,
while the waiting staff bowed and scraped for Britain.
Following an exquisite D'Amalfi limoncello, George asked for
the bill, somewhat dreading the final tally.

'Oh, don't worry, Lord Nelson, we'll just add it to your account,' came the maître d's reply, beckoning for George to put away his wallet.

How we kept our faces straight I'll never know.

'Don't let money rule your life, Wayne, just live for the day,' was a common phrase of George's. He used to lavish me with luxurious gifts and I would often reciprocate. I bought him the first ever gold propelling pencil – from William IV's reign, I was told – as well as a tiny Cartier travelling clock with a ruby winder. He went on to lose both items, probably on a train, as was his annoying habit. One year, George bought me a stunning Cartier necklace: a gold chain with a pea-sized orb designed to nestle perfectly in the space beneath my Adam's apple. We could hardly contain our laughter when the sales assistant called me 'madam' as he gently fastened it around my neck. Either he'd mistaken me for a woman or perhaps he couldn't bring himself to acknowledge that same-sex couples like us existed. A similar thing happened in France, when George and I were called 'monsieur et madame' in the local supermarché.

George would also earmark rare, first edition books for me, knowing that I coveted them (long before we met, I'd spent much of my spare time trawling bookstores in Charing Cross). My word blindness meant I could barely read these collectors' items, but I was nonetheless drawn to them. I spent a huge chunk of my Opera House wages on first editions and, while I bought them to possess rather than to sell, my £300 purchase of James Joyce's Ulysses was to pay dividends a few decades later. I sold it at auction for a very handsome amount; let's just say it paid for a new kitchen.

To many observers, George and I must have appeared a

very unlikely couple. A tall, quiet, upper-class book dealer hooking up with a short, spirited, working-class ballet dancer. But we were blissfully happy together, confounding many of our friends and acquaintances, who'd assumed we wouldn't last longer than our first date. Kasmin, the art dealer, certainly believed his best friend was punching down.

'You'll soon forget about your little ballet boy, George,' he once proclaimed in front of guests at a party hosted by Jane Kasmin, fully aware I was in earshot.

Willow Prizeman came to George's rescue: 'Don't be so rude, Kasmin. That's an awful thing to say.'

David Hockney had no such qualms – he was our match-maker, after all – and, in the early 1970s, famously depicted our unconventional relationship in a double portrait. He wanted to capture us in our domestic setting. The painting shows my partner in a formal suit, striking a note on a clav-ichord, while I lean casually against a door frame, wearing a t-shirt and flares.

David had always remarked 'Wayne is the body, George is the mind,' which I had always taken a little offence to, but when I think about it, David was right.

When David started painting the double portrait, for some reason he was unable to finish it, and decided that because he couldn't find a solution, he would put it away. He came back to it many years later, in 2014, thought, *Oh, that's not that bad*, and finished it. It now adorns a wall in the Tate Britain. George and I attended as guests of honour when it was unveiled. We were no longer romantically involved but it was still a very special moment: my first love and I, immor-talised on canvas by our friend. A friend who just happened

to be the finest British artist of modern times. If only Lady Agnew of Lochnaw had been around to see it.

In the summer of 1969, I packed my Royal Ballet suitcase and embarked on another three-month tour of North America, along with the likes of Rudolf Nureyev, Margot Fonteyn, Svetlana Beriosova and Donald MacLeary. This time I managed to stay injury free, so had plenty of performance time, courtesy of a repertoire that included the Peasant pas de deux in *Giselle*, the Mandolin Dance in *Romeo and Juliet*, the Bluebird in *Sleeping Beauty* (partnering another White Lodge alumna, the effortlessly graceful Lesley Collier) and, my enduring favourite, Puck in *The Dream* and George-Robinson Sinclair in *The Enigma Variations*. I may not have been cast in any leading roles – at five foot two I'd never play Romeo or The Prince – but, with time, I'd learned to accept my limitations and embrace my unique talents. Fixating on my height was futile. There was nothing I could do to change it.

And while I never had any of the many pre-show superstitions – unlike the dancers who'd tap the wall three times or hide a rabbit's foot in their pocket – I did have a mantra.

'Please God, help me,' I'd whisper to myself as I waited nervously in the wings. Simple as it sounds, I liked to imagine there was a reassuring presence beside me as I danced on stage. I could not have done it alone. While I wasn't a practising Christian, some remnants of my Church Army experience – the solace, the comfort – still lingered.

As other performers may attest, American crowds are much less restrained than their British counterparts. At home, audiences would applaud at the end of a performance; across

the Atlantic, they'd applaud while you were dancing. For me, these ovations felt invigorating, boosting my adrenalin and adding inches to my leaps. Sometimes, I'd have to focus intently on the conductor in order to hit my timings, since the music was often drowned out by spontaneous applause. And American crowds were big on flowers, too, which would frequently rain down from the amphitheatre at curtain call. I'd find myself having to dodge those weighted down with stones in foil, a trick used to ensure they reached the stage.

Whichever city we were appearing in – Chicago, Philadelphia, San Francisco – throngs of ballet fans would gather outside the stage door post-performance to catch a glimpse of Fonteyn and Nureyev. The pair of them would make a grand exit – as they did in England, too – draped in their designer clothes (Margot in a Chanel two-piece, Rudolf in thigh-high boots and a full-length fur coat) and would be greeted like rock stars. Autograph-signing tables would often be erected in order to create a little distance between them and their well-wishers, to keep them from smothering them.

Some fans, primarily female, would wait outside the stage door for me, too.

'We adore you, Mr Sleep,' they'd gush, flashing their toothy grins and wielding their autograph books.

I spotted a clutch of famous figures, some of whom spent a suspiciously long time in Rudi's boudoir-cum-dressing room. Male or female, they were drawn to him like bees to a honey pot. I'd never seen anything like it before, or since. I seem to recall Jackie Kennedy making a rather furtive exit one evening, toying with a red rose as she virtually floated down the corridor.

Our American hosts would lay on great aftershow parties for us – the Company had real cachet over there – but, in general, the invites were only extended to directors and principal dancers. However, perhaps due to all the plaudits I was getting (or my status as the 'cute' new boy), I was also invited, with other principals, to attend a variety of soirees, where I would meet stars of the stage and screen, like Roddy McDowall and Natalie Wood, which I found mind-blowing. Natalie had been my *West Side Story* poster girl for years, so I could hardly believe it when, along with Georgina Parkinson, a principal, I was invited to dine with her at Trader Vic's in Los Angeles. I just sat there, dumbfounded, as she praised me – yes, me! – for my performance at the Hollywood Bowl. After a couple of mai tai cocktails – invented in that very restaurant – this wonderful woman took the time to teach me how to pose properly for a profile.

'Press your tongue firmly against the roof of your mouth, Wayne, then smile nice and wide,' she said, while demonstrating it herself. '*Et voilà* . . . it tightens up the jowls under your chin.'

Her advice stayed with me forever. Even now, whenever I'm confronted with a photographer, I'll perform Natalie Wood's smile trick.

What made my second American trip extra special was the presence of my old pal, Graham Powell. He'd not long left the Royal Ballet touring company and, much to my delight, joined up with us for the spring. A good time was guaranteed when he was around . . . starting with an obligatory trip to Fire Island. We stayed in The Pines along with a mutual friend, Judy Colleypriest. We arrived at breakfast time, exhausted

from the overnight train, only to find that our chalet was locked. So, with no other option, we headed straight for the beach whereupon we promptly fell asleep on our sun loungers.

I awoke around 11am, barely able to move due to a combination of sunburn and sunstroke. My friends were also basted like turkeys, with Graham's permanent headache going into overdrive.

The following evening, leaving New York to open our next performance in Philidelphia, Graham and I were both in agony as we prepared for that night's performance. Just pulling our tights over our red-raw sunburned skin was absolutely torturous. This put us in very bad books with the powers-that-be, and rightly so: it wasn't exactly the height of professionalism. But was it worth it? Of course it was.

As the new season dawned at Covent Garden, I began rehearsing again for Sir Frederick Ashton's *Enigma Variations (My Friends Pictured Within)*, which had premiered the year before, in autumn 1968. A one-act ballet set to Edward Elgar's music, it celebrated and caricatured the members of his friendship circle using dance to reflect their personalities. I was cast as George Robertson Sinclair, a cathedral organist for whom Elgar had written a piece of music inspired by the man's pet. According to Sinclair, Dan the bulldog had fallen into the River Wye, and when bounding back onto dry land had 'barked rejoicing'. Sinclair asked his composer chum to set this scenario to music and he'd duly obliged with Enigma no. 11. Nothing like having friends in high places.

It was the first major solo role that had been created especially for me and was certainly the fastest sequence I've

ever done. Concentration was key and there was no room for error. Ashton thought I should interpret both Sinclair and his dog – *Not an animal again, Sir Fred*, I thought. To capture the playful spirit of Dan the dog, this variation featured hand-springs, forward rolls and 'paws up' gestures, with one pirouette even incorporating a deft hand-behind-the-back tail wag. I enjoyed the challenge of interpreting man and dog at the same time.

Each move of this short, strenuous routine had to be performed with pinpoint accuracy in order to keep up with the frenetic tempo of the music. Not only that, it all had to be executed without any breathlessness while wearing a cumbersome Edwardian costume with stiff collars and tweed breeches. Once done, I'd stagger into the wings on the verge of collapse. I felt like I'd run an Olympic sprint, five times over. When I reached backstage, I thought, *What the hell was that?!*

Enigma Variations was a tremendous success back then and remains a hugely popular ballet to this day. Ashton's trademark choreography – lyrical, nuanced, expressive – brought Elgar's magnificent music to life and, with an added sprinkling of charm and humour, reflected the true essence of English ballet. The piece demonstrated a creative genius at the peak of his powers, which made Sir Fred's shock retirement in 1970 so hard to comprehend. I'm not sure what instigated his exit, but he would soon be replaced as director by Kenneth MacMillan, who'd been brought over from the Deutscher Oper Ballet in West Berlin. I was truly sorry to see Ashton leave – he'd created some fabulous roles for me – but this wasn't the end of our working relationship. Our paths would soon cross again.

CHAPTER SEVEN
Drama Queen

THE MOST OUTSTANDING ballet dancers will possess theatrical as well as technical skills. The art of interpretation – adding depth and meaning to a piece with a subtle shrug, perhaps, or a knowing glance – can make all the difference. This emotional connectivity cannot be taught, though. It's innate and instinctive. You either have it or you don't. My most impactful roles, like Puck in *The Dream* and the puppet in *Petrushka*, relied on my natural sense of drama. But while I had always enjoyed the classical mime classes at the Upper School, I benefited most by watching professional actors onstage in plays. During the week, I'd head over to the National Theatre, then based at the Old Vic in Waterloo, where I'd buy cheap tickets in the side aisles. I'd keep an eye out for any spare seats in the stalls and then make a dash for them during the interval.

Most people came to watch but I came to learn. I was lucky in that regard because it was a brilliant time for British theatre and thespians. I was able to see Albert Finney in *Much Ado About Nothing*, directed by the great Franco Zeffirelli. Then came Peter Shaffer's *Black Comedy* with Derek Jacobi, followed by *The Dance of Death*, written by August Strindberg and

starring Laurence Olivier. It was fabulous to watch these actors at close quarters (so close, in fact, that I once got showered in John Gielgud's spittle, having found myself a seat on the front row). Seeing acting royalty in the flesh, rather than staring at me from posters and magazines, was awe-inspiring. It made me hungry to be part of this world. Perhaps my mother had felt similarly star-struck back in 1950s Plymouth when she'd served John Mills and Peggy Ashcroft at Fuller's tea room. I would later meet John Mills, several times, in fact, and his opening line to me would always be, 'Wayne, you've not grown yet.'

Witnessing these marvellous plays became the only upside to missing out on leading ballet roles. Attending fewer rehearsals in comparison with my colleagues allowed me to clock off early and catch a matinée. I was able to improve my knowledge and appreciation of spoken-word perfor-mance, from solo shows to ensemble pieces, and soon convinced myself that I could become a decent actor. And it felt timely to branch out into this field. The Royal Ballet wasn't giving me enough of a platform to display my talent and showcase my technique, and I felt imprisoned.

I'd often discuss these frustrations and my West End sojourns with Iris Law, the Company's artistic administrator and a fellow theatre-goer. An amiable woman in her forties, Iris acted as the link between the dancers and the directors. She was also well-known at Barons Court for dishing out the so-called 'yellow perils'. These little notes, from Iris, were pinned on the noticeboard in the corridor and, alongside your name, would always bear the same three words in capital letters: PLEASE SEE ME. This could signal good tidings

(you'd bagged a decent role), or bad tidings (you hadn't bagged a decent role), or ominous tidings (a pep talk or a dressing down from a director or a choreographer).

Impressed by my enthusiasm for acting, one summer, Iris invited me to accompany her to Stratford-upon-Avon, where the famed Royal Shakespeare Company was unveiling its new season of productions. Together with her partner Gwyneth Williams (secretary to the upper school director and a fellow culture vulture), we spent a great week in Warwickshire, taking in a repertoire that included *Romeo and Juliet* with Ian Holm and Estelle Kohler as the star-crossed lovers. Holm was a tiny man, not much taller than me, and I found it remarkable that he'd been cast in the lead role. In the cut-throat world of ballet, I'd always be too small for Romeo. It all seemed so unfair.

I also had the pleasure of watching *Twelfth Night* with Donald Sinden as Malvolio and Judi Dench as Viola. The former was great but the latter was incredible.

'She's mesmerising, isn't she?' I remarked to Iris.

'Wayne, that's a prime example of "acting without acting",' she replied. 'Only a master of the craft can make it look so effortless.'

To repay Iris's kindness, I decided to engineer an introduction to Judi. As an up-and-coming 'name' from the Royal Ballet, I was allowed to visit her dressing room and present her with a bouquet of roses, flanked by my lady friends. She was charm personified, chatting away like we were old friends. Neither Judi nor I knew that someday we'd be cast together in one of the most famous musicals of all time.

As fate would have it, it was one of Iris's PLEASE SEE ME

yellow perils that heralded the news of my own acting debut. She informed me that the director John Dexter had earmarked me for a potential film role (I'd never heard of him, but Iris assured me of his pedigree, having seen his highly regarded *Othello*, with Sir Laurence Olivier and Maggie Smith). I was rather taken aback. A Covent Garden regular, Dexter had seen me perform Napoleon in *Cinderella*, where the small/tall on-stage dynamic with the Duke of Wellington mirrored a pair of roles in a film he was working on. It was an adaptation of the bestselling novel by Leslie Thomas, *The Virgin Soldiers*, a semi-autobiographical tale of the author's national service in Malaya during the Korean War. Dexter encouraged me to audition for the part of Villiers, a small, gay soldier with a sense of fun. I was trembling under my mackintosh as I queued up for the audition along with other hopefuls – fear of the unknown, I suppose – but I passed it with flying colours. But before I could celebrate my good fortune in style – with George, and a bottle of Moët – I had to seek permission from the Company Director, as the Royal Ballet name could not be tarnished. I was given the green light, however. Dexter's esteemed reputation no doubt helped. So in my summer break, I travelled to the Far East to join a cast of well-regarded, classically trained actors that included Hywel Bennett, Lynn Redgrave and her mother Rachel Kempson.

Before that, however, a dozen or so junior cast members, myself included, were sent to a barracks near King's Cross for some genuine army training. We were drilled in how to stand to attention, march on parade and hold a heavy rifle. I found it almost impossible to keep a straight face, though, which infuriated the sergeant major instructor.

'Thumbs by your side, down the seams of your trousers . . . and about TURN!' he barked, as I tried in vain to stifle my laughter. 'Concentrate, Sleep, you BALLET BOY,' he yelled, quivering with rage, his nose touching mine. As a punishment, I was given a very heavy Sten gun and told to run around the barracks, holding it above my head, while all the other recruits enjoyed a cup of tea.

In the summer of 1968, we were flown over to Kuala Lumpur to film some beach scenes, which included Robert Bridges, the rotund actor I'd once dressed in the New Theatre, having to simulate being blown up by a booby-trapped football. We then travelled down to Singapore to capture some footage of Selarang barracks and the jungle; the script asked me to wade through a murky pond but since the water level reached my neck, I had to balance on a specially made bridge. This caused no end of merriment among the cast, one of whom asked me if I still shopped at Mothercare. I laughed it off, as per usual. I had to accept that these height-related wisecracks would follow me wherever I went, probably for the rest of my life. I made a conscious decision to take these jibes with a pinch of salt, no matter how irritating or predictable. This still remains the case today.

I was directed to flirt with Foster, a private played by Gregory Phillips, who – much to my envy – had once starred alongside my showbiz heroine, Judy Garland. In one of the film's many comedic moments, Sergeant Driscoll, played by Nigel Davenport, shouts 'What are you wearing pyjamas for on active service . . . Oh and Foster! Villiers! STOP HOLDING HANDS!' as he catches us sharing an affectionate moment. *The Virgin Soldiers* was a good test of my acting

ability – less is more when there's a camera pointing in your face – and it also gave me a valuable insight into a different artistic discipline. I had no qualms whatsoever that this particular role, a rather effeminate gay private, might raise a few eyebrows. As far as I was concerned, I was just playing a part. It was a fictional character. Well, at least, that's what I told my mother.

On location, it was refreshing to meet people from outside the classical ballet bubble. This included a handsome young extra, a budding musician called David, who'd often strum his guitar during breaks in filming.

'Play that one about Major Tom again,' I'd say to him. 'I love it.'

A year later, David Bowie's 'Space Oddity' was never off the radio.

I attended *The Virgin Soldiers* Leicester Square premiere with my Opera House colleague, the gorgeous Marguerite Porter (arriving with George on my arm would have been unthinkable, of course). The aftershow party took place at producer Ned Sherrin's place, where I got talking to a quiet, dark-haired, polo-necked New Yorker who seemingly worked in musical theatre. It took a couple of minutes and a passing reference to *West Side Story* for the penny to drop that I was in conversation with the great Stephen Sondheim. THE. STEPHEN. SONDHEIM. Lyricist of my FAVOURITE MUSICAL. It took some serious willpower to act coolly and calmly in his presence, but I think I just about managed it.

'You must look me up next time you're in New York City,' he drawled, probably out of politeness, before scribbling his number on a scrap of paper. I doubt whether he expected

me to actually take him up on this. But I was single-minded
– especially when it came to my career – and, unlike the
time when I very nearly met Noel Coward but didn't, I wasn't
going to let that opportunity slip away.

Back then, my professional life was crazy but my personal life
was content. I'd settled nicely into my relationship with George
– having him around felt so easy – and I felt very happy to
be one half of a same-sex couple. Those outside our close
friendship circle might not have approved, of course – including
my family – but I refused to let that spoil my domestic bliss.

In the late sixties, we decided to up sticks from Wigmore
Place and move to a larger pad in Powis Gardens in Notting
Hill, around the corner from David Hockney's place. And, in
doing so, we happened to break new ground. In those days,
pooling resources and securing a joint mortgage was tradi-
tionally the preserve of heterosexual couples, since the mere
notion of two gay men living together continued to appal
the masses. However, thanks to a friend of George's, the
renowned antiques dealer Christopher Gibbs, we were among
the first same-sex couples in Britain to buck the trend.

Gibbs, luckily for us, had family members in the banking
world who were tolerant and progressive, and they agreed to
offer us a mortgage deal. Using us as an example, many other
gay couples followed suit, by all accounts, with the Gibbs
family no doubt appreciating the additional business ('You're
the boyfriends' best friend,' George told our liberal-minded
lenders). Acquiring this mortgage did feel pretty momentous
and I'm immensely proud that we paved the way for others.

This stamp of approval wasn't reflected in the wider society,

though, sadly. In the eyes of the law, flat-sharing couples like us still couldn't live an ordinary life, free from fear and prejudice. The 'decriminalisation' outlined in the Sexual Offences Act, passed in 1967, was perhaps not as liberal as it sounded. For instance, private and consensual homosexual acts between men over the age of twenty-one were rendered illegal if another person was found to be in your property at the same time or if you didn't securely lock your bedroom door. Hotels and guest houses were deemed public places, too, so if you were found in flagrante with a man you'd be risking arrest, conviction and imprisonment. It was all ridiculously oppressive. Even people who, like George and me, enjoyed a loving and stable relationship, were made to feel immoral and perverted. This still makes my hackles rise today; such inequality and injustice should never be forgotten, regardless of the passage of time and the dawn of new freedoms.

But while I abhorred institutional homophobia, I never positioned myself as a gay rights activist. I left that to other people. I just wasn't ready to be out, proud and political, because I still felt the need to protect my career and shield my family. Whether Mum realised the true nature of mine and George's relationship is a moot point – I never disclosed he was my lover – but I know for sure she adored him.

'Your friend George is such a gentleman,' she said, following their first meeting in London – probably at Langan's Bistro – when he'd bowled her over with his signature charm and chivalry.

As far as my other relations were concerned, George was my 'friend', 'companion' or 'manager' (back then, gay men were well-accustomed to employing these smokescreen euphemisms).

Although I didn't attend London's first Gay Pride march in 1972, I respected those who did. I chose instead to display my solidarity in other ways. That same year, sculptor Andrew Logan (with help from my friend, the filmmaker Derek Jarman) established 'Alternative Miss World', a high camp art and fashion event that took place at Logan's Hackney-based studio. The guests, most of whom belonged to London's gay and lesbian community, were encouraged to dress as extravagantly as possible, with a special crown, sceptre and sash awarded to the most outrageous costume of all.

All sorts of creations sashayed down the makeshift catwalk, from men dressed as Marie Antoinette tottering beneath bouffant pink wigs to women sporting John Wayne-style outfits with lasso ropes, leather chaps and Stetsons. It was such a joyful pageant, with a bizarre-is-beautiful and a gender fluidity that was way ahead of its time. Alternative Miss World became a yearly event. Although I never went in costume, I'd sport my high fashion Ossie Clark finery, and I remember once being grabbed and snogged by Maggi Hambling, the lesbian artist, who was clad in a full police officer's outfit, complete with steel handcuffs and a leather truncheon. It was only when we met a few years later that she told me she had thought I was a girl, with my silky clothes, flowing locks and pert backside.

Alternative Miss World soon became the hottest ticket in town (it later had to relocate to a larger venue) and attracted a rollcall of style icons, like designer Zandra Rhodes and larger-than-life drag queen Divine. David Hockney gladly supported the event, too, offering sketches as auction prizes or sitting on the panel of judges. George and I helped to collect the donations,

often amounting to thousands of pounds, that were distributed among local gay and lesbian charities. I always supported the cause as I was proud to be part of the gay community, even if I didn't always feel able to shout about it.

In private, however – when I was in the company of close friends – I felt at liberty to be myself and behave how I liked. This was especially the case when I went on holiday. Travelling abroad still felt like a big treat for me, considering I'd never left British shores as a kid.

George and I often holidayed with Hockney and friends, which included Habitat founder Terence Conran, painter Howard Hodgkin and heiress Lady Henrietta Guinness. Ossie Clark and Celia would come along, too, as would Kasmin and his ex-wife Jane. In high summer, we'd head to France for a fortnight's stay in a huge, old, rambling chateau in Carrenac. David enjoyed visiting the famous spa towns, like Vichy, and would sometimes take us along. I became a big fan, too, and would join on several occasions. After a long season at Covent Garden, it was heavenly to relax in the baths and feel the spa water gently fizzing against your skin. Some of the others liked to chill out with a joint or two while *en vacances*, but, as a long-time non-smoker, marijuana really wasn't my thing. The first time I inhaled it, during an early French sojourn, my gills turned green and I had to dash to the loo to throw my guts up. I couldn't have been less rock 'n' roll if I'd tried.

David would relax abroad by painting, too. His creativity never stopped. Once, he did me a huge favour when I'd forgotten to bring George's twenty-eighth birthday present over to France.

'Damn, I haven't got anything to give him,' I said.

'Sit over there, Wayne, I'll sort it,' he replied, producing his pastels and drawing a beautiful head-and-shoulders portrait of me. Had George not returned unexpectedly early from a day trip, it would have been a full-length drawing. The finished article, which he generously signed 'Happy Birthday, love David and Wayne', was stunning. The curly brown hair, the ice-blue eyes, the upward-looking gaze, the coolly resolute expression . . . he'd captured my spirit and essence so perfectly. George treasured his unique gift. He still has it in his possession, and plans to bequeath it to the National Portrait Gallery.

Carennac, a quaint town in the heart of the Dordogne, was a favourite destination for Hockney's Holidays Ltd. George and I journeyed over in our new car, a tiny blue two-seater Fiat Vignale Gamine that we'd spotted in a showroom in Queensway – a bargain at £300. We christened him Noddy, for obvious reasons. While I'd never passed my driving test – I hadn't had time to learn – I was completely obsessed with cars. Catching sight of my first Ford Mustang while on tour in Los Angeles gave me the hots, big time. It was gorgeous – so sleek, shiny and handsome.

Halfway through one French trip, probably after he'd had a few glasses of local malbec, David had the bright idea of teaching me how to drive. He'd just bought a brand new, limited edition BMW convertible and – more fool him – was happy to let me loose in it.

'Let's me, you and George go for a spin, Wayne,' he said, in his Bradfordian brogue.

'Are you sure?' I replied.

An hour later, while being given directions by David, I found myself desperately trying to negotiate a narrow dirt track at the

top of a ravine, swerving past oncoming tractors, my knuckles white as I gripped the steering wheel, my size six feet barely able to touch the pedals. If David and George felt their lives were in mortal danger, they had a strange way of showing it. The pair of them rolled around on the back seat, crying with laughter as I sweated buckets and screeched like a banshee. I was seething with rage when – God knows how – I finally reached the foot of the valley with car and passengers intact.

'Never again, you lousy bastards,' I hissed, as they dabbed away their tears and thanked me for the free entertainment.

This traumatic experience put paid to any driving ambitions, but my affection for classic cars remained. I adored them. I remember once sending George out to a central London auction house because I needed a baby grand piano, only for him to return with a Rolls Bentley.

'I couldn't resist,' he said.

'But I can't drive!' I replied.

'You have to have it. It's only done 30,000 miles!'

That prompted the arrival of Mac the chauffeur, who'd also go on to drive our subsequent car, a Daimler, that we bought from George Harrison's Transcendental Enlightenment Company. With its eight seats and curtains in the windows, the car, I was told, had been used to transport his spiritual guru, the Maharishi, around the UK. Me and George (my boyfriend, not the Beatle) nicknamed the Daimler 'Big Ears' and used to love taking it for a spin around The Mall and Birdcage Walk, giving royal waves to camera-toting tourists as we swept past.

* * *

Back at Covent Garden, I was feeling a little unsettled. Sir Frederick Ashton's unexpected departure in 1970 had shaken every dancer in the Company, especially those of us who'd fared well under his tenure, and I did catch myself wondering whether I might soon be moving on and branching out. Sir Fred's replacement as artistic director, Kenneth MacMillan – a former ballet protégé of Ninette De Valois and a superb choreographer of *Romeo and Juliet* – was a different entity altogether. He and Ashton were both brilliant choreographers but they were poles apart, both inside and outside the salon. MacMillan was regarded as an anti-establishment rebel who liked to challenge and subvert, more of an angry young man than a member of the old boys' club.

Sir Fred had always choreographed with performance in mind – he was actively dancing well into his sixties – and, as we rehearsed, placed great emphasis on the feeling of being on stage and connecting emotionally with the audience. However, the fact that MacMillan no longer performed – it was rumoured he had stage fright – made his approach less sensory and sensitive, in my opinion, and allowed him to take risks and push boundaries.

And, as our new choreographer began to put his own stamp on the Royal Ballet, it became clear that he preferred his dancers lean and long-limbed, like Lynn Seymour, as opposed to stocky and compact, like little ol' me.

'If you're an Ashton dancer, you're not a MacMillan dancer,' was the general consensus. It was like the arrival of a new hotshot manager at a football club: if you didn't fit into his squad and you weren't his kind of player, you'd be dropped or transferred.

Oh well, that's me gone, I thought to myself. *I'll be following Sir Fred out of the door before I know it.*

I was being realistic, not pessimistic; I still had great faith in my own ability, I just doubted I'd be MacMillan's type. But there was still a chance I could win him over. I knew he'd admired my performance in the revival of *Rite of Spring*, staged by the Company in 1968. He'd singled me out from the entire corps de ballet, I was told at the time, even though we'd all been performing the same steps.

Thankfully, I wasn't given my marching orders at Covent Garden, but for the next couple of years I hardly got a look in. Principal roles continued to evade me and I was restricted to my customary solos in *Swan Lake*, *Jazz Calendar* and *Enigma Variations*, with minor roles in MacMillan creations like *The Rite of Spring* and *The Invitation*. Though I always gave everything to the character – how could I not? – my stage time began to feel rather humdrum. I'd never dream of letting my paying audience down – best foot forward, in every sense – but poor George would often have to withstand my moans and groans when I returned to the flat, feeling utterly dejected.

But the final straw for me, career-wise, came in the spring of 1972 when I discovered that MacMillan and the associate director, Peter Wright, had only pencilled me in for one role – Puck, in *The Dream*, albeit in the first cast – for the forthcoming season in New York. It felt like a huge slap in the face; in previous trips, I'd performed ten or so roles. I wasn't prepared to go away for six weeks for such a measly reward.

So when I was approached by director Richard Digby-Day

to audition for the part of Ariel in *The Tempest* – a three-month acting role, six weeks in Regent's Park, six weeks on tour – I couldn't believe my luck. A golden opportunity to tread the boards, and in Shakespeare, no less. It all felt so serendipitous. After I was offered the part, I made up my mind to ask for a leave of absence from the Royal Ballet. When I let my intentions be known to the Directors, Kenneth MacMillan and Peter Wright, I was summoned to their Barons Court office.

'You've had your little corner in this company for some time, Sleep,' said Peter, 'and if you decide to go away, we might have to fill it with someone else. So think carefully about what you're doing, and come and see us again on Monday.'

I talked things through with George over the weekend. We both agreed that I should stick to my guns, but nonetheless I felt quite miserable about their response, which had sounded like a veiled threat to edge me out of the Company.

That Monday morning, as I approached the office to give in my notice, I found Michael Somes waiting in a corridor for me. His advice? To go into the office, not say a word, and hear what they had to say. He'd clearly got a steer of their view on things.

'So have you made your mind up, Sleep? D'you want to do *The Tempest*?' I was asked.

I nodded, keeping my mouth firmly shut as advised.

'Well, that's decided, then,' said a director. 'Have a wonderful tour and we'll see you back here next season.'

I felt vindicated. I would later discover that Michael Somes had spoken to the board, and they had effectively granted

me a sabbatical, a leave of absence, a sensible compromise without the need for resignation or retirement.

This gentleman's agreement of sorts remained in situ for the rest of my career. Although I'd go on to pursue many different avenues and perform to many different audiences, I'd never officially leave the Company and would continue to enjoy the Royal Ballet warrant, as it were (any TV or theatre credits had to state 'Wayne Sleep appearing by kind permission of the Royal Opera House, Covent Garden'). I was in the driving seat; I knew it was in my best interest to keep those credentials and maintain that cachet. Sir Robert Helpmann knew the score.

'Never leave the ballet, Wayne,' he'd often tell me.

I'd had some voice coaching for *The Virgin Soldiers*, which came in handy for outdoor Shakespeare. I learned how to project and amplify my voice, and how to tone down my Devonian burr, with its stretched vowels and soft Rs. Weirdly, I'd kept much of my native accent despite leaving Plymouth as a youngster. I was an adopted son of London, with an upwardly mobile status, yet such an intrinsic part of me – my voice – was still rooted in the past. My voice coach did a great job. Too great, some would argue, because he spawned a foghorn. Even now, I'm often asked to keep the noise down in pubs and restaurants; sometimes I'm even told to move to another table. I have no volume control whatsoever. I can't help myself. What I lack in inches, I make up for in decibels.

It was a privilege to rehearse and perform Shakespeare among such marvellous company. Michael Denison, who

played the magician Prospero, was a West End stalwart and Celia Bannerman, who took on role of his daughter, Miranda, had starred in ITV's *Upstairs, Downstairs*. And playing the part of Ariel – an ethereal spirit full of magic – was an absolute joy. My classical ballet training was intrinsic to the portrayal, even when the script required Ariel to be 'invisible'. Remaining totally motionless while conveying meaning was a difficult skill that I'd honed through the years. It was all about poise.

Acting Shakespeare was infinitely more nerve-wracking than performing any ballet. It demanded a certain mental acuity – articulating the archaic language, adhering to the poetic rhythms – which meant I'd be pacing around backstage before each show, practising my lines and breathing. But the good reviews made it all worthwhile. Some critics even said I could forge a full-time acting career, if I so desired. That was never on the agenda – dance was my calling and my first love – but it validated my difficult decision to expand my horizons.

The Bard came calling again in the summer of 1973. John Copley, the producer in residence at Covent Garden, asked me to play Puck in Benjamin Britten's opera of *A Midsummer Night's Dream* – John Gielgud's original production – sharing the stage with Geraint Evans, the famous Welsh baritone. I didn't have to sing, as such – in Britten's libretto, Puck spoke in metre – but, as with the acting, the experience gave me a window into a different art form and added another string to my bow. In fact, it's only in retrospect that I realise the level of fearlessness and confidence needed to tackle these new disciplines. Nothing – and no one – fazed or

intimidated me back then. Risks had to be taken, boundaries had to be pushed and opportunities had to be grasped. I didn't want to spend my life rueing and regretting my career choices, like I suspected my mother did.

'Maybe it's time to get yourself a stage name,' George joked as we celebrated my promotion over dinner. 'How's about "Wayne Sleepova"?'

'More like Wayne Sleepitov,' I replied, as we clinked our champagne glasses.

One morning in January 1973, after responding to another yellow peril note pinned to the board, I was directed to head over to BBC Wood Lane to make a live appearance on the children's television show *Record Breakers*. The producers wanted me and another dancer, Brenda Last, to demonstrate various ballet steps in relation to a segment they were running about dance-related Guinness world records. So, sent by Kenneth MacMillan, Brenda and I went along in our classical ballet outfits, ready to show off our repertoire of moves. Presenter Roy Castle, himself a very talented tap dancer and all-round entertainer, introduced us to a studio audience of excited school children before inviting us to go through the motions.

The kids particularly liked my demonstration of entrechats, the blink-and-you-miss-it jump that involves multiple crossing and uncrossing of the legs. There were gasps of 'Wow!' and 'Gosh!' as I bowed before them.

'Hey, while you're here, Wayne,' said Roy, rather conspiratorially, 'how's about attempting the entrechat world record on live TV?' He then explained to the TV audience how the

great Vaslav Nijinsky was the only person to have completed an entrechat dix (the ten movements being five criss-crosses in the air before landing).

I was completely taken aback – I'd had no idea this was on the cards – and didn't quite know how to respond.

'Well, um, I'm, um . . .' I stuttered, as the kids in the studio audience began a slow handclap. I'd done a 'dix' before, in class, but never a 'douze'. And the prospect of making a complete idiot of myself on national television, in front of millions of viewers, well . . .

'That's brilliant, Wayne!' said Roy, patting me on the back. 'Isn't he a good sport, children? Drum roll, please!'

So, I took a deep breath and just did the best I could, my heels and toes criss-crossing like the clappers as Roy and chief adjudicator Norris McWhirter looked on.

'Has he done it, Norris?' asked Roy, as they replayed the slow-motion footage.

'Yes, I've counted twelve movements, Roy. He's done it!' proclaimed McWhirter. 'It's official! Wayne Sleep, you're a record breaker.'

Cue a sudden burst of the theme tune and two hundred kids going bananas.

The American poet Roy Blount would later pen a poem about my achievement; it was such big news it had crossed the Atlantic. Reciting his ditty off by heart, beginning with the first verse, which opened 'A dreamlike leap/By England's Sleep', still remains a party piece of mine.

I was soon brought back down to earth, though. When I turned up at Barons Court the following morning, the response to my feat – or my feet, as it were – was cool at

best. None of the staff said a word (some looked at me with barely masked disdain) and my classmates, perhaps envious of my brief moment of fame, made snide remarks about me 'going in for competitions now'. So instead of being congratulated for giving the Royal Ballet some positive exposure, I was scorned for appearing on telly and entertaining the masses. My *Record Breakers* experience would be a taste of things to come.

Some meatier roles came my way at the Royal Ballet in the mid-1970s, notably in *Elite Syncopations, Concerto* and *Petrushka*. The latter is a masterful one-act ballet with music by Stravinsky that had been originally choreographed for Nijinsky by the legendary Michel Fokine. Based on a Russian folk tale, it tells the story of a love triangle between three puppets – Petrushka, the Ballerina and the Blackamoor – who have been brought to life by a magician. It's a difficult ballet, with an intense narrative and an intricate score, but it became an extremely popular piece among dance purists.

I only had four performances as the eponymous puppet and sadly it didn't require my trademark jumps, leaps and spins. Rather, to depict this sad and soulless figure – and his unrequited love for the Ballerina – I had to draw upon my miming and acting skills to convey a full range of emotion, from delight to dejection. Three of us were cast as Petrushka in rotation – me, Rudolf Nureyev and Alexander Grant – and we each brought our own unique styles and interpretations to the role. But there came a point where I flatly refused to rehearse alongside Rudi and Alex as I found it too conflicting and confusing. Both had prior experience of the ballet and

I just felt our wires were crossing. My wish was granted, thankfully – I had a bit more clout now – and instead I had hugely productive one-to-ones with John Taras, New York City Ballet's ballet master, who'd been flown over to mount the production. As senior principal, I was learning to pull rank, like the rest of them.

I was delighted with the response I received from my first-night audience (which included Dame Marie Rambert, the legendary ballet director and teacher, who was sitting in the front stalls). When I bowed to her, she gave me a standing ovation, which I was very moved by. I only received one bad review, from *The Times*' dance critic, John Percival, who complained I was 'too small' to play Petrushka. Which was a bit rich, in my opinion, considering the character was a doll, for goodness' sake, and that Nijinksy, who pioneered the role, was exactly the same height as me. Ho-hum. You can't win 'em all.

Elite Syncopations elicited some positive reactions. It was a very light soufflé, and not like MacMillan's usual work, with an angst and deep meaning, but it went down very well with audiences. Ashton's *Jazz Calendar* was similar in this respect. Ironically, they were the only two ballets I did at Covent Garden that got an encore, which said it all – a choreographer's most popular piece isn't necessarily their best piece. The *Elite Syncopations* idea was hatched in the early 1970s when lots of Scott Joplin's music came out of copyright, thus allowing his compositions to be used freely in ballets and concerts. MacMillan jumped on the bandwagon with aplomb, producing a quirky and playful 'ragtime ballet' which celebrated Joplin's classics – and others – with a Covent Garden twist. He brought

in the eccentric Australian costumier Ian Spurling to create Lycra bodysuits with painted-on braces, jackets and stripy trousers, sported by a superb cast that included Merle Park, Monica Mason, David Wall and Donald MacLeary.

For the Alaskan Rag, I was paired with Vergie Derman, who was the tallest woman in the Company, to perform a tall gal–small guy routine. Our esteemed choreographer was insistent that my pas de deux with Vergie had to hit the right note and make people laugh.

'If it doesn't work, I'm scrapping it,' he said.

I was used to partnering the tall girls in the class so I was confident that this tried-and-tested comedy formula would work.

MacMillan was amused and pleasantly surprised by how I was able to lift, catch and support Vergie with such ease. Back in my upper school days, I'd often been paired with the most statuesque ballerinas – usually because the taller boys bagged the smaller girls to partner – and as a result had become as strong as an ox, which was unexpected in someone of my stature. The denouement of our slick slapstick routine involved Vergie deftly cartwheeling off my shoulders and being scooped up in the air as I performed a backward roll. The audience loved it. I think we got three calls for everyone else's two.

I admired MacMillan as a professional – only a maverick could have staged something like *Elite Syncopations* – and by this point in time, we had warmed to each other. However, had it not been for him, I might have got my big break in the United States. In 1977, a brilliant principal dancer with the New York City Ballet, Edward Villella, suffered a serious knee

injury which would prevent him from performing, and I was earmarked as the perfect candidate to replace him for a season as a guest artist. I was Villella's equivalent in many respects, as we possessed similar dance styles and I'd performed many of the virtuoso roles that he had. I was even given the seal of approval by the Company's director, the legendary choreographer George Balanchine, who'd seen me in class while the Royal Ballet was touring in the States and had been suitably impressed by my beats and jumps. Co-founder of New York City Ballet Lincoln Kirstein then came up with the idea of organising a dancer exchange – whereby a New York principal would benefit from the Covent Garden experience and vice versa – and he duly wrote to the Royal Ballet to beg the question.

But much to Lincoln Kirstein's disappointment, he informed me that no answer ever came. So the dancer exchange never materialised and someone else was found to fill Villella's ballet shoes. I was crestfallen. I felt I was at the peak of my ballet career and performing with the New York City Ballet – and living in the Big Apple – would have been such an enriching experience, personally and professionally.

Even the finest dancers at the Royal Ballet were expected to improve and develop. Resting on your laurels was not an option. Often, the best way to learn was to observe a master of their craft, perhaps someone who was embracing innovation and breaking new ground. In the summer of 1970, rumours had spread through Barons Court that a brilliant young Russian was appearing at the Royal Festival Hall with Leningrad's Kirov Ballet. People said he was the best since Nureyev, better than Nijinsky, even. Dancers can be narcissistic

individuals – we spend half our lives looking in the mirror, after all – but this never stopped us from appreciating our peers and checking out the competition.

'You've got to catch him in the matinee,' I was told after class one day. 'Run, before all the tickets sell out.'

When I saw Mikhail Baryshnikov on stage that afternoon, I knew I was witnessing steps that I had never seen before. He was simply phenomenal, a complete package of artistry, technique and charisma. And he wasn't that much taller than me, at five foot seven-ish – proof positive that the finest male dancers didn't have to be beanpoles.

Five years later, in the summer of 1975, he became a guest artist with the Royal Ballet to perform the lead in *Romeo and Juliet*. I became Misha's tour guide and drinking partner, although it was nigh on impossible to keep up with him. Whisky went down the hatch extremely easily. In 1976 in New York, on the final night at the Met, I had just performed the Mandolin Dance, and the audience would not stop applauding, until I came forward again to take yet another call. I was used to getting two curtain calls, but on this occasion the audience simply wouldn't let me go. I received so many calls that Misha said, 'Remind me never to appear on the stage with you again!' For him to say that, even in jest, was quite something.

One day, at the end of class, he took me to one side.

'Wayne, I have a special step for you,' he said. 'You are the first person to see it. I think only you can do it and nobody else.'

He then taught me one of the most intricate, acrobatic moves I'd ever witnessed.

A couple of weeks' later, I was in the studio, perfecting this new addition to my repertoire, when Rudolf Nureyev stormed over.

'What the f*** was that, Sleep?' he demanded.

'Well, there's no word for it,' I replied. 'It's not in the syllabus yet. Misha showed me.'

'Well, I have a word,' he said, hand on hips. 'We call it the double mother-f***er.'

The officially named dance step got its first public airing in *A Month in the Country*, a ballet that saw Sir Frederick Ashton interrupting his retirement to act as our choreographer. Despite Sir Fred's pre-performance nerves this delightful ballet, a Russian family saga set to the music of Chopin, proved to be as good as anything he'd ever done. He had found his inner muse again. He created the role of Kolia specially for me (a small child, *quelle surprise*) and, as ever, he wanted the creative process to be as collaborative as possible.

He'd sit with his legs crossed in the rehearsal studio, sporting an immaculate suit (he'd never wear casual practice clothes) and puffing nervously on a cigarette.

'Hello Sleep, what have you got? ' I remember him asking one morning as I warmed up.

'I've got this . . .' I replied, and proceeded to fly across the room, just as Misha had shown me. Sir Fred agreed to embed this virtuoso step into my routine, though he decided to add in something to make it his own, namely a landing on one knee. This one-upmanship was typical of the world of ballet.

* * *

As the seventies edged nearer to the eighties, my quest to develop and diversify my career continued. I felt I had more to offer alongside ballet. I acquired two more movie credits: one as an actor and one as a choreographer. In 1978, *The First Great Train Robbery*, directed by Michael Crichton (who would later write *Jurassic Park*) was filmed on location in England and Ireland. I was cast as Clean Willy – no laughing at the back – a cat burglar turned informant. Crichton needed someone small and agile to scale high walls and scamper along narrow ledges, and I fitted the bill.

It felt fabulous to rub shoulders with the leading men, Donald Sutherland and Sean Connery, but the scene in which I was due to be callously strangled by the latter ended up being changed at the last minute. Crichton decided it was out of character – Pierce, the brains of the robbery, was supposed to be a loveable rogue – so another actor, George Downing, throttled me instead.

I left the film set under a bit of a cloud, as it happened, because I kicked up a fuss about not being paid extra for doing my own stunts (it transpired they couldn't find a stunt man small enough). Not for the first time in my career, I caused a right royal rumpus. I threatened to involve my agent so, minutes before filming, they gave me £500 in notes to keep me quiet. So when you see me in *The First Great Train Robbery*, leaping across walls and scampering up stairs, I've actually got a big wad in my pocket. It seems I didn't burn all my bridges, though. Following the film's premiere, I was sounded out by Colombia Pictures about the possibility of signing a contract to appear in more movies (my cameo had turned a few heads in the film world, apparently). But I felt

it was too much of a risk. I was on a roll with the Royal Ballet, being cast in most new ballets. Plus, I wasn't ready to abandon dancing – I had trained for so long for this that I couldn't give up. So those initial enquiries came to nothing, but it was nice to be in demand.

That same year, I was asked to choreograph a tango scene in the film of Agatha Christie's *Death on the Nile*. I'd offered similar services to actors before; I'd worked with Albert Finney in *Cromwell* (directed by Anthony Page at the Royal Court Theatre) and had choreographed the musical *Salad Days* at Duke of York's Theatre in the West End and *The Changeling* at the Birmingham Rep. But I rather liked the idea of progressing to a movie. The cast was laden with stars – including Bette Davis, David Niven, Mia Farrow and Peter Ustinov. The prospect of working with these famous faces got my knees a-knocking, and I had to remind myself that underneath their Hollywood veneer they were human.

When I arrived at Pinewood Studios at 6am on a winter's morning, I met a group of actors who were fraying at the edges. The cast would arrive in their limos and refuse to get out until they read the day's schedule, ordering their chauffeurs to turn around if they weren't needed. They'd also spent ten weeks on location in Egypt, cooped up in a steamship moored on the Nile, which had caused tensions to flare. Mia Farrow had a long, gossipy chat with me one afternoon, lamenting personal and professional matters. A bored rigid Peter Ustinov entertained me with his riotous repertoire of orchestral instrument impersonations. And, on the morning of the filming, there was a very nervous energy

in the air, until a seventy-something Bette Davis grabbed my shoulder, lifted up her frock, and performed the can-can.

'Now follow that!' she cackled.

The legendary David Niven, however – one of my favourite all-time actors – was much less forthcoming. It seemed he was reluctant to join Angela Lansbury (yes, the Broadway musical's star) to rehearse a tango for a scene that needed shooting the next day.

'Go find him, Wayne, and have a word,' said Guillermin, the film's director.

'What, you expect me to call the shots?' I replied, worried about rankling one of my matinée idols.

But I eventually plucked up the courage. And it transpired that David Niven, Oscar-winning movie legend, had his own hang-ups to deal with. He told me in his cut-glass accent that being on a film set made him anxious ('I'm always petrified it'll be a dud, Wayne . . .') and that he was scared witless about dancing in public.

'I think you should at least come to a rehearsal, so I can teach you how to avoid getting in Miss Lansbury's way,' I said, trying to appeal to his gentlemanly instincts. 'I mean, you wouldn't want to trip her up, would you?'

'I'll be there tomorrow, Mr Sleep,' he replied.

But this encounter stayed with me. It taught me that even award-winning film stars had their fears and frailties, contrary to their grand reputations.

Working on *Death on the Nile* was the first time I'd met Angela Lansbury after queuing up for her autograph almost ten years earlier. Meeting your idols can sometimes be disappointing, but that wasn't the case with Angela. She was

divine. We hit it off immediately – neither of us took ourselves too seriously – and we became great friends. She'd invite me to her Broadway productions (I happened to watch *Sweeney Todd* with its composer, my buddy Stephen Sondheim) and, following the curtain call, I'd meet Angela in her dressing room before going out to dinner.

Although my career was on an upward trajectory, this wasn't always the way with my contemporaries. My good friend Graham Powell, with whom I'd grown up at White Lodge and Barons Court, was a case in point. Despite our journeys veering in different directions – my star was in the ascendancy, his less so – we still kept in touch. In the early 1970s, he'd relocated to Athens after guesting with the Australian Ballet, working as a dance teacher while his partner Stephan continued his lucrative career as an interpreter, sometimes translating news stories from Greek to Russian for the Soviet secret service, the KGB. A few years later, the couple decided to return to London. They moved to a basement flat in Chelsea and, much to my delight, Graham rejoined the Royal Ballet. It ended up being a short-lived stint, sadly, with both parties realising that his heart just wasn't in it anymore, and – if truth be told – that his talent had diminished.

I remember Graham aiming a few barbs in my direction at the time, revealing a jealousy and bitterness that I'd never sensed before. My friend had always been so proud of me, but now he was openly criticising my performances.

'He doesn't seem himself,' I remember saying to George after we'd met him for lunch.

'I know,' he replied. 'Something's not quite right.'

Graham decided to channel his creativity into poetry, prose and painting, but found it hard to focus, his concentration hampered by the severe headaches and nosebleeds that had plagued him for years. Then, following a trip home to Greece, his beloved Stephan was refused entry into Britain: the Cold War was at its peak and his KGB links were red flagged. This devastating news plunged Graham into a deep depression. Now living alone and having lost the love of his life, he became a virtual recluse and severed contact with his close friends, including me. In the spring of 1977, I discovered he'd been rushed to St Stephen's Hospital in Fulham, having suffered a brain haemorrhage that had left him in a coma.

My final memory of Graham is of him in that hospital. I was sitting by his bedside, gently stroking his hand and talking to him about all the good times we'd shared. I was struck by how serene he looked – as if he was in a slumber rather than a coma – but the doctors had already told me there was no hope of recovery. He looked as beautiful as ever. I prayed to God he'd slip away quickly and peacefully because I couldn't bear the thought of this creative and charismatic young man wired up to a ventilator, lying in a hospital bed, effectively brain dead.

A few days later, my desolate prayers were answered. I was playing the lead role in *Fourth Symphony of Gustav Mahler* at Covent Garden, having been handpicked by legendary guest choreographer John Neumeier. Moments after coming off stage, I was asked to take a call from George in the prompt room. There was a distinct chill in the air as I walked in, dreading the news I was about to hear.

'He's gone, Wayne. I'm so sorry.'

George had been informed about Graham's death a few hours before but had decided to hold off telling me until I'd got through my opening night's performance. It was a wise decision. Some of the piece was about heavenly matters and I'm not sure I'd have been able to get through it without losing my composure.

Following Graham's funeral, I visited his flat to help to sort out his belongings. Stacked in piles around the place was his artwork, including a striking pencil sketch of me, drawn when we were twelve-year-old White Lodge hopefuls. The next day, I went to John Kasmin's gallery to get it framed.

'What a lovely portrait,' visitors to my Chiswick home say when they spy it, pride of place on my console table. 'Who's the artist?'

And I tell them about the beautiful soul I lost too soon, who's still missed to this day.

CHAPTER EIGHT
Dancing to My Own Tune

AS A YOUNGER man, I often wished I'd been born in the same era as Gene Kelly and Fred Astaire. I reckon my talents would have been perfect for those fabulous musical films – *Swing Time, On the Town, Singin' in the Rain* – and had I upped sticks to America, I might have bagged myself a big-bucks movie contract along with a nice pad in Beverly Hills. Sad though it sounds, a little part of me still awaits that phone call from MGM or Paramount: 'Mr Sleep, we have just the role for you, topping the bill with Miss Charisse . . .'

In retrospect, though, being a post-war baby didn't turn out too badly for my career. Not only was I honoured to play a part in the so-called 'golden era' of the Royal Ballet – in the sixties and seventies, when it was regarded in the same light as its Russian counterparts – but I was also in the right place at the right time to make the most of a television phenomenon. 'Light entertainment' was the umbrella term for a host of chat shows, quiz shows and variety shows that featured all sorts of acts, from comics to crooners, mimics to magicians. Many of these performers were talent spotted in provincial theatres and social clubs, making the leap from stage to studio having been lured by the promise of nationwide exposure

and a handsome pay packet. People from similar working-class backgrounds to mine – Les Dawson, Marti Caine, Paul Daniels – who had worked their socks off to make the grade.

Television gave a new platform to dance troupes, too. Each show (or star) had their own dancers. Often, they were named after their choreographer – the Paddy Stone Dancers or the Dougie Squires Dancers – and generally played second fiddle to the main act, perhaps a West End star or a chart-topping singer. I used to call them 'moving wallpaper' which, in hindsight, was rather mean and uncharitable. Paddy, Dougie *et al* were bringing dance into people's living rooms, when all was said and done, and their performers were often given only a couple of days to rehearse their routines, especially at ITV, as time cost money. Only top professionals could carry that off. And these artistes always had plenty of work, whether it was in musical films at Elstree and Pinewood, or summer seasons.

My light entertainment journey began in the mid-1970s, while performing in charity galas. I'd choreograph my own solo piece for some of the galas – a version of the Hornpipe Dance, perhaps – or something fast, athletic and acrobatic that would enthral the audience, many of whom would have never seen me perform before. And, crucially, these gala evenings would also attract the movers and shakers of the television world, who were always on the look out for up-and-coming talent.

One evening in 1976, the influential head of London Weekend Television, Michael Grade, saw me performing a skit of Russian gymnast Olga Korbut. He thought it would be great to reprise it on TV and invited me to guest-star in *The John Curry Ice Spectacular*. Curry had won a gold medal at the recent Montréal Olympic Games, his balletic artistry

and agility earning him the tag of 'Nureyev of the Ice'. Being a huge fan, I was thrilled to be asked.

The Korbut thing, incidentally, had begun as backstage larks at the Opera House. Like many people, I'd been won over by her perky personality at the 1972 and 1976 Olympics – Soviet gymnasts weren't generally renowned for their gaiety – and prior to a class, as the cast and I lingered in the wings, I'd mimic her routine. I'd tie my hair in bunches, imitate her funny arched-back walk and prance around doing handstands, backflips and cartwheels, pulling my leotard down to cover my naked cheeks. It got so many laughs I expanded it into a short routine, ideal for one-off charity shows and galas. It regularly brought the house down and for a while it almost became my signature performance.

My 'Olga' didn't materialise for the Ice Spectacular, as it happened, since John was worried my send up might offend his fellow gold medallist.

'OK then, why don't I do you?' I suggested cheekily.

'Go on,' replied John with a grin. 'I dare you.'

So, sporting his hallmark white silk shirt and black flared catsuit, I sent up his medal-winning free skate, comically slipping and sliding in time to Ludwig Minkus's *Don Quixote*, the ballet of which I'd performed on countless occasions. John loved it. He was a good sport with a great sense of fun, as well as a trailblazer in ice dancing. Tragically, in the 1990s, he'd die of an AIDS-related illness, aged just forty-four.

Among the audience in the Theatre Royal Drury Lane one night, when I was performing my hornpipe in a charity gala, was the wife of Dickie Henderson, a well-known all-round

entertainer who had his own TV variety show. She was so impressed that she'd gone back home and convinced her husband that he should offer me a guest slot. So, in 1978, I got the chance to appear on *I'm Dickie – That's Show Business*. Wearing casual gear, I performed a light-hearted dance routine full of laughs, gags and props (I seem to remember playing the piano with my feet and taking a swing with a golf club). I taught Dickie the five ballet positions at the barre before treating him to an array of my trademark leaps and spins.

I was very pleased that the performance went down so well on television. I held my own on primetime TV. A home-grown ballet dancer appearing on millions of screens, clearly, transmitted such a positive message that male dancers weren't cissies. We were athletes.

My primetime TV appearances continued apace, without the necessity to audition. For a while, I didn't even have a proper agent or PA; George and his secretary at Bertram Rota, Penny, kindly helped out with my admin, invoices and fan mail after office hours. However, there came a point when they couldn't cope with the volume of calls and messages, so I signed myself up with one of the largest talent agencies in London, who handled all my professional enquiries. Grade was very influential in the entertainment world, particularly since buying the television rights for the Royal Variety Performance, on which I'd appear many times during my career.

In 1979, I was offered half a dozen episodes of *Lena Zavaroni and Music*, devising and performing zany song and dance numbers with the sixteen-year-old starlet who, after triumphing in TV's *Opportunity Knocks*, found herself atop the showbiz

DANCING TO MY OWN TUNE

ladder. She had barrels of talent, not least her remarkably powerful singing voice. People didn't expect such a tiny individual to pack such a punch. I could identify with that entirely. Sadly, she died in her mid-thirties, following well-documented struggles with her mental and physical health.

I performed a number called 'Don't Nobody Bring Me No Bad News' from *The Wiz*, the musical starring Diana Ross, while wearing a green sequinned all-in-one. For some harebrained reason, I attempted to perform the entire routine on roller skates. A disastrous move. In rehearsals I crashed into the set so often it ended up looking like an East End scrap yard.

'Well, this is a career low,' I said, while crumpled in a heap, as my co-star cried with laughter. 'To think, last week I was doing *Romeo and Juliet* at the Opera House, darling.'

Things also went awry when I was invited onto on the flagship of all chat shows, *Parkinson*. It was quite the accolade in those days. Britain's finest interviewer attracted the biggest and best names in show business – A-list raconteurs like Orson Welles, Bette Davis and Peter Sellers – and, in the past, had welcomed Royal Ballet stalwarts like Sir Robert Helpmann and Dame Margot Fonteyn. Following in their footsteps felt like a huge responsibility, so it was no wonder I was quaking with nerves in the green room beforehand. Furthermore, public speaking wasn't really my forte. I'd never done a long, in-depth interview before and at the Royal Ballet we were just expected to talk with our feet. With Parky, there'd be no costumes, scenery or orchestra. Just me, laid bare.

'Gosh, I've got the jitters,' I admitted to the make-up artist as she dusted me with face powder.

'Ah, don't worry,' she replied. 'Let Michael have the first three laughs and he'll give you the floor.' In other words, treat him with due respect and refrain from being overconfident.

Prior to the interview, I performed a slick tap dance, tagging on a sequence from my daft Olga Korbut routine. The laughter that rang around the studio gave me such a boost and as I took my seat next to the great man himself, my nerves just seemed to melt away. Parky was absolutely charming, posing questions about my career and my upbringing, and as I relaxed into the interview, I found myself talking quite freely and animatedly about my life as a dancer. However, according to friends who watched the show (whose opinions I respected), I came across as rather arrogant and vulgar. That genuinely hadn't been my intention.

It's true to say that my Parky appearance offended some dance traditionalists and I sensed a few rumbles of discontent.

Sleep has gone too far, I imagined people saying. *He's getting above his station. If you're a principal at the Royal Ballet, you don't ponce around on TV doing impersonations of Russian gymnasts . . .*

The prestigious *Dancing Times* published a reader's letter questioning my credibility as a member of the Royal Ballet and hate mail was sent to me via the Opera House (which I never read, fortunately, since it was vetted and binned by the office staff). I was even confronted by a middle-aged Covent Garden regular in a Soho restaurant.

'Sleep . . . what on earth were you playing at on *Parkinson?*' he sneered. 'You're a disgrace to the ballet. You ought to be ashamed of yourself.'

I ignored them but his slur hit me where it hurt. I'd

appeared on the show to entertain a new audience, not to attract a load of criticism.

On another occasion, a mismanaged situation involved a much-loved Russian dancer and an often-watched TV series. *The Muppet Show* had been brought to British TV screens by Lew Grade – a famously shrewd operator – and in 1978 I was informed via one of Iris Law's yellow peril notes that Rudolf Nureyev had been invited onto the show as its star guest and had requested that I partner him. He'd agreed to perform a pas de deux with the legendary Miss Piggy in 'Swine Lake' (tee-hee) and needed someone small and agile to climb inside the pink piggy costume and perform the skit. My name had been the first to spring to mind.

But did I jump at the chance to appear alongside a ballet luminary on a primetime TV show? Did I heck.

I stubbornly wanted to do a deal that Miss Piggy would have a solo on her own. With my status as principal dancer and my appearances on television, which were becoming increasingly frequent, I wasn't willing to go on and perform a bit-part in an animal skit. I would have done it if they were willing to give me a solo appearance as myself.

Owing to my diva-like behaviour, the show approached another Royal Ballet dancer, Graham Fletcher, who willingly donned the pink foam fat suit, complete with tights and tutu. The end result was a comedy masterclass. A deadpan Rudi lampooned himself beautifully, allowing himself to be dragged around the stage by his porky paramour and being flattened after he'd flung her into the air. 'Swine Lake' became one of *The Muppet Show*'s most memorable moments – and I regret in many ways having turned it down.

As I continued to ride onto the coattails of light entertainment, the TV bookings kept on coming – *Morecambe and Wise*, Oscar Peterson, Marti Caine – as did the hefty appearance fees, which were more than I'd earned at Covent Garden. I also received invitations for variety shows in Europe, namely *Sàbardo Noche* ('Saturday Night') in Spain and *Sotto le Stelle* ('Under the Stars') in Italy.

But while I was being fêted on the television, I was being spurned by many of my superiors at Barons Court. It was that post-*Record Breakers* snootiness all over again, most likely born out of jealousy and resentment. In their eyes, by committing the cardinal sin of taking commercial work that appealed to the masses and appearing on 'that kind of programme', I'd sold my soul and sullied the Company. The fact I was promoting dance to millions of viewers was immaterial. To them, primetime television wasn't art. Indeed, many Covent Garden types wouldn't have even lowered themselves to watch TV, especially the commercial channel.

This ill-feeling spread to class, too. If I'd appeared on telly the previous night, the following morning, certain dancers would studiously avoid eye contact or conversation with me while I was at the barre, as if I was somehow polluting their space. I remember performing *Swan Lake* in Liverpool while on tour with the Company and receiving the loudest round of applause when I walked on stage, in the ballroom scene in Act III. This seldom happened in the ballet, certainly not at Covent Garden. It just wasn't the done thing.

But this was another sign, I suppose, that my fame and celebrity were growing. Now that TV had made me more widely recognisable, doors started to open that never had

before, like receiving invites for VIP openings or being ushered to the best table in a top restaurant. I developed a small following of ballet fans, too, although nothing on the level of the hordes that awaited Rudolf and Margot's grand exits. My fans comprised of mainly middle-aged women who'd traced my career from the early days. They'd sometimes collar me outside Opera House stage door for a chat or an autograph after a performance, clutching their programmes and ticket stubs for me to sign.

Down in Plymouth, passers-by began to approach my mother, too, having seen me on the box the previous night.

'Eh, Joan, I caught your boy on *The Eamonn Andrews Show*,' they'd say.

'Well, I didn't!' she'd grumble, annoyed that I'd not thought to tell her.

I was too busy to give her a running commentary about my shows and my schedule. And she had no telephone, either, which didn't help matters.

I didn't realise it at the time, but Mum assiduously collected newspaper clippings, articles and photos that gave her son a mention (the huge extent of her collection was only revealed after she'd died). And while she never told me to my face that she was proud of me – being lavish with praise just wasn't her style – I knew she felt that way, at heart.

My sister Joanne, who'd since passed her tenth birthday, soon found out what it was like to have a brother in the spotlight and feel somewhat in his shadow. Being the sibling of a celebrity could be tough – Joanne was often referred to as 'Wayne Sleep's sister', as if she had no other identity – but luckily she possessed the strength of character to handle it.

She always stood her ground (that's not changed to this day) and Mum, to her credit, treated both siblings fairly and equally. And while my relationship with Stan was virtually non-existent, Joanne was the apple of his eye, which was fine by me – at least one of us made him happy. As my sister grew older, we definitely became closer – that ten-year age gap seemed to narrow with time – and we'd often exchange letters and postcards about her family life in Plymouth and my social whirl in London. She loved hearing all the gossip about domineering directors and catty co-stars.

My jam-packed schedule meant I still didn't get down to Devon much ('I see you more on telly than I do in person,' moaned Mum) so I'd often invite my relatives to London to take in a Covent Garden matinée. My mother, my grandmother and a selection of aunties and cousins would pile into a mini-bus and dump their belongings at their hotel – a fleapit on Russell Square – before taking their seats at the Opera House.

While it was nice to have the Pinto clan in the audience, sometimes they didn't quite understand theatre etiquette. Once, my mother set off the auditorium's fire alarm by lighting up a herbal cigarette (for some reason, she'd thought her minty fumes wouldn't trigger it). Another kerfuffle occurred during a performance of *Sleeping Beauty* when I was playing the Wolf in the Red Riding Hood divertissement. When our fifty-piece orchestra struck up a rather loud and menacing opening chord, my grandmother let out a high-pitched scream before leaping out of her seat and running up the aisle, back to the foyer. The boom of the big bass drum and the clash of the cymbals had frightened the living daylights out of her.

After these matinées, I'd take the Pinto clan for dinner at either Langan's or Odin's, a pair of swanky eateries owned by my friend, the noted bon viveur Peter Langan. This was despite their protestations that they'd already eaten.

'We had Spam sandwiches on the minibus, Wayne. We're not hungry.'

'But Granny, you must! You're in London! This is my treat, remember!'

Deep down, I think my family were worried they'd feel out of place at these haute cuisine restaurants with their impenetrable French menus. The concept of 'wining and dining' was alien to them, and they'd have much rather frequented the Pizza Express round the corner from their hotel. Nonetheless, Peter always treated them like royalty. He was very unstuffy like that, once telling me he much preferred catering for 'real-life people' over 'Hooray Henrys'. He particularly adored my mother. I remember him once waltzing her around the restaurant, much to the bemusement of fellow diners. She later returned the compliment by teaching him how to foxtrot, a dance she'd learned while she was a nurse during the war.

'You must have been a good mover in your day, Mrs Sleep,' he'd suggest, with a grin.

'I was a singer, not a dancer,' she'd answer, before giving him a note-perfect rendition of 'Ave Maria' to prove her point. Peter loved it.

Seeing Mum tipsy on wine and giddy with laughter was uncharted territory for me, but it was very refreshing to witness. She looked so happy and carefree. This was in such a contrast to the humdrum existence she led with Stan, of course, back in Plymouth.

To make her home life a little easier, however, I'd started to quietly assist her financially, paying off the odd bill here and there and buying her household appliances. This wasn't a discussion point with Stan – I didn't expect him to kiss my feet with gratitude – but the implication was crystal clear: I was doing this for Mum. My celebrity status had its advantages, including a bit more money in the bank, and I was only too pleased to help her out. I never wanted to lose sight of where I came from and who'd supported me along the way.

While my professional life was motoring, my personal life was stalling. Over time, my relationship with George had begun to falter. We now had separate rooms and different needs – and, rightly or wrongly, I'd begun to seek my pleasures elsewhere. Sex as a main vice, as opposed to drinking and drug-taking, never affected your ability to rehearse and perform (some would argue it is an enhancer). But my encounters were more impromptu than intentional. I had neither the time nor inclination to cruise gay hotspots like Hampstead Heath, Barnes Common or Brompton Cemetery. These green spaces were among the few places where like-minded men could discreetly meet. But you still ran the risk of police raids or skinhead attacks, which scared me to death.

Instead, I might bump into a rather nice-looking person as I walked home to Notting Hill, taking my usual short cut through Holland Park, and engage in a little bit of harmless fun. Or I might be window shopping outside my favourite fashion boutique or antique emporium in Portobello Road and sense the presence of another man beside me. If I liked the look of his reflection in the window and he was giving

off the right signals I would introduce myself and take it from there, and we might have exchanged numbers to meet up in the future.

George had probably got wind that I was playing away. However, when I brought someone home one night (at this point we had agreed to have separate bedrooms) – a world champion ballroom dancer – and this young man was still in my bedroom the following morning, George quite rightly saw red. As far as he was concerned, this was the final straw. I was testing the water to see if George didn't mind, but it had clearly upset him.

'Wayne, we can't go on like this,' he said.

'You're right,' I replied. 'We need to talk.'

After a long heart-to-heart, and without a cross word or a raised voice, we agreed to part as a couple and sell our maisonette. But we pledged to remain the best of friends. We still loved each other dearly and very much enjoyed spending time together, it's just that our relationship had become more platonic. Not only was George my cultural guru – he'd introduced me to the finest art, music and literature – his bone-dry wit made me laugh like nobody else. All it took was a certain word or a funny gesture and I'd collapse into fits of giggles. And while it was sad to bid farewell to my first proper relationship, I knew I'd gained a friend for life.

As luck would have it, George's employers were relocating to new premises at 31 Long Acre, a renovated coach house in the heart of Covent Garden (namechecked in Samuel Pepys's diaries, no less) above which there were two adjoining apartments available to purchase. I immediately snapped one

up, as did George, and in no time, we became next-door neighbours, living a stone's throw away from the Royal Opera House and theatreland. It couldn't have been more perfect. He and I even shared a cute long-haired tabby, Grace, who'd scamper from flat to flat, hopping across our balconies. I'd never had a pet before and I loved having my moggy around the place. To this day, Grace remains immortalised in the metalwork outside the top-floor penthouse flat in Long Acre that George renovated. Look closely and you'll just make out her face and whiskers.

Now that George and I were officially apart, I didn't feel so guilty about the occasional flirtations and dalliances with other men. It was around this time I became more familiar with Stephen Sondheim. The legendary lyricist had given me his New York telephone number at *The Virgin Soldiers* premiere afterparty and, with great chutzpah, I'd decided to call him during a tour of America, back in the early 1970s. I'd very much doubted that he'd remember me but, hey, 'in for a dime, in for a dollar' as they say over there.

'Hello, Stephen? It's Wayne Sleep, from the Royal Ballet. We met in London, at Ned Sherrin's place. I'm performing at the Met right now and I was just wondering if you'd like a ticket?'

'Wayne! How delightful to hear from you! I can't make the show, but if you're free afterwards, come on over for a bite to eat.'

His place on East 48th Street, known as Turtle Bay, in midtown Manhattan, was a majestic four-floor townhouse with fine art on the walls, songbooks on his shelves and – be still my beating heart – a grand piano in a corner, strewn with sheet music bearing scrawled-on lyrics. Stephen (or Steve,

as he preferred to be known) was a delightful person: small-ish in stature – though taller than me, of course – with dark, collar-length hair, twinkly eyes and a gravelly voice. Like many gifted creatives, he was deeply intense and intelligent, with a near-obsessive dedication to his craft. But this gravity was leavened by an endearing modesty and a self-deprecating sense of humour which, in spite of his fame and status, allowed me to feel incredibly relaxed in his company. We had a fine time together, listening to music and talking about our respective lives in London and New York. And then we got to know each other a little better, as they say.

That week, Steve took me out for dinner, too, opting for a tiny trattoria tucked away on a side street rather than Sardi's, the starry theatreland restaurant beloved of Broadway's movers and shakers. All the top directors and producers would congregate there after their first nights, nervously awaiting the early editions of the *New York Times* to gauge whether their show would be praised or panned by Clive Barnes, its ruthless theatre critic. But Steve was quite reclusive in those days – he avoided the limelight and eschewed celebrity – and Sardi's wasn't his kind of place. The director John Dexter would take me there one day, though, and I loved it, particularly the array of starry signed cartoons that lined its walls.

I learned so much about musical theatre during those conversations over dinner. That's what we bonded over, more than anything else. I'd seen every West End production going, from the hits to the flops, and I was so keen to sample that world myself, regardless of the fact that I was a ballet dancer. In America, that fusion between the classical and

the commercial was seen as a wonderful thing; in the UK, sadly, it wasn't.

I could have listened to Steve's recollections and ruminations all night. His insights were fascinating. I remember him explaining that, in his opinion, it was the understanding of a show that remained paramount. For those two hours, your audience's senses are bombarded – lights and movement, colour and costumes, music and lyrics – which means the core narrative has to be strong and has to cut through. No matter how lavish the production or starry the performers, if those paying theatre-goers can't follow the story, you've failed in your duty. Wise words from a class act.

Steve and I kept in touch throughout the seventies. We enjoyed what I'd call a casual relationship – it was more friends-with-benefits than a full-blown relationship – and would meet up once or twice a year, usually to coincide with one of his Broadway or West End premieres. When he came to London, I stayed with him at The Savoy or his rented apartment in Belgrave Square. He asked me to attend a performance of *Company* at Her Majesty's Theatre – I was honoured to sit between Steve and Hal Prince, the legendary producer-director – and afterwards we all dined out at San Lorenzo along with the stars of the show Elaine Stritch and its choreographer, Michael Bennett. I felt quite comfortable in the company of these esteemed people as I chinked my champagne glass to celebrate the success of this magnificent musical. They hadn't all seen me perform but they knew of me. Our respect was definitely mutual.

Back in New York, some time later, Steve gave me a sneak preview of the new score he was working on, *A Little Night*

Music. As he played the beautiful 'Send in the Clowns' on his grand piano, there was a loud thudding on the wall.

'What on earth is that?' I asked.

'It's just Kate, next door, banging her poker,' replied Steve, with a grin. 'She gets in a froth if I play the piano at night.'

That cantankerous next-door neighbour was none other than the legendary Katharine Hepburn.

As the 1980s progressed, a perpetual clash of schedules meant that our meet-ups became few and far between. But I'll forever cherish our time together. And I'll always treasure the collector's item he gave me, a private recording he'd composed for *Evening Primrose*, an American TV drama. On its cover he simply wrote 'Love, Steve.'

When I hit my mid-thirties, I found myself faced with a choice. Should I keep ticking along nicely at the Royal Ballet, despite the feeling that I was stagnating, or – deep breath – should I break out of the Covent Garden cocoon and go it alone, perhaps with a view to producing my own show? Over time, I'd begun to realise that my growing celebrity status might act as an escape route. If I were to branch out on my own – and, crucially, attract the interest of theatres – a high public profile was essential. Only a tiny number of ballet dancers had entered the public consciousness – Rudolf and Margot being the main exemplars – and through my TV work, I'd become a recognisable figure, too. As a senior principal with the Company, however, the idea of performing something other than classical ballet felt like a huge risk. But it was becoming increasingly difficult to ignore my deep desire to explore different sides of my talents and to bring the world of dance to wider society.

Back at my apartment, with Grace curled up on my knee, I mulled over devising my own dance group. A revue-style show, perhaps, with a hat-tip to the music hall, that would celebrate the world of classical, jazz and contemporary dance. A festival of music and movement that could be toured around British towns and cities, taking the medium of dance to a whole new audience. The West End and the Opera House were out of reach for the average Joe and Joanna – for financial or geographical reasons – and I was so keen to break down that barrier. I wanted to popularise dance among people who'd not normally watch it. As a classically trained ballet dancer who'd crossed over to light entertainment, I felt I was perfectly placed.

I'd drawn lots of inspiration from Bette Midler's one-woman cabaret at the London Palladium. A camp and bawdy blend of song, dance and comedy, it featured a cavalcade of outrageous characters in incredible costumes (at one point, she came on stage in a wheelchair, sporting a mermaid costume). The Divine Miss B was at the top of her game and she had the audience in the palm of her hand. And while I wouldn't dare replicate her risqué raunchiness – some jokes weren't remotely suitable for a family audience – she skilfully demonstrated how different disciplines could be worked into one show. I came out of the theatre thinking, *If Bette can do it, so can I* . . .

The more I pondered the idea, the more reasons I found for taking the plunge. It would give me the freedom to perform and express all my different styles and ideas. I wanted to create, invent and innovate. So, using savings of £8,000, I set about building my own show from scratch,

working on ideas for routines that would be short and slick enough to hold everyone's attention. I envisaged a fiesta of the four disciplines of dance – ballet, tap, jazz and modern – all performed to a standard that would dignify any Covent Garden or West End stage. I would pay homage to legendary artistes like Martha Graham and Charlie Chaplin. Finally, I'd add a tongue-in-cheek twist by lampooning the big-name celebrities of the day, from pop singers to sports stars.

My project would be a huge leap into the unknown, of course. Never before had anyone in Britain staged a dance show so varied and diverse. Not only that, I was essentially taking on four roles in one – producer, director, choreographer and performer – with limited-to-no experience in the first two. And I never considered approaching the Arts Council for funding since I knew I'd be turned down: I wasn't planning a fully formed dance company and I fitted neither the classical nor contemporary mould. I had to plough all my savings into the project, therefore, with the hope that decent ticket sales would make it sustainable. I knew that a show devoted solely to dance would be a hard sell. But I felt ready to take the risk – and if it flopped, to take the flak. I had nerves of steel back in those days. Nothing seemed to faze me.

So I set to task. I recruited half a dozen dancers – only the very best passed the audition – as well as a small team of musicians and technicians. As for the all-important brand, I needed something that conveyed energy and effervescence – words often attributed to me, both on and off stage – so I eventually plumped for *Dash*.

'I like that very much,' said George when I told him. 'Very succinct.'

'Unlike your suggestion,' I replied. '"The Wayne Sleep Dance Consort" was never going to trouble the box office, was it?'

George's rather grand strapline graced the programme cover for our first night in Chichester, but it didn't survive much longer than that.

My little *Dash* troupe – just six dancers and four musicians – rehearsed at various venues around central London. This included Pineapple Dance Studios, owned by the model and entrepreneur Debbie Moore, a fabulous woman who would become my lifelong friend. She'd opened up the place in 1979, taking possession of an old Covent Garden fruit warehouse (hence the name). As it was just a stone's throw away from Long Acre, I'd often visit the slick, ultra-modern facilities to rehearse my solos or participate in a jazz, tap or modern class. I clearly remember the day that Dame Ninette De Valois walked over to Pineapple to check out this 'new kid on the block'. Debbie and I found the whole experience extremely unnerving – the great woman's standards were so exacting.

'Well, thank goodness you're providing somewhere for dancers to come after me,' she said, when she saw that former principals of hers were taking classes. 'And your floors are all right, too.'

'You've received the royal seal of approval,' I said to Debbie afterwards.

My friend was hugely supportive in the early days of *Dash*. Aware that I was working on a shoestring, she waived four weeks' worth of studio rental while we rehearsed and also gave me free-of-charge or heavily discounted Pineapple Dance

Studio gear. I gladly took receipt of bags full of tights, legwarmers, leotards and all-in-ones, some of which – with a little help from some costume designer friends – I adapted for performances. My mother's resourcefulness had clearly rubbed off. Without much money to spare, she'd always had a 'make do and mend' philosophy, typified by that bearskin hat she had made for me when I was young, fashioned out of blackout curtains and a toilet chain.

When I felt we had the makings of a half-decent show, I wrote to fifteen theatre producers, crossing my fingers they'd recognise me from the telly and take a punt on this innovative concept. Only two venues came back with a positive response: the Chichester Festival Theatre and the King's Theatre in Edinburgh. But two were better than nothing. It was high time to get my act together.

In the run up to the Chichester premiere, in late 1980, I felt like a circus ringmaster. I had so much to organise and supervise, and, for the first time ever, I was responsible for other performers, not just myself. To create something successful in such a short space of time, I had to put them through the wringer, which didn't always rest easy with me. They'd be absolutely exhausted by the end of the working day. And I grafted so hard that my normal, everyday life became a blur. I was so focused on getting things right and finishing on time that I almost lost my head when I stepped out of the 'zone'. George coined a nickname for me – Wobble – because whenever we met away from work, I'd trip over kerbstones, bump into pedestrians and bang into doors. In restaurants, I'd habitually drop my cutlery and knock over

wine glasses. I used to compare myself to a tightrope walker. While at work I was focused, controlled and determined not to put a foot wrong. Then, when my task was achieved, I became hyper-relaxed and jelly-legged, allowing myself to flop mentally and physically.

The first incarnation of *Dash* was quite basic – inevitably so, with such a low budget – but I prayed we had enough on-stage oomph to entertain the paying public. Ticket sales had gone fairly well, with the theatre expecting a good crowd (including a busload of Pintos from Plymouth). Also in attendance would be *The Times* ballet critic John Percival, an authority on dance, which only exacerbated my first night nerves. This particular journalist had reviewed me for years, sometimes negatively (his 'too small for Petrushka' comment still rankled), and, in truth, I was dreading how he'd perceive *Dash*. Imagining him penning words like 'low-brow' and 'downmarket' kept me awake at night.

All things considered, the premiere of my shoestring show went better than expected. The *Dash* cast brought its A-game to the stage and the Chichester audience was treated to a two-hour festival of dance interwoven with music and comedy. The opening act symbolised the whole ethos of the show: four dance disciplines under one roof. Four cupboards stood on a pitch black stage with their bottom doors opening to reveal four pairs of illuminated feet dancing in a line. The first pair wore ballet shoes, the second pair jazz sneakers, the third pair tap shoes and the fourth with bare feet, in the contemporary style. Then the middle doors revealed four shimmying torsos – in a tutu, a jazzy frock, a pair of Gene Kelly slacks and a Lycra bodysuit – and the top doors revealed

our bobbing heads and shoulders, sporting apt hats and hairstyles. I would then knock on all the doors and bring them out of their respective closets.

The rest of the show included a send-up of ballroom dancers, a Charlie Chaplin tribute, pastiches of skater John Curry and Wimbledon favourite John 'you cannot be serious' McEnroe. The latter saw me angrily waving a tennis racket at an imaginary umpire before tap dancing my way through a tennis match. For the grand finale, I laid on an uplifting rock 'n' roll number in which the cast let ourselves loose, did our own thing and got the audience clapping along. A minute before the end, however, I came onto the stage wearing a spangly Bette Midler-style outfit (teamed with high heels, a blonde wig and tassels on my bra) as a mini-tribute to my major inspiration. The standing ovation that we received at the curtain call spoke volumes. My project had promise. We started the week with a small audience, which grew and grew as the week went on. Word had clearly got around, and we had a full house for the final shows. *Dash* had legs.

The following morning, I received a knock on my hotel room door. It was George, who'd reserved the adjoining room, bearing a copy of *The Times*. Inside its arts section was one of the best reviews I'd ever received.

'Dash's reliance on flair rather than spectacle must be an asset,' wrote John Percival, who went on to compare it with Bob Fosse's famous *Dancin'*, saying it was 'consistently more enjoyable than its transatlantic big brother.'

I read it and burst into tears. I don't think I'd cried like that since 1954, when I'd cut my face with Grandad's razor.

'George, we need to celebrate,' I said, between sobs. 'Let's order a champagne breakfast.'

'Well, I can sort the bacon and eggs, Wayne, but the drink might be a problem,' he replied, rather sheepishly. 'I'm afraid we are staying in a temperance hotel.'

Unbeknown to George, for the entirety of our Chichester run – one whole week – he'd booked us into a place owned by devout Methodists who didn't drink or serve alcohol. Oh dear. We ended up toasting my good news over a nice pot of Typhoo.

Percival's review proved to be pivotal. On the strength of his endorsement, a dozen or so theatre producers made contact with me, from Bristol to Bradford, all wanting a piece of the action. A grand tour of the UK was chalked up, and between 1980 and 1981 Wayne Sleep's *Dash* would go on to play to a succession of full houses, receiving standing ovations and rave reviews wherever it went. And it attracted a whole new audience of new dance fans, including plenty of men. Seeing them sitting in the stalls thrilled me to bits because I'd always wanted to create a show that appealed to husbands as well as wives. The closest many of them got to theatres was doing the drop-offs and pick-ups. But it was my decision to perform short, sharp, sports-related comedy routines that finally got the men out of their cars. Seeing me fooling around with footballs, racquets and snooker cues made dance so much more relatable. Looking back, it was a masterstroke on my part.

I'd actually end up staging different incarnations of the show for over a decade (in between stints at the Opera House and elsewhere), directing an ever-growing and hugely talented

company that increased to twelve dancers plus eight musicians and four singers. Bringing *Dash* to London meant the world to me, with triumphant West End runs at the Dominion, Sadler's Wells and the Apollo Victoria. We were booked for an eight-week occupancy at the latter – a theatre seating 3,000 people – and, such was the show's popularity, had to extend our stint by two weeks.

And while it was great to have my name up in lights in my adopted city, it was wonderful to perform in my birthplace, too. During one *Dash* matinee in Plymouth, while I was performing a routine dressed as a little kid crying 'I want my mummy', my own mother ran onto the stage and promptly shoved a dummy in my mouth. The look of shock on my face must have been a picture. I had no idea this was happening. The cast had been in cahoots with my family, the bunch of rascals, and had provided the show with a moment of comedy gold.

Among the Plymouth audience one night was Beryl Cook, the famed artist, who loved the show so much that the next evening she presented me with a special portrait. It depicted Beryl en pointe in an arabesque, supported by a slightly porky version of me, with an exceedingly big bottom. The painting was so brilliant that I obtained her permission to use it for some *Dash* publicity posters.

Having friends in high (artistic) places had its benefits. For a subsequent *Dash* tour, David Hockney allowed me to use one of his designs for posters and programmes. An abstract of two Harlequin-type figures dancing pencilled in primary colours, it had been created for a front-drop for a charity gala I'd organised with Anya Sainsbury, *A Good Night's*

Sleep, at which I'd wanted showgoers to see a fine work of art instead of a drab velvet curtain. David would only lend his name to projects that he truly believed in. He fiercely protected his reputation and turned down more requests than he accepted, even some from good friends.

'I've never asked you to do anything for me before, David,' I'd said to him, 'but would you just do a little sketch for a front-drop?'

'Oh, go on, then,' he'd replied, with a customary chuckle.

Thankfully, he gave me the nod for the *Dash* posters too because he loved the premise and intention of my show. Bringing art to the masses was our *raison d'être*.

Dash went global, too, with overseas tours in Europe and the Far East, which involved the transportation of 400 stage lights, 250 pairs of dancing shoes and a variety of wigs in two 60-foot trucks. Much of the money we made from ticket sales was ploughed straight back into the business. That was always going to be the case, since lining my pockets had never been my primary motivation. After covering wages, staging, logistics and advertising, there was no million-pound bounty left for me, but certainly enough for nice meals, nice holidays and nice things for the flat. And nice cars that I didn't actually drive.

Dash even inspired a primetime TV programme. First aired in 1983, the *Hot Shoe Show* was a medley of every dance genre you could imagine set to fabulous music and performed by a brilliant ensemble that included me, Bonnie Langford, Cherry Gillespie and Claud-Paul Henry, alongside a host of Royal Ballet guest artists. I directed some of the choreography along with Arlene Philips, who'd already had great success with her Hot Gossip dance troupe. The show's format was perfect for BBC1's

light entertainment offering, and attracted eight million viewers whenever it aired. All this exposure probably helped me bag the 1984 Variety Club of Great Britain's Showbusiness Personality of the Year award, the first ever dancer to do so.

With my star very much in the ascendancy, I received a lovely letter from Dame Ninette De Valois, delightedly informing me I was 'the most well-known dancer in Great Britain' and telling me that if she could have created her own honorary award, she'd have given the first one to me, bless her. Royal Ballet legend Dame Alicia Markova also sent me a note, congratulating me 'with great admiration'. They were among the few ballet luminaries who could relate to my West End success because, before the days of ballet companies, they too had had to 'go commercial' to survive, in pantos and end-of-pier shows. Among their ranks was Sir Frederick Ashton, who himself had performed in revues long before he'd performed in ballet: a Spanish flamenco one night, a Fred Astaire tap routine the next. He'd kept such dances in his memory bank and they influenced his unique choreography within the classical sphere.

One evening, Sir Fred, accompanied by Natalia Makarova, came along to the Apollo Victoria to see me in *Dash*. Afterwards, when I met him for dinner, he said something so profound that it almost knocked me sideways.

'I always weep when I see you on stage, Wayne,' he told me, his use of my first name, after all these years, indicative of our progression from the master-apprentice dynamic. 'I don't know why it is I get so emotional. Maybe it's because I know how hard you've worked to get here.'

CHAPTER NINE
'Fly, Miss Sleep, Fly . . .'

ONE OF THE perks of living and working in Covent Garden was having musical theatre right on my doorstep. If some last minute half-priced tickets became available, I was able to get there in two minutes, and would be at the front of the queue, whether it was *Chicago* at the Cambridge Theatre or *A Chorus Line* at the Theatre Royal. Failing that, I'd happily pay full whack for the latest on-stage sensation, splashing out on the best seats in the house in order to immerse myself in the whole experience, from curtain up to curtain call. And it must be said that so many of those seventies and eighties box office hits – *Evita, Jesus Christ Superstar, Joseph and His Technicolour Dreamcoat* – were masterminded by a certain Andrew Lloyd Webber.

Partnered by his lyricist, Tim Rice – and aided by the crème de la crème of performers, choreographers and designers – this composer-cum-producer helped to put British musicals back on the map. Until then, the market had been cornered by the Americans (none more so than a certain Mr Sondheim), who specialised in slick and stylish spectaculars that were exported all over the world. But by combining vivid melodies with riveting stories – and enlivening them

with dance – Lloyd Webber's 'rock operas' soon rivalled anything staged on Broadway.

Like me, he was the product of a classical institution yet had successfully crossed over to the world of popular culture. I was surprised, therefore, when in autumn 1980 – and completely out of the blue – the man himself invited me to dinner at his place. I was on a publicity drive for my own show, *Dash*, and assumed that Andrew was looking to pick my brains about dancers and choreographers. He suggested I bring a guest – his wife, Sarah, would be there, too – so I opted for George as my plus one. Despite our separation, my ex-partner and I remained very close and still enjoyed each other's company.

Considering his fame and fortune, Andrew was a refreshingly down-to-earth individual. But beneath all the bonhomie, I sensed a steely grit and determination: the hallmarks of any successful entrepreneur. As we tucked into our meal, our host explained he was working on a new dance-orientated musical based on T. S. Eliot's *Old Possum's Book of Practical Cats*, one of his favourite childhood reads. I wasn't familiar with the work but George, as to be expected, was more acquainted than I.

'So do you have any Eliot in your bookshop?' asked Andrew.

'You could say that,' replied George. 'Valerie, his widow, comes in to sell me his first editions and then I'll treat her to beef carpaccio at San Lorenzo.'

His deadpan delivery made us laugh and broke the ice – good old George. Andrew then quizzed me about a few choreographers I'd worked with, as I'd thought he would. Then he got up from the table and sidled over to his grand piano.

'Let me give you a sense of the music I'm writing,' he said,

striking up the opening chords to a song I'd later recognise as the 'The Old Gumbie Cat'. 'In fact, Wayne, why don't you come over here and sing while I play?'

And that's when the penny dropped. This wasn't just dinner; this was an audition. I immediately regretted quaffing half a bottle of Châteauneuf du Pape. But I did what he asked and duly sat beside him, squinting at the sheet music and warbling along as best I could. Maybe I'd be able to channel just a scintilla of my mother's talent.

Sarah came running in from the kitchen, cheeseboard in hand.

'Goodness me, Wayne, I didn't know you could sing!' she said.

'Neither did I!' I replied, laughing.

A few months later, I found myself appearing in Lloyd Webber's *Cats*, the longest-running Lloyd Webber musical of all. I was cast as two characters: Quaxo in the first act and the Magical Mr Mistoffelees in the second – the latter being a cocksure cat with conjuring powers. I'd been working with director Trevor Nunn – of Royal Shakespeare Company renown – and Gillian Lynne, one of the best choreographers in the country, who I knew from the Royal Ballet. Renowned designer and costumier John Napier had come on board, too. The show's cast included Brian Blessed, Judi Dench and Paul Nicholas – a triumvirate of stage legends – as well as Sarah Brightman and Bonnie Langford, who were both gifted all-rounders.

Conceptually, *Cats* was an oddity – an entire musical based upon a whimsical book of poetry – and, at first, I could make neither head nor tail of it. When rehearsals began, many of the cast struggled to master the libretto and grasp the plot

(there didn't appear to be one, in all honesty). Not only were the complex lyrics difficult to sing clearly, but the scoring was constantly being adapted – the ink was barely dry on one sheet of music before another version was rewritten.

The dancers among us were slightly flummoxed by Trevor Nunn's workshops – we found the feline-themed improvisation a bit odd and unfamiliar – and, conversely, a couple of our resident thespians battled to keep pace with Gillian Lynne's movement sessions.

And then – calamity! – Judi suffered a terrible injury. We'd been rehearsing the steps to the Gumbie Cat routine together when she suddenly yelped in pain and clutched the back of her ankle.

'Wayne, did you just kick me?' she asked, her face contorted in pain.

'No, no, I didn't,' I replied, aghast, before guiding her to a chair.

An ambulance arrived to take Judi to hospital, where she was diagnosed with a ruptured Achilles tendon. It was impossible for her to continue – she'd be out of action for weeks. Judi tried to see if the role would be workable, but the difficult to navigate set would have proved impossible with a cast – so Elaine Paige, fresh from her show-stopping stint as Eva Peron in *Evita*, stepped into the role as Grizabella, the Glamour Cat. I'll never forget the first time I heard Elaine rehearse 'Memory' while Andrew accompanied her on piano. She sang it with such purity and poignancy that I and the rest of the cast were snivelling wrecks by the outro.

Elaine was as effervescent off stage as she was on it – she loved a giggle and a gossip – and she and I became very good

friends. Indeed, she was one of the first people to congratulate me when I received my OBE, almost two decades later.

'Many congratulations on your long overdue gong,' she wrote on her personalised notepaper. 'They gotcha!'

The run-up to our opening night wasn't straightforward, inside or outside the rehearsal studio. After signing programmes on the first night, on the back page I saw a photograph proclaiming '9 out of 10 Cats prefer Whiskas', with six members of the cast, including myself. We hadn't been informed that our images were being used for advertising cat food, and a meeting was called. I think I had become a little unpopular with the producers: but years of witnessing Rudolf Nureyev's hard-nosed attitude had rubbed off on me. Back at the Opera House, whenever things hadn't been to his liking (usually during rehearsals), he'd always exploded like a powder keg.

'Move out of my f***ing way!' I remember him once snarling at me.

'Rudi, why don't you use proper English, instead of that dirty slang,' I'd said to him at the time. 'Why don't you ask me politely?'

'Wayne, I learn to speak your language. I learn to say please and thank you, but where does it get me? Nowhere! When I use these words, people move their f***ing asses!'

'OK, fair enough . . .'

But there were some lighter moments, too. As the *Cats* first night drew closer, some cast members half-jokingly discussed whether we should invest money into the show.

'Hey, Wayne, d'you fancy putting your hand in your pocket?'

smiled my co-star Paul Nicholas one day, as he enjoyed a cuppa in my dressing room.

'Not likely,' I giggled, mindful of our patchy rehearsals. 'I've spent all my money on *Dash*.'

Of course, looking back, I wish I had been able to find the money. The West End production famously ended up running for over twenty years, playing to sell-out audiences and grossing millions along the way. Had I chosen to invest, I'd now be spending the rest of my days aboard a luxury yacht in the Bahamas, living on a diet of lobster Thermidor and Dom Pérignon.

Eventually, though, our *Cats* rehearsals began to make sense – helped by Trevor and Gillian holding rehearsals together, in harmony – and this quirky musical about glorious pasts and hopeless futures, with its junkyard set and vibrant costumes, began to come together. Dress rehearsals can be so subjective when you're at the coalface; it's hard to gauge if you're about to star in a smash hit or a dead duck. But the first *Cats* previews seemed to go down well with the audience, as did the opening night at the New London Theatre in 1981. It was an out-and-out triumph, in fact – I lost count of the standing ovations – and this despite a bomb scare that had temporarily evacuated the auditorium. Some accused the hierarchy of deliberately engineering this to gain publicity – total balderdash – and it turned out we didn't need the additional PR anyway. *Cats* soon became the hottest ticket in town, with Hollywood royalty like Shirley MacLaine, Barbra Streisand, Paul Newman and his wife Joanne Woodward all clamouring for VIP seats. And guess whose lap I chose to nuzzle in during Mr Mistoffelees's nightly prowl into the front row? Newman's,

of course. Staring up at those famous ice-blue eyes as they crinkled with laughter was just heavenly. Studying my pet cat Grace's feline traits back home at Long Acre – the purring, the pawing, the mewing – had come in very useful indeed.

My heroine Bette Midler even came to see us backstage – she was just as sexy and sassy as I'd hoped – as did the great Ginger Rogers, by then in her seventies and sporting a copper-coloured crop and a face full of freckles. Having given me a standing ovation following my solo (the only person to do so, not that I was complaining), Ginger met me in the green room. I couldn't resist the opportunity to ask her for a dance. 'Well certainly,' she replied. We joined arms and improvised a little waltz while chatting about her famous partnership with Fred Astaire.

'I should have been paid more than Fred, you know,' she said, arching an eyebrow.

'Why was that, Miss Rogers?'

'I had to do all his steps, darling, but backwards and in heels,' she quipped. What a woman.

In early 1982, however, after a nine-month stint (not missing a single performance), I became the first original cast member to leave the Company. I felt very proud to have created the role of Mr Mistoffelees but I felt it was time to go. The punishing eight shows per week schedule was draining in any case – it felt like I was on a treadmill – and I needed to devote more time and energy to my own endeavour, *Dash*. Andrew, his producer Cameron Mackintosh and I remained on good terms, fortunately, and I would go on to work with Andrew again very soon.

I left *Cats* with a clutch of fond memories, however – not least the aftermath of our matinee performance on 28 October 1981.

I'd been feeling somewhat down in the dumps that day, so hadn't been impressed to learn that Thames TV were filming the finale of our matinee performance for a documentary. I almost had to be dragged to the curtain call by Elaine and Bonnie, the latter of whom smoothed down my hair and rubbed some stray mascara off my face, which I found a little odd. Then, to my surprise, a tall figure carrying a big red book strode across the back of the stage before pausing behind me. The audience suddenly went crazy, clapping and whooping. When I turned around to see what all the fuss was about, I could hardly believe my eyes.

'Wayne Sleep . . . this is your life,' said Eamonn Andrews.

'But I've not lived it yet!' came my shocked reply.

Within hours of Eamonn's ambush, I found myself sitting in a Thames TV studio wearing my favourite blue satin Antony Price suit (which George had had specially dry cleaned, having been secretly involved in this sting for weeks). I then witnessed a cavalcade of friends, family and colleagues paying tribute to my life and my career. My mother, sitting alongside Stan, George and a busload of aunties and uncles, described my journey from Muriel Carr's to the Royal Ballet. Angela Lansbury, speaking from a Hollywood poolside, congratulated me on my success and recalled the time we worked together on *Death on the Nile*. And my great friend Dame Ninette De Valois explained how I'd excelled as both a student and a performer.

'In my opinion, Wayne is the greatest virtuoso dancer the Royal Ballet has ever produced,' she said, which is possibly the highest compliment I've ever received. Her words choked me up then and they still choke me up now.

My other beloved dame, Margot Fonteyn, filmed a sweet message from Panama, where she now lived with her husband Roberto, having finally retired from ballet in 1979 at the age of sixty.

'So sorry for not being able to join you, dear Wayne,' she said, before describing how much she admired my grit and determination, remembering the time I refused to quit a performance of Gilbert and Sullivan's *HMS Pinafore* despite feeling terribly ill and throwing up in the wings.

But it transpired that Dame Margot was in on the act, too, because – lo and behold – it was she who swanned through the big door as the show's time-honoured star guest, having secretly flown in from Central America to share my special night. What a privilege to count this cultural icon as a friend. Indeed, the whole *This Is Your Life* experience filled me with immense pride. Receiving recognition from my mentors and my loved ones meant the world to me.

When having a drink together after the recording, I overheard a conversation between Madam and Margot.

'Hasn't Wayne done well?' said the latter.

'Yes, and what's wonderful, Margot, is that Wayne did it all by himself.'

Song and Dance became Andrew Lloyd Webber's next project, post *Cats*, and I confess to having a little hand in the whole concept. Sometime in 1981, I'd had a meeting with him about the possibility of using a piece for the second half of *Dash*, namely 'Variations', based on Paganini's original theme for violin, that he'd composed for his cellist brother, Julian.

'Goodness me, Wayne,' he exclaimed, 'you might just have done me a huge favour.'

'Really?' I replied, intrigued.

He revealed he'd been struggling to adapt his album *Tell Me on a Sunday* into a two-act musical. Despite being co-written by the brilliant Don Black, and performed by the equally brilliant Marti Webb. On the strength of our conversation, however, he resolved to fuse both concepts (one act of dance and one act of singing) together to create an innovative 'concert for the theatre'. Cameron Mackintosh bought into the idea with gusto.

So *Song and Dance* was born, telling the story of an English woman, Emma, who'd travelled to America in search of love. He very kindly acknowledged my contribution in the show's programme, penning something about me being 'irritatingly right about everything'. Generosity was one of Andrew's many attributes; he wasn't afraid to give credit where it was due.

A fine ensemble of classical, contemporary and jazz dancers was assembled for Act Two – choreographed by Anthony Van Laast – and rehearsals began. I had to learn to tap dance in the American style – a lot more loose and relaxed than its comparatively sprightly English counterpart – but, with the help of a fabulous coach, Anne Emery, I mastered it in a matter of weeks. But my favourite sequence in the show – full of zestful leaps, spins and high kicks – was set to Andrew's classical-rock interpretation of Paganini's 'Caprice No. 24', which would later be memorably used as the theme to *The South Bank Show*.

This routine became an immediate hit with the audience

when *Song and Dance* opened in April 1982. The show itself, however, received mixed reviews from the critics – some found the two-act format a little jarring – but the overwhelmingly positive response from theatre-goers told a wholly different story. The finale was an exuberant rock 'n' roll number that brought Marti and me together and, without fail, got everyone out of their seats, clapping wildly to the music. We were performing for the public, not the critics.

As I had other commitments, my contract was for six months, but each time the cast changed I returned to dance in the first two weeks of the production. Once, I even reported for duty within hours of major dental surgery. I performed with my cheeks packed with cotton wool to stem the bleeding, while my dentist waited nervously in the wings just in case any vigorous pirouetting burst my stitches. My face was so swollen I even asked the make-up artist to shade in some cheekbones and draw a false jawline with a kohl pencil.

My contract stipulated that I had to be among the *Song and Dance* cast if it were to transfer to America. Sadly, this didn't happen. Frank Rich, the prominent New York theatre critic, had reviewed the London show and commented that I'd outranked the choreography in ten minutes. As a consequence, the Broadway production team decided to employ a new choreographer, thus rendering my contract invalid since it wasn't technically the same production. I was heartbroken to miss out, especially since my co-star would have been the great diva Bernadette Peters. Ironically, I received a good first-night review from Rich despite not even being there: 'If Bernadette Peters and Wayne Sleep had met

mid-Atlantic on first night, this would have been a sure-fire success,' he wrote.

I regret not being able to have performed with Miss Peters, we would have made a brilliant pairing (she said so herself when we met a few years later), though I tried not to dwell on this lost opportunity. But I do remember wondering at the time if my height had also been a factor. I knew that many directors just didn't think I 'looked right' on stage. It was their loss. I just had to shrug my shoulders and move on.

While I wasn't able to cross the Atlantic, I was delighted to join the cast of *Song and Dance* when it crossed the border into Scotland, as part of its UK and European tour. Not only did I love the country, it also meant that George – an Edinburgh native – would likely accompany me, as he always relished the opportunity to visit his family. It could sometimes get lonely on tour, and I knew I'd enjoy my best friend's company. Sadly, however, it was while staying in George's birthplace that I suffered a vicious assault – the very last thing I expected to happen in this genteel old city.

I'd been heading back to my rented apartment after a Saturday evening performance and had noticed two couples, probably in their twenties, loitering on the other side of the street.

'Here, there's that dancer, come over here you poof,' slurred one of the blokes, who'd probably had a whisky or three. 'Go on then, give us a twirl.'

When I shook my head and quickened my pace he hurled a barrage of homophobic abuse. Fairy. Gay-boy. Nancy. Faggot. A whole thesaurus-worth.

Instead of ignoring him and taking the sensible option, I replied as I might have done to a school bully at Baltic Street Juniors, circa 1957.

'Come here and say that!' I yelled.

Unsurprisingly, he did.

'You've got thirty seconds to run, you dirty little queer,' he said, charging across the road.

'I don't run for anybody,' I retorted – what was I thinking? – adding 'I thought you said I had thirty sec—' when I sensed his footsteps pounding behind me.

Before I could reach the end of the sentence, I was pushed against a solid stone wall and headbutted. As I reeled in shock, I was punched twice in the face with such brute force that I collapsed in a heap on the pavement. Then, one of the girls aimed a flurry of kicks to my ribs, hooting with laughter as she did so. I remember catching sight of her cheap stilettos, freshly whitened with that awful powdery Meltonian fluid. It's funny what you notice when you're getting your head smashed in.

I lay still, playing dead, until my assailants gave up and left. Clinging to the wall, I managed to drag myself upright, my primary concern being for my vintage Ossie Clark jacket, which was now smudged with Meltonian.

Damn, that'll need a good dry clean, I thought to myself.

Then, as I gingerly touched my throbbing face, I realised my nose was gushing with blood. The crisp white shirt I'd changed into after the show was turning scarlet. In a very weird way – I blame the concussion – I stood there for a moment, illuminated by a Victorian streetlamp, revelling in the pure theatre of it all. The grim reality of this hate crime had yet to sink in.

I staggered over to a phone box and called 999. A few minutes later, a police car drew up and a couple of officers gestured for me to climb into the back seat. I gave them the relevant details and descriptions as best I could – including the homophobic nature of the attack, which many would have called 'gay bashing' back then – and assumed they'd then drop me off at a nearby A&E. Not likely. They planned to drive me around the streets and alleys of Edinburgh city centre, they said, so I could try to spot the perpetrators. I was horrified at the very prospect – I never wanted to see those thugs again for the rest of my life – so I said, 'Excuse me, I'm bleeding to death. I don't want to go out; I want to go home.' They looked at me like I was a piece of filth.

'What d'you think we are, a f***ing taxi service?' said one.

'Get out, now,' snarled the other, manhandling me out of the car. Then they sped off into the night, leaving me stranded.

Not an ounce of sympathy or support. It almost felt like I'd been assaulted a second time. Thank goodness the vast majority of hate crimes are treated with more care and compassion by the emergency services nowadays.

I somehow found my way to the Caledonian Hotel, where George was staying. Initially, the night porter didn't recognise me and had to call up to George's room. George was horrified to see the state I was in – my face and torso were caked in blood – and was heartbroken that his fellow citizens could commit such violence. By then it was the early hours, and I was too exhausted to queue up in A&E, so he cleaned me up and lay me down in the twin bed next to his.

The next morning, I underwent an X-ray at Edinburgh Royal Infirmary – followed by a later procedure to click my

nose joint back into place – and was sent away with a jar full of painkillers. But despite all the trauma, I was back on stage the following night. For me, there was no better analgesic.

My West End success brought me into contact with a Who's Who of fellow celebrities, who'd either introduce themselves at aftershow receptions or visit me in my dressing room. This included the late, great Freddie Mercury. I first became aware of this unique individual on Christmas Eve 1975, while staying at my parents' house in Plymouth. I was watching late-night television – Mum, Stan and Joanne had gone to bed – when *The Old Grey Whistle Test* came on. BBC2's flag-ship music show was broadcasting a live concert from the Hammersmith Odeon, featuring the rock group Queen. Being so busy at Covent Garden, I'd hardly noticed the meteoric rise of this four-piece from London whose new single, the mock-operatic 'Bohemian Rhapsody', had just claimed the prestigious Christmas number one.

My jaw almost hit the Axminster carpet when Freddie swept onto the stage. Wearing skin-tight white trousers teamed with a white puff-sleeved jacket cut to the navel, exposing his hairy chest, he looked sensational. And judging by his high heels, pink lips and long black hair, he was happy to flaunt his feminine side, following in the great tradition of Mick Jagger and David Bowie. The band launched into its first number, 'Now I'm Here', prompting Freddie to unleash his amazing octave-climbing voice. But it was his movement that made me edge closer to the television. The way he stuck out his chest and strutted around the stage, like a preening peacock. The way he sculpted his body into arcs and lines,

courtesy of an outstretched arm or a pointed foot. The way he posed and postured before his adoring fans, every gesture oozing drama and grandiosity.

As I watched, mesmerised, it suddenly struck me who Freddie reminded me of. He had the same swagger and bravado as Rudolf Nureyev in his pomp. My Russian comrade would have the Opera House audience rapt, commanding their attention just by stepping into the spotlight before a single chord was struck. Everyone in those seats knew they were about to witness something unique and unforgettable. I guessed the Christmas Eve concert-goers in the Hammersmith Odeon felt the same.

This man's got presence, I thought to myself, as I watched him hold his microphone stand aloft with his legs apart, forming a perfect letter X. *With some proper training, he could make a decent dancer . . .*

I wasn't far off the mark. Fast-forward four years and Freddie was centre stage as a surprise act in a charity gala, performing a one-off ballet to 'Bohemian Rhapsody'. I was on the bill, too, providing the finale. Freddie had nurtured a long-time ambition to dance before an audience, it seemed, and had gratefully accepted the invitation to do so at the Coliseum.

Choreographed by my friend and colleague Wayne Eagling and accompanied by our corps de ballet, Freddie's dance dreams were realised in spectacular fashion that night. The Opera House had never seen anything like this fusion of ballet and heavy rock, starring one of the most famous and flamboyant vocalists in the world. I watched from the wings as Freddie sang beautifully and moved effortlessly – his lifts

were terrific – while looking lean and lithe in a sequinned silver catsuit. We bumped into each other very briefly backstage, where I told him how brilliantly he'd performed.

The compliment was returned in the spring of 1982 at London's Palace Theatre, when I was starring in *Song and Dance*. Freddie was at the height of his fame – Queen's *Greatest Hits* album had just been released – when he turned up unannounced in my dressing room to congratulate me on my performance.

'Darling, you were wonderful!' he proclaimed, flashing a moustachioed smile, and would later whisk me off to dinner at the Bluebird Café – an exclusive Art Deco restaurant on the King's Road – with his best friend Peter Straker. There, we chatted ten to the dozen, like we'd known each other for years, and I found myself warming immediately to Freddie's sweet nature and self-effacing sense of humour. Surprisingly softly spoken, he came across as an incredibly clever, cultured and well-read individual. We had so much to talk about, and none more so than our shared passion for live performance. I told Freddie how his on-stage presence reminded me of Nureyev (he was tickled pink by that, being a huge fan of Rudi) and he quizzed me about the rigours of classical ballet. He, more than anyone, appreciated how much dedication and discipline were required to reach the top of your game.

We also had a laugh about my recent ill-fated foray into the music world. While starring in *Cats*, I'd fancied my chances as a pop star, recording a New Wave number called 'Man to Man'. Written and produced by Keith Chegwin's twin brother, Jeff, its sparse lyrics and electro beats were intended to symbolise life in a futuristic, apocalyptic wasteland.

But the end result was so dismal, in my opinion, that I cancelled its release.

'No need to give up the day job, Freddie,' I grinned.

'You stick to your fabulous dancing, darling,' came his reply.

To this day, I still have thousands of signed discs piled up in my attic (it's a synth-pop collector's item, I'm told). And it's only now I realise the irony of a closeted gay man recording a song called 'Man to Man' and posing for a butch, leather-clad photo on the cover sleeve.

I'm sure Freddie was aware I was gay and vice versa (or bisexual in Freddie's case, perhaps, since he'd had a long-term relationship with a lovely woman, Mary Austin) but it wasn't a subject we talked about. Few people in my friendship circle did, to be honest; there just wasn't the same candour and openness that exists these days. But I got the distinct impression that, like me, he was very comfortable with his sexuality behind closed doors, even though in public he preferred not to fully disclose this very private, personal matter. It would have been worse for Freddie, as a pop idol with thousands of female fans, than for me, as in the ballet world people presumed I was gay.

Having hit it off at the Bluebird Café, Freddie and I became close pals, and he'd often invite me to join his small circle of friends for nights out in London. They included his chauffeur, his friend Peter Straker and his dresser-cum-personal assistant, Peter Freestone, who Freddie poached from me, the cad. He'd met Peter many times in my dressing room and would watch, fascinated, as he deftly shoehorned me in and out of my costumes, and diligently attended to my control freakery (like sticking my tights to my ballet shoes with Bostik so they didn't slip – the only failsafe method). Freddie invited Peter

to join us for dinner one night and, lo and behold, within days, my colleague had jumped ship.

'You stole my dresser!' I screeched the next time I saw Freddie.

'Well, if you're going to steal, darling, you may as well steal from the best,' he replied, with a twinkle in his eye.

Gadding about London with Freddie's crew was such a treat. We'd all have dinner at San Lorenzo before heading over to the Embassy Club on Bond Street or Heaven in Charing Cross. In the early 1980s, the latter had become the club du jour for partygoers.

When I waltzed through Heaven's doors for the first time, I felt part of a cultural revolution. The club was glam, glitzy and unashamedly gay. Finally, after years of being treated like outcasts, there was a mainstream venue designed for people like us. A place where you could feel safe and secure without any fear of a police raid or a paparazzi ambush. I remember gasping with excitement at my first sighting of 2,000 gay men under the same roof, together in harmony.

I can't say I was a regular visitor to Heaven – I much preferred dining to clubbing – but when I did, I had lots of fun. Paradoxically, though, I tended to stay away from the dance floor. If I was to go to straight nightclubs, I'd invariably find myself surrounded by a circle of clapping guys and gals, urging me to strut my stuff. If I didn't, and tried to dance 'normally' and blend in with the crowd, I'd be accused of being a spoilsport. If I did, and obliged with a few high kicks and pirouettes, I'd be accused of being a show-off (that particular barb, levelled at me in childhood from aunties and teachers, still stung). I couldn't win either way.

Unlike other rock stars, Freddie was no hell-raising attention

seeker; he was a caring, well-mannered gentleman who was generous to a T. When we visited bars and restaurants he behaved with decency and decorum – the very last person you'd find having a food fight or doing a striptease on a table (I'd certainly been guilty of the latter at Langan's). My friend preferred to keep a low profile at Heaven and liked to be treated like a regular club-goer, without any red carpets or VIP cordons. But we, his trusted circle, would form a protective ring around him to repel any hangers-on or autograph hunters, the only exceptions being any handsome hunks who caught Freddie's eye (Heaven certainly boasted plenty of them). He'd then send over his chauffeur to invite them to join our party for cocktails. I can't remember anyone declining. Sometimes I'd feel like a king's courtier (Freddie was showbiz royalty, after all) but I had no issue with it. I was rather in awe of him, if truth be told.

Occasionally, we'd enjoy some after-hours revelries at Freddie's mansion in Earl's Court, where he'd relax and let his hair down with his closest friends, away from the public gaze. Freddie would often ask me to perform my party piece, namely leaping balletically across his sitting room and landing squarely into someone's lap, often his own.

'Fly, Miss Sleep, fly!' he'd shriek as I soared over, before dissolving into fits of laughter. 'Miss Sleep' was his camp nickname for me; he very rarely called me Wayne. I'd often address him as 'Melina' (after Melina Mercouri, a Greek singer) and our pet names for Elton John and his manager, John Reid, were 'Sharon' and 'Beryl' respectively. Rod Stewart was 'Phyllis', if memory serves. It was all good fun.

Freddie had a decidedly mischievous streak. One evening, after a long and boozy dinner in Knightsbridge, he was

travelling in his chauffeured Rolls Royce while the dancer Wayne Eagling and I followed in the car behind. The Rolls came to a sudden halt outside the department store's grand entrance, whereupon Freddie flung open the car door and leaped out onto the pavement. He then beckoned me to join him, producing a tiny white envelope from his pocket. I had no idea what was going on.

'Miss Sleep, Miss Sleep, I know you're not much into this,' he grinned, 'but I demand that you have your first line of cocaine outside Harrods.'

In front of that famous bottle-green façade, he expertly cut the powder with a credit card before inviting me to take a snort. Which I did – very quickly, before any police cars passed by – while Freddie squealed with laughter, the naughty boy. The drug didn't have a massive effect on me, in truth, and I'm glad to say that I didn't develop a taste for it, unlike many of my pals in the entertainment world. I always preferred champagne to Charlie.

I had some rather more serene moments with Freddie, too, including a magical evening I spent with him at home in Earl's Court in the mid-1980s. There, in the luxurious surroundings of his living room, we sat together at his grand piano, upon which he'd composed 'Bohemian Rhapsody', among other Queen classics. For the next hour or so I received a personal, one-to-one insight into his genius. It's only now, as I look back, that I realise what a privilege that was.

'So this is how I do it,' he said with a smile, his long, delicate fingers dancing across the keys. 'I start with one note, or one chord, and I test how far I can take it. I like to go to extremes, to shock and surprise . . .'

Freddie would then delve into his extensive video cassette collection before selecting arias from different operas – knowing that, like him, I was a devotee. Covent Garden had been my second home for over two decades, of course, so I'd witnessed plenty of wonderful performances. He'd replay footage of the various sopranos, clapping his hands with glee as they hit some blisteringly high notes.

These amazing women were a huge source of inspiration to him. Indeed, in 1987, he was in seventh heaven when he recorded and performed 'Barcelona' with the renowned Spanish soprano Montserrat Caballé. And it was by pure chance that I met her myself. I was walking along St Martin's Lane, following a rehearsal, when a Rolls Royce drew up beside me. The window wound down and I heard a familiar voice.

'Miss Sleep! I thought it was you. Get in, darling. There's someone I want you to meet.'

So I did and – to my astonishment – I found myself sitting beside an opera legend and kissing her outstretched hand. I was utterly star-struck. Freddie seemed thrilled to introduce me to Monserrat ('Please meet one of the best dancers in the world') and after she and I had a friendly chat, I spent the rest of the day floating on air. My opera-loving friends, like dancer and choreographer Frank Freeman, melted with envy when I told them.

Freddie and I had a meeting of minds, both personally and professionally. And with so many shared passions, it was perhaps inevitable that he and I would discuss the idea of working together. A collaboration was a regular conversation topic of ours. I was keen for Freddie to be a pioneer in creating something fit for the Royal Opera House – a place

we both worshipped – and we'd talk about combining our expertise and creating something really special. A classical ballet with a contemporary twist, perhaps, with Freddie composing the music and me creating the choreography. He and I would get giddy with excitement as we talked about staging our own show and perhaps involving other virtuoso artistes-cum-friends, like Elton John and David Hockney (the latter of whom I was still in regular contact with, despite him living in California).

Freddie wasn't the only rock star, from my experience, who wanted to build a bridge between the contemporary and the classical. Pete Townshend – songwriter and guitarist with The Who – once met me backstage following a performance of *Dash* and told me it was the best dance show he'd ever seen, on either side of the Atlantic. Pete virtually got on his knees to beg me to choreograph the West End production of his rock-opera, *Tommy*, and seemed crestfallen when I politely declined. The proposition sounded fantastic, but I simply didn't have the time.

In contrast, I'd discover that another band, who were The Who's contemporaries, weren't so keen on a collaboration.

'Have you ever thought about composing something for a classical ballet?' I remember asking one of the band members as we made small talk at a VIP party.

'No way,' he'd replied, with a sneer. 'Who wants to see the fairies at the bottom of Covent Garden?'

I took that as a definite no.

In her fifties, and somewhat out of the blue, my mother became a member of the Church of the Latter Day Saints,

which put more distance between us. A relative had encouraged her to join a Bible reading group at a neighbour's house and, though she'd never been overly religious, Mum had happily gone along. I think she was seeking female company and friendship more than anything, especially since Joanne had left home and my grandmother had moved to Glastonbury to live with Auntie Sybil. Nonetheless, within no time she'd found God and wholeheartedly embraced her new faith, attending gatherings and joining forces with her fellow devotees to spread the Word.

I had no issue whatsoever with my mother seeking comfort and solace from the church, as I knew it provided an antidote to an unhappy and unfulfilling home life. However, I didn't appreciate her repeated attempts to convert me to the faith. Whenever we met, she'd try to convince me that by becoming a 'chosen one', I'd be granted eternal life and would be able to sit with God, and with her, forever. She'd quote carefully selected passages of the Bible to me, implying that I should ditch my lavish lifestyle in favour of a modest and devout existence, like hers.

When I refused to bow to this pressure, Mum would take great offence, accusing me of cruelty and hard-heartedness for refusing to meet her in the afterlife. My short fuse would be lit by this emotional blackmail, as I saw it; yet, the following day, I'd be full of remorse for quarrelling with my mother, to whom I owed so much. Sometimes I wondered if this tit-for-tat cycle would ever end and whether our loving bond would ever be restored. It would take the intervention of a very special person – a princess, no less – to do just that.

CHAPTER TEN

Uptown Girl

SOMETIMES IT'S HARD to believe I once danced with the most famous young woman in the world. But then I'll take a call from an American TV company asking for my memories of that magical afternoon nearly forty years ago or I'll be quizzed about our 'Uptown Girl' rendition by a chatty London cabbie. And then I'll be reminded that yes, it actually happened – I danced with Princess Diana. I'm still somewhat baffled that this three-minute dance that I devised for a private Christmas party has become so iconic, particularly since it was only ever witnessed by those 2,000 guests in the Opera House. The fact that our pas de deux was never captured on film – only a few black and white snapshots were taken – has certainly heightened the sense of mystique and the public fascination.

My royal connections didn't start or end with Diana, though. My long association with the Royal Ballet allowed me to witness the Windsors at close quarters, whether it was chatting with Queen Elizabeth at the Opera House or partying with Princess Margaret at Kensington Palace. In 1998, I was very pleased to be recognised for my contribution to the arts with an Order of the British Empire, which was presented to

me by King Charles (at the time, Prince Charles). Yet another pinch-me moment for a working-class lad from Devon.

Most of my mum's family had naval connections, either working on the ships or in the yards, so were well accustomed to pledging their allegiance to Queen and country. Plymouth had been one of the most heavily bombed cities in Great Britain during the Second World War – over a thousand civilians lost their lives – and many locally born sailors, based at His Majesty's Naval Base in Devonport, were killed in battle. Growing up, I remember being told harrowing tales of wartime blackouts and air raid shelters (Mum's was at the end of her street) and often walking past a bombed-out church in the middle of town, minus its roof and spire.

Queen Elizabeth's coronation ceremony, in June 1953, was a cause for celebration, though. We had no television at Percy Terrace, so me, Mum and Grandad instead gathered around our radio, listening to a BBC presenter with a cut-glass accent describe all the pomp and pageantry in London. I loved hearing the clippety-clop of the royal horses' hooves trotting down The Mall, and the hip-hip-hoorays of the crowds gathering outside Buckingham Palace.

A few weeks' later, every child at my infant school was handed a commemorative hardback, *Long Live the Queen*. I couldn't wait to bring it home and make it my own. Featuring pop-ups of Horse Guards Parade and Buckingham Palace, and full of colourful drawings of the royal regalia and pageantry, I treasured this gift like the crown jewels. It was one of the few books I ever possessed as a child.

The following year, I encountered my first royal in the flesh. Princess Margaret paid an official visit to Plymouth to

unveil a Commonwealth naval memorial on the Hoe, the city's famous park and promenade. My mother gladly took me along ('she's virtually on our doorstep!') and became very excited when this dark-haired lady in a pretty dress walked past the throngs of flag-waving well-wishers.

'Wayne, that's Princess Margaret,' she said, raising me higher to get a better view as the royal shook someone's hand and accepted a posy. 'I'd love to meet her one day, wouldn't you?'

'Um, maybe,' I replied, probably more bothered about the marching band.

My disinterest came to haunt me fifteen years later, when – *quelle horreur* – I failed to recognise Her Royal Highness at the Opera House. It was the premiere of a new creation of *Jazz Calendar*, choreographed by Sir Frederick Ashton, and an aftershow reception had been laid on in the Crush Bar (the most sumptuous lounge in the building). I turned up in all my foppish finery: a black satin double-breasted jacket worn over a white shirt with long, lacy cuffs, teamed with bell-bottomed trousers and Cuban-heeled boots. And, to add to the dandy theme, an orange jabot neckpiece, attached to my Beau Brummell-style collar with elastic. In my eyes, I was doing a service to the fashion industry by bringing Carnaby Street to the Opera House and thought I looked the bee's knees. In reality, I must have looked completely over the top.

With Sir Fred at my side, I struck up a conversation with a handsome couple in their forties, whose accents and deport-ment gave them a decidedly high-class air. The wife looked incredibly chic – glossy brown hairdo, emerald green dress, elegant cigarette holder – and the husband was tall, dark and

tanned, wearing a smart three-piece suit. As we chatted, though, I noticed them exchanging smirks and wondered whether it had anything to do with my natty dressing.

Clearly jealous, I surmised. *Not everyone has my style . . .*

Suddenly, I felt Ashton's hand pushing down on my head, quite roughly. *Ouch! What the heck is he playing at, embarrassing me in front of this well-to-do pair?*

'You're supposed to bow before royalty, Sleep!' he hissed into my ear, before performing the honours himself.

'Your Royal Highness, Lord Snowdon, I can only apologise,' he said. 'May I introduce you to Wayne Sleep, one of the newest members of our corps de ballet?'

Puce with embarrassment, I duly bowed my head, wishing the ground would swallow me up.

'Oh, never mind, Freddie,' laughed Princess Margaret, as Lord Snowdon grinned beside her. She then turned to me, flashing me a red-lipstick smile. 'Actually, I should say one loves those marvellous spins that you do, Sleep. How very fast they are!'

'Thank you, Ma'am,' I replied, relieved that my faux pas hadn't caused offence and that I wouldn't be slung into the Tower for gross impertinence.

Over the next few years, our paths would cross regularly. Princess Margaret was among the coterie of working royals who attended first nights, almost in rotation – so you might be introduced to King Charles one season and the Queen Mother the next. I'd soon learn that Margaret had an abiding love for the arts. Indeed, she'd become patron of the London Festival Ballet, later known as English National Ballet, a role that one day would be passed on to Princess Diana.

In 1977, Princess Margaret very kindly attended a gala

performance at the Adelphi Theatre – *A Good Night's Sleep* – that I'd organised with my friend Anya Sainsbury, formerly of the Royal Ballet, to raise funds for the Friends of Fatherless Families charity. The gala was a cause close to my heart, knowing how much my mother had struggled with single parenthood, both emotionally and financially. The show was directed by Burt Shevelove, one of the biggest names in US musicals (he wrote *A Funny Thing Happened on the Way to the Forum* with Stephen Sondheim) and featured an array of stage talent, including the cast of *A Chorus Line*. It was the first time that John Curry had danced in public, away from the ice, taking to the stage with Anthony Dowell. His naturally balletic style made for great entertainment.

In another coup, the gala also featured the premiere of a short ballet by Sir Frederick Ashton, *Tweedle-Dum and Tweedle-Dee*, with Graham Fletcher and I cast as the cheeky twins and Lesley Collier taking the role of Alice. Our acrobatic slapstick thrilled the Adelphi audience that night; it went down so well, in fact, that I'd reprise it for other gala performances. It entered the repertoire and is still performed now.

Her Royal Highness came to see me in Lloyd Webber's *Song and Dance*, too, attending with her friends, actress Nanette Newman and her film director husband, Bryan Forbes. She wore an elegant headscarf in order to remain incognito, although I knew she was coming as I'd been invited to a post-show dinner at her apartment in Kensington Palace. That evening, the Palace Theatre was abuzz with the news that Diana, Princess of Wales had entered into labour with her second child. George happened to be hovering in the

wings (now and again he liked to experience the backstage hubbub) and, during the interval, told me the royal birth had just been announced on the radio. I found myself facing a dilemma. Should I keep this momentous news to myself? Or, in a flagrant breach of protocol, should I share it with an audience that included a senior member of the royal family? I opted for the latter – I was so devil-may-care back then – and after the finale I came forward onto the stage announcing, 'I hope Her Royal Highness doesn't mind me taking the liberty of announcing that she has yet again become a great aunt and' – cue dramatic pause – 'it's a BOY!'

The entire audience got to their feet and applauded, while the Princess broke cover by acknowledging them with a smile and a royal wave. It was such a special moment and I'm so glad I threw caution to the wind.

The Kensington Palace soirée was a very sophisticated affair, with Princess Margaret holding court over a group of witty and erudite people from the arts and theatre circuit. Towards the end of the evening, though, the Princess did slightly let her guard down to amusing effect. When all the other guests had gone – it was just the two of us plus a male guest – we engaged in an energetic pas de deux, during which she implored me to lift her onto my shoulder.

'Are you quite sure, Ma'am?' asked her friend, who was immediately given short shrift.

'Of course one is,' she laughed. 'It's an ambition of mine. Come on, Sleep!'

Having to carefully ensure my hands didn't accidentally stray into the wrong places, I couldn't hold her as firmly as I did other partners.

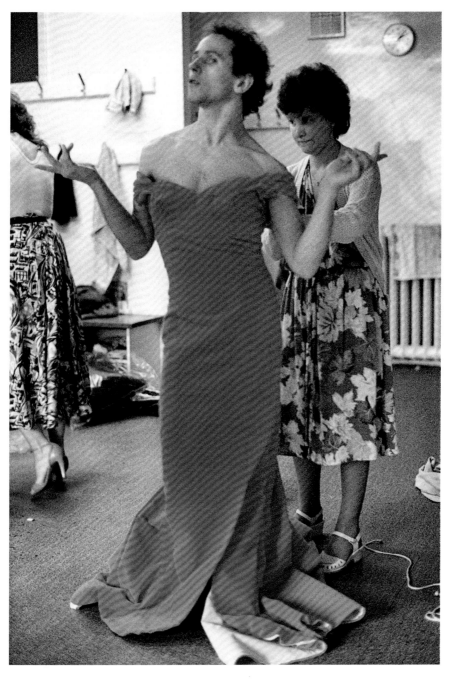

Being fitted by the BBC for a Mae West impression. Watch out Ru-Paul.

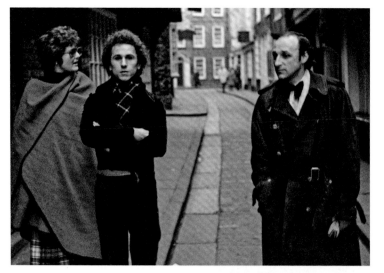

Myself, George and Lady Henrietta Guinness, in Paris. We often travelled across Europe together for holidays.

My mother, escorted by Mack (my driver), to a Garden Party at Buckingham Palace. I had just bought the Daimler from George Harrison's Transcendental Enlightenment Company.

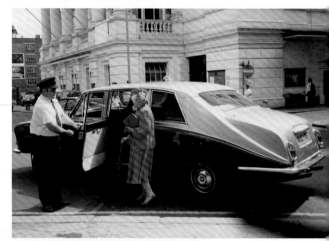

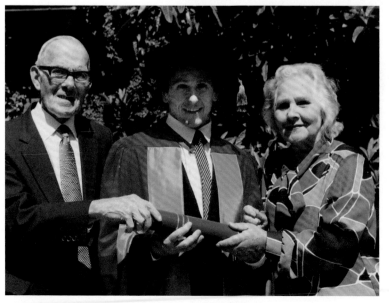

My mother always wanted a doctor in the family. Here I am, with my first honorary doctorate from Exeter!

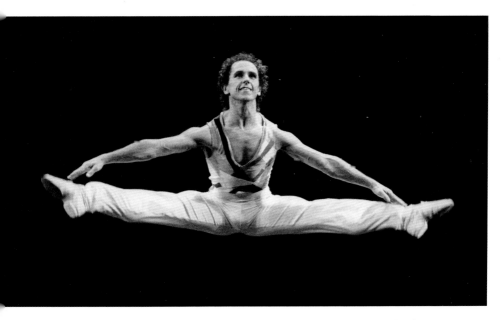

The energy from a full house always spurred me on to jump higher.

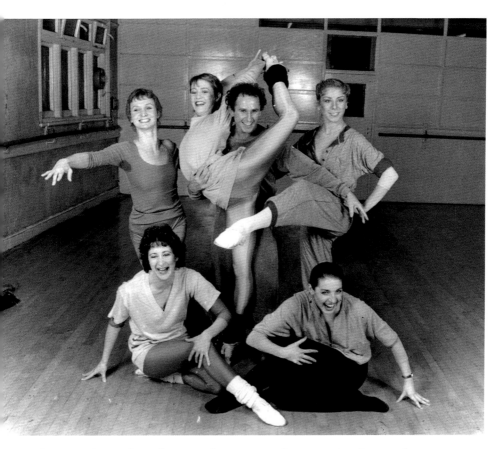

The first members of my show *Dash*, at Pineapple Dance Studios, with costumes
kindly supplied by Debbie Moore.

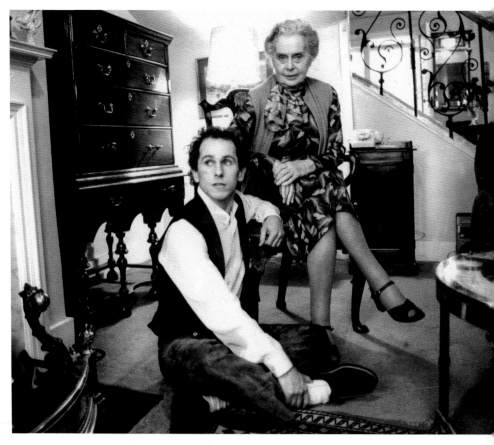

With Madam my mentor, at her terrace in Barnes, sitting at her feet, where I belong. This photo was taken for the *Telegraph* with the headline: 'There's nothing like a Dame'.

With Mikhail Baryshnikov and Dame Antoinette Sibley.

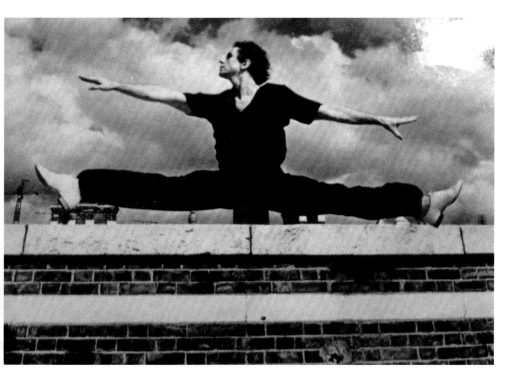

Feeling like the wind. One of my favourite photographs by Tony McGee.

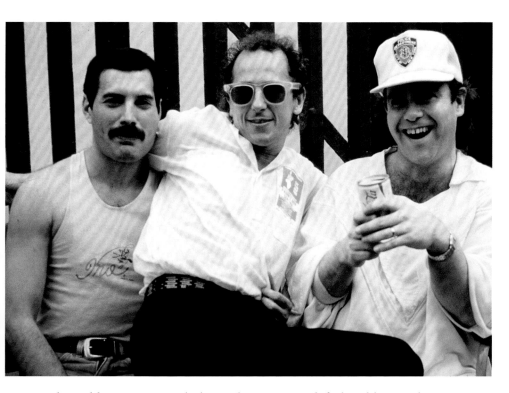

With Freddie Mercury and Elton John at Live Aid, feeling like a rocket man wearing Elton's glasses.

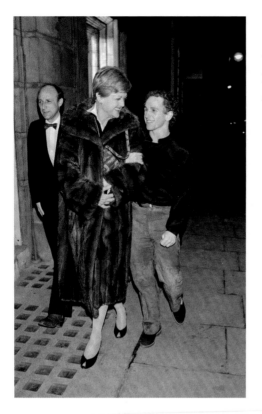

With Angela Lansbury and George Lawson. After choreographing *Death on the Nile* we became good friends.

Being held up by two icons, Shirley Bassey and Liza Minelli.

With Rudolph Nureyev. He reluctantly agreed to a photo with me, at Madam's 80th birthday party at The ROH.

Only one official photographer was permitted to take photos of myself and Princess Diana dancing that evening. Thank God for Wayne Eagling, who came to my rescue, and refused to hand his film in to an usher . . .

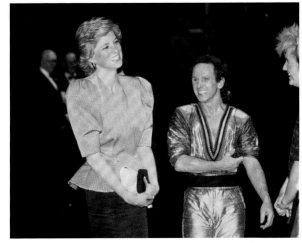

With Princess Diana at the Bristol Hippodrome, after a charity performance of *Song and Dance*.

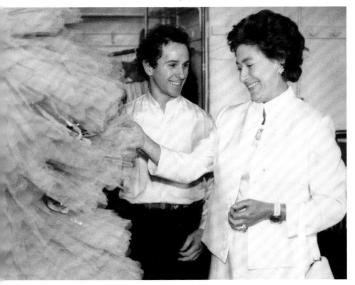

Whilst filming a fundraising appeal at the Royal Opera House, Princess Margaret insisted that I take her on a tour of the worst parts of the building.

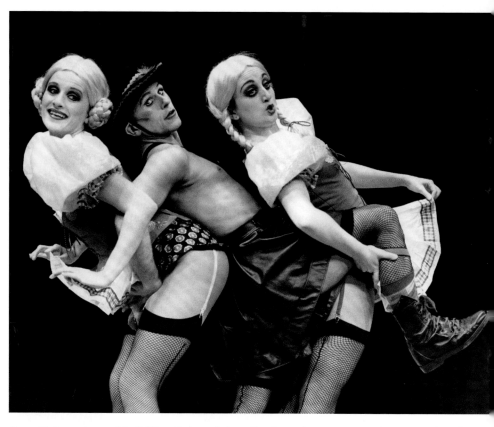

In collaboration with Gillian Lynne (after *Cats*), as the Emcee in the musical *Cabaret*.

I love playing the villain.

'I'm not on, Sleep, I'm not on!'

'Well stick your bum out, then.'

Not the most deferential language, I admit (had anyone else ever dared to utter the word 'bum' to Princess Margaret?) but thankfully she took it in good humour, yelling 'hooray!' when I finally got into position, held her aloft and spun her around. As I did so she laughed and performed an exaggerated royal wave.

If only my mother could see me now, I remember thinking at the time. *The princess we saw on Plymouth Hoe is currently balancing on my shoulders . . .*

While I got on extremely well with Her Royal Highness, I knew others who found her difficult. In those days, I had a chauffeur to drive my Daimler, a very reliable and trustworthy Eastender called Mac. Having dropped me off at Kensington Palace that night, he'd asked the policeman on duty to give him an idea of when he should return to collect me.

'It could be anything from three minutes to three hours, Sir,' came his telling response. In other words, all depended on whether a guest passed Princess Margaret's likeability test. Mac had to wait in the car till past midnight, so I can only assume I received the royal nod of approval.

The Royal Variety Performance, an annual charity fundraiser, was usually staged at the London Palladium or the Theatre Royal, Drury Lane, and I had the honour of appearing in several. My first took place in November 1978, in front of the Queen Mother, when I shared a typically eclectic bill with Harry Secombe, Danny La Rue, Showaddywaddy and the Nolan Sisters. Millions of TV viewers would tune in, so

if you happened to be an up-and-coming talent – a comedian, perhaps, or a magician – the show had the clout to make you a star or break you overnight. That year, the legendary Gracie Fields performed 'Sally' as a finale – a favourite of my mother's – and backstage, she made La Rue laugh by bemoaning that she'd been singing a 'man's song' all her life.

Working their way along the customary Royal Variety Performance receiving line, our eminent guest would be introduced to hand-picked performers and behind-the-scenes staff. I always found these rituals most illuminating, whether they followed a Variety Performance or a West End opening night, because you'd get the rare opportunity to see the royals up close and personal, dressed in their finery and regalia. Meeting the Queen Mother in the line was always a treat. She had a real aura about her. Whenever she attended the theatre, she'd ramp up the glamour stakes, teaming her long, shimmering dresses with a sparkly tiara, a feather boa and a pair of silk gloves. Like her youngest daughter, the Queen Mother was very attuned to the cultural world and would talk about it with genuine enthusiasm. She was 'on', as they say in the business: a very charismatic individual who turned up the charm and relished the limelight.

Her son-in-law the Duke of Edinburgh was a different kettle of fish. His bone-dry wit was often mistaken for downright rudeness, but I don't think he set out to cause offence. Indeed, I got the distinct impression that Prince Philip used hijinks and humour to amuse himself and to enliven his regimented public duties. I couldn't blame him, really. All that ribbon cutting and plaque unveiling would probably have driven me to mischief.

A few years back, I became the target of one of the Prince's hallmark put-downs. For several years, on and off, I'd been presenting Duke of Edinburgh awards at St James's Palace. Once, however, I found myself doing the honours for two years running, owing to the original choice dropping out at the last minute. I was more than happy to help the organisers out of a hole, even though there'd be no fee, of course, it being a charitable event. So I put on my best suit and asked Mac to chauffeur me to St James's Palace. I arrived in good time, ready to honour yet more marvellous achievements.

'Not you again,' grumbled Prince Philip as I walked through the grand state room to join him.

I just smiled and nodded, while a voice in my head said, *Charming . . . I'm actually doing this as a favour.* Maybe he saw past my cheery façade because I wasn't invited again.

I can't say I ever felt daunted or intimidated by the presence of a royal; I was always perfectly relaxed in their company, as I was with most people I encountered. I have no doubt that my upbringing, both in the family home and in the Royal Ballet School, helped in this respect. My mother instilled me with beautiful manners from a young age. She was fastidious about pleases and thank yous ('mind your Ps and Qs, Wayne') and taught me how to speak when I was spoken to, how to treat people with courtesy and how to show interest in others. And reinforcing this was a matron at White Lodge who'd always be looking out for bad table manners – no speaking with your mouth full, no elbows on the tables and suchlike.

Then, as I'd progressed through the lower and upper school, I'd come into contact with our version of the royal family:

King Rudolf and Queen Margot. As a student, you learned not to speak to them unless they deigned to speak to you, and not to gawp at them through rehearsal room windows. Upsetting their majesties just wasn't the done thing. There was an etiquette. You learned not to overstep the mark. This politesse became ingrained and instinctive, and I'm convinced it helped me cope within those royal circles.

I first met King Charles when I was eighteen years old. Only a few months separates us, age wise, although our background and upbringing couldn't have been more different, of course! Nevertheless, I found myself chatting to him quite easily when I first met him at the Royal Opera House, during the making of a promotional fundraising film. I found him extremely friendly, courteous and good-humoured.

'Goodness me, how on earth do you get yourself into that?' he asked me, referring to the skin-tight unitard I was wearing.

'Well, Sir, it's rather like stuffing a sausage,' came my reply.

In 1980, the tabloids were ablaze with the news that King Charles was courting a pretty young woman, Lady Diana Spencer, and, when their engagement was announced, I sent him a congratulatory telegram. The royal wedding coincided with a hectic time in my career – I was performing in *Cats* eight shows a week while working on *Dash* – so I can't say I gave it my undivided attention. Nonetheless, similar to the rest of the country (and the Queen, no doubt), I was delighted that the heir to the throne had seemingly fallen in love and was finally settling down. And I was grateful for a rare day off work, too, and watched the entire ceremony on telly.

Diana, Princess of Wales, was only a few months into her marriage when I first met her, following a performance of *Swan Lake* at the Opera House. After *Cats*, I appeared only occasionally with the Royal Ballet – although I remained a senior principal dancer – but I was invited back for a month in 1981 to appear in Tchaikovsky's finest, alongside Anthony Dowell and Natalia Makarova.

As I bowed and shook hands with King Charles in the Crush Bar, I caught sight of Diana across the room.

'It's wonderful to see you again, Your Highness, but I haven't yet met your wife,' I said.

'Oh, haven't you?' he replied, before bringing her over for a fleeting pleased-to-meet-you.

Two years later, I was asked by a royal lady-in-waiting if I could give Diana some private lessons. She'd been a keen ballet dancer at boarding school, apparently, and wanted to hone her technique. I had to politely but reluctantly decline – I was touring incessantly and couldn't spare the time – so a colleague, Anne Allan, was approached instead. A talented dancer and choreographer, she'd worked with me on *Dash* and was also attached to the London City Ballet.

Then, in the summer of 1985 I received a phone call from Anne, asking me to be available the following morning to speak to the Princess. It was all very intriguing. What was this all about? The next day my telephone rang, and down the line came a softly spoken voice.

'Hello . . . Princess Diana, here,' she said. 'I have a question to ask you, if I may?'

'Of course, Ma'am,' I replied.

She told me about her desire to dance at the Friends of

Covent Garden Christmas Party, as a surprise 'present' for her husband. This private cabaret, which I'd performed in for years, was laid on by the Opera House as a special thank you to its donors. It featured a variety of opera and ballet acts and, for added kudos, sometimes included a novelty, one-off finale that involved a member of the royal family. Indeed, in 1982, Charles and Diana had taken part in a Romeo and Juliet spoof. The Prince had taken to the stage in a gold cloak, tights and mask before climbing up a ladder to his wife in the royal box to croon 'Just One Cornetto . . . '

'So I've come up with an idea,' said Diana. 'I'd like you and me to dance together at the party, in the finale.'

For once in my life, I was momentarily lost for words. I was shocked and flattered in equal measure. But my first thought, I admit, was, *But you're so tall, Your Royal Highness, and I'm so small . . . how could that possibly work?*

'Goodness, that's come rather out of the blue,' I laughed, as she giggled nervously. 'OK, so how about we meet up when I'm next in London and you can tell me more?'

'That would be wonderful.'

'Anne will find us a studio, somewhere nice and private.'

I put down the phone and lay on my bed for a few minutes, staring at the ceiling and processing our conversation. I didn't know it then, but I was about to make history.

On a Tuesday morning, Diana, Anne and I met in a Chiswick dance studio that was hidden down an alley, well away from the prying eyes of press or public. The only person accompanying the Princess was her detective, who waited outside with his walkie-talkie. I entered the studio to find

If our diaries or schedules clashed, the rehearsals would take place over the telephone: I'd go through the steps with Anne while Diana put it all into practice.

'Good news, Wayne,' she said when she arrived for lunch one day. 'Our number has just received the royal seal of approval.'

'I thought you weren't going to tell Prince Charles?' I asked.

'I haven't! I've just performed it for Wills and Harry, and they both applauded!'

'Wonderful!'

In rehearsals, I treated Diana like any other dancing partner. She didn't mind me critiquing her – and she was eager to learn – because if 'Uptown Girl' was going to work I needed to pinpoint her flaws and perfect her technique. Ultimately, I wanted her to look fabulous on that Covent Garden stage. But I'd be quick to compliment her, too: the Princess had a very natural dancing style, with good line and could perform high kicks and pirouettes like a professional. She also possessed something I could never teach her: star quality.

During these rehearsals, our friendship grew and grew. She rarely talked about family matters – she was too focused on her dance steps – but on the odd occasion when she strayed into talking about domestic life, she knew our conversations would go no further than the studio. She'd become very wary of people – understandably so, since so-called confidantes had leaked stories to the press – but she knew she could count on me. We felt an invisible bond.

* * *

On the day of the performance – Monday, 23 December 1985 – the Princess sneaked out of Kensington Palace to rehearse with me on the Opera House stage. We worked on a 'closed set', and a clutch of technicians and front-of-house staff were sworn to secrecy and promised not to give the game away. Diana wore her show-stopping dress for the first time – a diaphanous white silk number with a strappy top and a full, calf-length skirt, which, as we danced, swished and floated in all the right places. She looked breathtakingly beautiful. And, just for me, she wore her lowest heels.

I needed to be sure that she felt OK under the glare of the spotlight. For a novice it can feel quite overwhelming (I've often described the feeling as dancing with your eyes closed or stepping off the edge of the world) but Diana seemed utterly unfazed. She positively basked in the lime-light, shrugging off her natural shyness and coming alive, like a flower in full bloom.

A few hours later, 2,000 Friends of Covent Garden filed into the Opera House while the Prince and Princess of Wales and their entourage took their places in and around the royal box. By that time, and purely for security reasons, Diana had been obliged to inform Charles and his aides that she'd be leaving her seat for a few minutes to take part in a special finale. He had no inkling of its nature, of course – although the Royal Family had often before performed short skits, with King Charles performing 'Just One Cornetto' with Diana previously.

As the big moment loomed, I gave Diana a secret signal from the wings – I mouthed 'NOW' – whereupon she slipped out of the royal box to meet me in the King's Smoking room,

as planned. She got changed, swapping her red velvet gown for her white floaty dress. I was wearing a simple shirt and slacks combo. She removed her diamonds, handed them to a security man and whispered to me, 'Thank God for Butler and Wilson', and once she was ready, we had a final run-through. She was remarkably calm and composed. I was far more nervous, as it happens. The magnitude of our dance had suddenly hit home. As we waited in the wings, not saying a word, for what felt like forever, the excitement and pressure continued to intensify. It felt like the previous act would never finish, but finally, it was time – we shared an excited smile, I blew her a kiss and took to the stage.

The routine began with me dancing a solo to the opening bars of 'Uptown Girl' while Diana waited in the wings. The Friends in the audience loved it from the off and when they broke into spontaneous applause, I remember thinking, *Just you wait . . . you ain't seen nothin' yet!* I beckoned towards the Princess, which was her cue to enter stage left. I'd choreographed her to strut out like a model on a catwalk: out for eight counts, pause for another four, then repeat the sequence. This gave time for the audience to register that this wasn't a look-a-like. This was the real deal. There was an audible gasp from the 2,000 people in the auditorium – Princess Diana? – but as the reality sank in, there was a stunned silence, then a few whispers of 'Is it really her?!'

Diana lived up to all expectations. Her steps and sequences went exactly as planned, with deft pirouettes, smooth hip rolls and even a slightly risqué high kick over my head that probably made King Charles sit up in his seat. At one point,

I even carried my partner diagonally from one corner of the stage to another. As we flew across the stage, I remember thinking that she had a look of gay abandon on her face, and I remember saying to myself: *For God's sake, Wayne, don't drop the future Queen of England . . .*

If there was one person in the world who I didn't mind being upstaged by it was her. She was the star of the show – she barely put a foot wrong – and I couldn't have been more thrilled. Our dance ended with Diana performing a pirouette as I bowed down to her on one knee.

Following eight curtain calls, it was only appropriate to bow to the Prince in the royal box.

'Go on, then,' I said, under my breath.

'I'm not bowing to him, he's my hubby!' she laughed.

'Well, I have to, and so should you,' I said.

'Well, you won't get your OBE like that,' came her witty riposte as we ran offstage.

Diana was all set to perform an encore. Loud cries of 'More! More!' rang around the auditorium and I could see she was itching to reprise our routine. I had to be quite firm with her.

'There's a mantra in the entertainment world, Ma'am,' I explained. 'Always leave them wanting more . . .'

As we met in the wings, she whispered something in my ear that I'll never forget: 'Beats the wedding . . .' she said, with an impish grin. She'd enjoyed every single second of it.

Afterwards, the Princess asked me to join her, and we headed over to the King's Smoking Room where her husband and selected VIPs were gathered for a reception. I remember Diana clasping my hand quite tightly as we approached the double door. I think she wanted me by her

side for moral support. The Prince of Wales was standing in the middle of the room with his hands behind his back, among a semi-circle of a dozen or so men, while the women were gathered to the side. It all seemed rather intimidating.

To break the ice, I lifted the mood in the best way I could: by intentionally going over-the-top.

'Hello darlings, did we all have a good time?' I cooed, prancing with arms outstretched towards the semi-circle of males. Some of them were probably thinking, *What's this bloody fairy up to?*

But it made them titter, and it made King Charles titter, and the atmosphere lifted as a result. The Prince asked me if I wanted a drink – heavens, did I need that champagne! – before mentioning something about enjoying our dance. I wasn't entirely convinced.

The following day, I received a handwritten, hand-delivered letter from Kensington Palace.

Dear Wayne,

I just wanted to write and say an enormous thank you for dancing with me last night – I can't believe it's all happened but you might be glad to hear that I have calmed down at last! I must say the nerves do have a real bashing, don't they, and I can so understand the buzz of wanting to dance and be on the stage now . . . Heartfelt thanks, Wayne, for making my evening such a special and memorable one and HAPPY too!

With love from your dancing partner,
Diana.

Once news of our duet filtered out, the media went into a frenzy. Every tabloid reporter was desperate to get their hands on some cold, hard evidence but, without any film or audio footage (and with the official photographs under strict lock and key, for mine and Diana's eyes only), they were out of luck. I had press guys knocking on my door and barraging me with phone calls – they even door-stepped George – but, much to their dismay, I kept totally schtum. They were getting nothing from me.

Our Covent Garden dance marked the start of a long and enduring friendship. Diana and I kept in regular touch, embarking on London lunch dates (at my place in South Kensington or in the Groucho Club) and exchanging an array of cards, gifts and letters. She was never technically 'alone' during our meet-ups – her detective was usually at the other end of the restaurant or elsewhere in my house, often with George for company – but it was still lovely to catch up with my former dancing partner and keep her abreast of all the juicy West End gossip she so liked to hear. Occasionally Anne Allan would come along, too.

Our lunch date at the members-only Groucho Club, in December 1986, gave me a window into her crazy, chaotic world. Before we even arrived, the place had to be 'swept' by her security men, who checked for bugs, devices and escape routes, before driving up and down Dean Street and Old Compton Street to pinpoint any suspicious-looking activity. And within hours of settling the bill – it was Diana's turn – the *Evening Standard* had printed a story in its second edition about our rendezvous, including precise details of our menu choices and the final tally. A 'mole' had seemingly

tipped off a reporter; big bucks were always paid for Diana stories.

We even became fodder for a Fleet Street gossip columnist, who raised eyebrows that we were dining together, while at the same time referring to me as a 'confirmed bachelor'. This was code for 'gay man' in the world of journalism. They deployed this euphemism all the time; a 'soft outing', if you will. The reporter would have known there was nothing suspect about our liaison, but wrote his nudge-nudge-wink-wink nonsense anyway. Diana had become wearily accustomed to all this palaver – being hounded by the press was her normal – but I found it truly bizarre. She wouldn't even allow me to give her a kiss on the cheek in public, for fear it would be misconstrued by some mischief-maker.

The Princess came to see every show I did in London, often popping into my dressing room during the interval and after the show, having a chat about the performance while enjoying a cuppa. Not long after our Opera House dance, she came along to *Dash* at Christmas at the Dominion Theatre, keen to see a skit I'd created about her young son, William.

Heaven help me, I thought to myself, dreading the thought of her seeing me prancing around the stage in a babygrow and a gold crown, holding an orb and sceptre, while singing about thrones, riches and the 'royal wee'. There was even a rather naughty quip about Diana's nose. But it was all good-natured fun and I hoped she'd take it in the right spirit.

At one performance, the Princess asked me if I wanted her to watch from the wings, or out front. I replied that I wanted her to sit out front, to which she said, 'Do you want them to be watching me or you', and laughed. I quickly

replied, 'Sit in the wings!' And we giggled together. So for the duration of the show she sat on a wooden stool, beside her detective. The Dominion theatre-goers were totally oblivious to the Princess in their midst. She didn't seem to mind dodging flying tennis balls (part of my John McEnroe impression) or witnessing frantic costume changes and scenery shifts. The scurrying stagehands gave her detective a fright, though. Their black all-in-one outfits teamed with balaclavas with eyeholes (designed to conceal them in ultraviolet light) gave them a distinct SAS air. He breathed easy once he realised they were bona fide staff.

Afterwards, Diana met me in the dressing room to tell me how much she enjoyed the show, including the baby prince skit. Phew. And, with a wry smile and a wagging finger, she even alluded to the nose joke, revealing an endearing self-deprecation that made me warm to her even more.

She watched me in the 1986 revival of Kander and Ebb's *Cabaret* at the Strand Theatre, directed and choreographed by Gillian Lynne. It was a wonderful production with a marvellous cast, including my great friend Janie Dee – one of the few Brits who boasted the sing/dance/act 'triple threat' – in her first West End role as Gertie. I was cast as EmCee, the sleazy, sinister nightclub owner. In the dressing room afterwards Diana spotted a mug of mine, inscribed with 'Let's Dance, Yah?' along with a cartoon of herself wearing dance gear and legwarmers. She loved it so much that I had to buy thirty-six of them from a Covent Garden market stall so she could gift them to friends at Christmas.

While dress-rehearsing my role in *Cabaret* I had the honour

of meeting one of my great idols, Liza Minelli. She was performing her West End revue and, having previously met me on Michael Aspel's chat show, asked if I'd like to see one of her dress rehearsals. I jumped at the chance. The first time around I just watched and admired from the stalls, but on subsequent occasions she invited me to the stage for a little boogie together. We got on famously, Liza and I, and loved bantering with each other.

'I'm going to make your day, Wayne. I met Charles Aznavour today and he's smaller than you.'

One evening, just before a performance, she promised to sing one of her ballads directly to me, requesting that I wave a white handkerchief in the auditorium so she could locate me. It was a moment I'll never forget. As her eyes locked with mine I felt like the only person in the theatre.

The Princess of Wales attended many of the charity galas that I enjoyed directing. By calling in favours from my theatrical friends in high-places, on stage and off, I'd create one-off, never-to-be-repeated spectacles that fully justified the £100-plus entry fee. If I was able to secure the attendance of a royal, however – usually Princesses Margaret or Diana – I could easily double, sometimes treble, the ticket price because people clamoured to be in their company.

Diana never turned me down, bless her, whether it was 'Wayne Sleep and his World of Dance' (an event in aid of Malcolm Sargent Cancer Fund for Children) or a gala I directed at St John's Smith Square concert hall, in Westminster, to raise funds to repair a Baroque organ. Or even Bristol Hippodrome, to raise money for a cricket team

local to her country home, Highgrove House. People spent
£15,000 to sit at the top table with the Princess, which was
a hefty whack even in those days, but that was testament
to her allure and attraction.

I remember a rather well-known individual waltzing over
to our table (Diana had insisted I occupied the seat next to
her), which prompted her to dig me in the ribs.

'Oh, God, here comes one of my least favourite people,'
she muttered. 'Awful man.'

As he knelt beside her, full of his own importance, she
smiled gracefully and conversed with him for a good ten
minutes.

'I thought you didn't like him?' I asked, once he'd sidled
away. 'Why didn't you just brush him off?'

She held me in that famous gaze of hers, head dipped,
eyes peering upwards.

'Wayne, it's easier to be nice.'

It was a sentiment I always tried to abide by.

I'm still trying.

Another notable gala was the Carnival for the Birds, an
exuberant fusion of dance and fashion that benefited the
Royal Society for the Protection of Birds. Staged at Covent
Garden, it showcased one-off, bird-inspired designs by the
likes of Gianni Versace, Karl Lagerfeld and Rifat Ozbek. I'd
coordinated top choreographers to devise dances to comple-
ment each costume. My own Red Robin outfit – a Katherine
Hamnett sequinned catsuit teamed with a Philip Treacy top
hat – was camp as Christmas. Diana burst into laughter when
she first saw it.

'What on earth have you got on?' she giggled, as I performed

an exaggerated flutter. 'I'm not going out with you wearing that!'

We shared another comedy moment after the show.

I introduced the Princess to the many notable designers during the line up: 'Ma'am, may I introduce you to Vivienne Westwood?' I said. And we continued down the line: 'And may I also introduce you to Karl Lagerfeld, Rifat Ozbek . . . and Vivienne Westwood.'

And when she popped up for the third time, I heard the Princess whisper under her breath, 'And Vivienne Westwood . . . again,' as the designer beamed with joy, doing yet another curtsey. It took all our will and resolve not to burst out laughing. Westwood desperately wanted to design for the Princess, it seemed, and was prepared to flout all the rules to get her attention.

When it was professional, I behaved accordingly, but when it was private we could behave freely, and we had lots of fun, Diana and I, and shared a very offbeat sense of humour. In public, she had to show an element of restraint, but in private, she was a hoot, a real giggler. I'd often send silly and tacky birthday presents to Kensington Palace: a joke squirting watch, perhaps, or a dancing Coca-Cola figurine. On her thirtieth birthday, I sent her a green frog baseball hat, with attached webbed feet that clapped in the air. It read 'Kiss me, I'm a prince.' The following day, I received one of her customary thank you notes.

'Dear Wayne, I love the hat. Where do I wear it . . . Ascot?!'

My mother had first met Princess Diana in December 1985, following our big night at the Royal Opera House. Although we'd grown apart somewhat, largely due to her religious

beliefs, she always enjoyed coming to my performances, and I couldn't allow her to miss this particularly momentous occasion. She was a little bewildered by the invitation, however.

'But why are you asking me to a Friends of Covent Garden event, Wayne?' she asked. 'Aren't they just for VIPs?'

'I'm performing with someone very special,' I replied. 'And I want you to be there to see it for yourself.'

The Princess was aware of the tensions between my mother and me. I'd mentioned our differences in passing, during a break in our rehearsals – 'It's one of those things, Ma'am, we're both so opinionated, and we just clash too much . . .' – and it had prompted a sad little sigh, perhaps since she'd had complicated relationships with her mother and her stepmother.

At the Opera House, following the aftershow gathering in the King's Smoking Room, I was heading for the foyer to meet Mum when Diana tapped me on the shoulder.

'Wayne, go and get your mother from the Crush Bar,' she said. 'I'd love to pull a cracker with her.'

So I did as requested and, five minutes later, my somewhat bamboozled mother found herself holding one end of a Christmas cracker as the Princess of Wales held the other. Mum pocketed the little gold chain that fell out after the snap (it would remain a keepsake for life; I now have it at home). Diana proceeded to ask Mum if she'd known beforehand that we were dancing together at Covent Garden. This was a sneaky little test, I reckoned, to check if I'd spilled the beans.

'Oh, no, I had absolutely no idea,' said my mother. 'When Wayne said "someone very special" I thought it was Margot Fonteyn.'

'I'm awfully sorry, Ma'am, but do you mind if we sit down?' I said. 'I've had a very late night.'

Her face broke into a grin. 'You naughty boy!' she said, with a hint of camp, and we both dissolved into a fit of giggles.

And it was at that moment, with that flash of humour, that I knew I could make the dance work. By putting together a comedic number, I could reflect the upbeat nature of the song and also stay within the boundaries of respectability. So I created a theme of playful one-upmanship, through which we'd try to outdo each other's steps and sequences while sending up our height disparity. We'd stick to jazz rather than classical, with lots of finger clicks, shoulder raises and hip isolations. I'd keep the moves suitably refined, though – no disco strutting around – so the Princess could retain her royal dignity and elegance.

'So does that mean you're on board, Sleep?' she asked.

'Of course,' I replied. 'It'd be an honour and a privilege.'

'So what are you going to wear, then?

'Hmm, good question . . .'

Diana and I rehearsed whenever we could. We switched venues each time to keep the paparazzi off the scent and ensured the studios were totally private to deter any snoopers. The Princess was thrilled that we were able to shroud everything in secrecy – as someone who was hounded by the press, this was a rare occurrence. In total, only four of us knew what was afoot, if you included Anne Allan and Diana's detective; even her loyal lady-in-waiting, Anne Beckwith Smith, was kept in the dark until the day itself, which made her very nervous about what to say to the Kensington Palace officials, or the 'men in grey' as Diana referred to them.

the Princess practising some steps at the barre with Anne. She looked astonishing, sporting a pink leotard, pink tights, grey legwarmers and a grey headband. And, judging by the gleaming white jazz shoes that completed her outfit, this was a woman who took dance very seriously indeed.

'Hello, Wayne,' she said, blushing slightly.

'How do you do,' I replied, bowing my head.

I was immediately struck by her beautiful blue eyes, her ink-black lashes and her dazzling smile. *What a fabulous addition to the royal family*, I thought. *I can see exactly why Charles fell for her.*

And yet, while she may have looked like a goddess, our height disparity still perturbed me. Even in flatties, she towered over me – she was eight inches taller – and almost had to crouch down to talk to me. I felt a pang of doubt. I feared her idea was a total non-starter. Much as I wanted to dance with Diana, it might be wiser for me to choreograph the piece instead and recruit a handsome, six-foot Royal Ballet principal to partner the Princess. But, out of courtesy, I'd hear what she had to say.

It transpired that Diana had earmarked the chart-topping 'Uptown Girl' as the song for our pas de deux, having seen the accompanying video which featured the singer, Billy Joel – a diminutive 'backstreet guy' – trying to woo a statuesque socialite, played by model (and real-life wife) Christie Brinkley. The Princess thought we could perhaps replicate that dynamic in a humorous way, in a dance suitable for the Covent Garden event. Diana seemed to have a very clear vision of how she wanted this little act to pan out, from the choice of song to the choice of outfit – and the choice of dancer. But I still wasn't convinced.

Her intonation made it sound like Diana was something of a climb-down, which wasn't her intention, but it really tickled the Princess. She took a shine to Mum that evening – I think she liked her plain-speaking honesty – and, to my surprise, I found it all strangely heart-warming. Within days, my mother and stepfather had received an official invitation to the royal Christmas party at Kensington Palace. This event was hosted as a thank you to people who'd helped the Waleses in some way – from entertainers like me to nannies, florists, swimming instructors and helicopter pilots – and Diana thought it might be nice for my parents to accompany me.

As it happened, they went to these exclusive soirées for three years running, as well as a couple of Buckingham Palace garden parties. Once they attended without me, when I was away on tour – the cheek of it! – which was personally approved by Diana. I understand that Stan rather enjoyed these royal gatherings, but it was hard to tell because we rarely exchanged a word. The passage of time hadn't improved our relationship, sadly, and he still felt like a stranger to me. There were no fireworks between my step-father and I, just a sense of mutual apathy and indifference. A very sad state of affairs.

Mum certainly loved these royal jaunts, though. Perhaps a little too much. On one occasion, having downed a few glasses of Chablis, she buttonholed the Prince of Wales himself. I had to physically stop her from grabbing hold of his arm and breaching protocol in one fell swoop.

'Mrs Sleep, how are you?' he said, with genuine warmth.

'Oh, Your Royal Highness, you saved my life!' declared my mother.

Gawd almighty . . . ! I remember thinking. *What's she on about?*

She regaled King Charles with a tale of how she'd been admitted to the Royal Naval Hospital in Plymouth for a liver complaint, which had been treated swiftly and successfully by the medical team. But, in Mum's eyes, the fact the hospital was 'royal' meant the Prince had somehow played a part. He took it all in good humour. In fairness to the Windsors, they were unfailingly kind to people's friends and family. I remember Prince Phillip once having a joke with my mother, albeit at my expense.

'How do you cope with him?' he said, gesturing towards me.

'Oh, he's a handful, alright,' she replied.

Mum's encounter with the Prince of Wales took place in the late 1980s at a Christmas party that was notable for the fact that one grand room in the state apartment contained Diana's guests and another contained Charles's. I didn't think too much about this segregation – I avoided tabloid tittle-tattle about the couple and never discussed their private matters – but, looking back, it was a portent for things to come. The Wales's marriage was not in a good place. Soon, the customary family photograph on Diana's official Christmas card, which would take pride of place on my hearth each December, would only feature Wills, Harry and herself. And, eventually, just the Princess on her own.

However, on a more positive note, these royal get-togethers drastically improved relations between Mum and me. By almost forcing us together in such a rarefied, highbrow environment – in state apartments, on palace lawns – we were obliged to be kind and considerate with each other, and to

conduct cordial, two-way conversations. And from those green shoots of recovery grew a new sense of tolerance and understanding of our different lives: she acknowledged the pressures and vagaries of the entertainment world and I understood her need to feel more valued and appreciated. And, importantly, we agreed not to talk about religion. The subject was just far too inflammatory.

In hindsight, I think this rapprochement had been Diana's objective all along. She'd sensed that Mum and I had grown apart and, in her own way, had set about remedying this, perhaps with her own personal circumstances in mind. By introducing herself to my mother at the Opera House and then inviting her to the Palace, she was giving her the attention and the affection I wasn't. The Princess went out of her way to make her happy, perhaps in the hope that I might take heed and follow suit. Which, for the last few years of Mum's life, I think I did. Mission accomplished.

During my friendship with Diana, I witnessed first-hand her extraordinary ability to connect with people from all backgrounds. I saw how her humility and humanity – and great sensitivity – was able to build a bridge between the British monarchy and its public. And this would include the gay community. Because when a devastating disease threatened to wipe us out, and expel us from society, the Princess of Wales turned towards us. Defying convention and challenging stigma, she held victims' hands and expressed words of hope. I'd find myself doing the same.

CHAPTER ELEVEN
Beginnings and Endings

MODERN LIFE CAN be so hectic, you often don't get time to think. Sometimes you need to climb off that metaphorical hamster wheel in order to allow yourself the opportunity to sit back, relax and contemplate. And for me, that was the spring of 2020. Since the turn of the millennium, I'd done the occasional stint on cruise liners, delivering a forty-five-minute celebrity guest lecture about my life and career. Performing on the ships was very pleasant – a business-class flight there and back; my own luxury cabin suite – and I'd often incorporate it with a nice holiday at a coastal stop-off like Honolulu or San Diego, and I would always be able to take a guest.

I'd been booked for a week-long Indian Ocean cruise in March 2020, starting in Sri Lanka, but when this scary new virus hit Asia the first port of call was switched from Colombo to Perth. And then – disaster – as our cruise ship set sail, other major ports around the world began to close, including Dubai, where I'd planned to disembark. With nowhere to dock, we had to sail aimlessly around the coast of Africa, briefly dropping anchor in Tenerife to refuel before eventually heading back to Southampton.

I ended up being marooned on the ship for thirty-three

days. Most of the passengers were charming, but others were a pain in the backside, either bugging me with inanities ('Gosh, aren't you small?') or admonishing me for daring to crack open a cold beer before midday ('You've started early . . .'). And although nobody on board was infected with the virus, thank goodness, super-strict social distancing and mask-wearing rules were enforced, which I found extremely hard to handle.

As a consequence, I ended up spending hour upon hour alone in my cabin. With just myself for company, and with so much time on my hands, I suddenly had the space to think about the past. And it was while sitting on my balcony, surrounded by the ocean, that something struck me. The last global epidemic I'd experienced was AIDS, way back in the 1980s. And that's when all the memories came flooding back.

It was in 1983, while performing in New York, that I first heard mention of this mysterious disease. I remember visiting the West Village only to discover that many of the bars and clubs were closed, due to a virulent disease afflicting many gay men in the city. I then started to hear stories about people dying in horrific circumstances, particularly in New York and San Francisco. Joe MacDonald, a gorgeous male model in his twenties – and a muse of David Hockney and Andy Warhol – was one such victim. I recall David telling me how this young and healthy Adonis had almost melted away to skin and bone.

Doctors named this disease 'Acquired Immunodeficiency Syndrome', or AIDS. Triggered by a contagious virus called HIV – most likely transmitted through sexual activity, intravenous drug use or blood transfusions – it left people

vulnerable to all manner of infections by destroying their immune system. With no cure or treatment, many died of pneumonia, tuberculosis or cancer. I recall an atmosphere of panic and confusion in those early days. I'd never been great at keeping up with news and current affairs – I was too busy rehearsing or touring to read papers or watch bulletins – but this felt too important to ignore. I shuddered as I saw *News at Ten* reports detailing new AIDS cases emerging in London. Would I be among the casualties one day? Was this disease going to take me? Before then, I'd never really considered my mortality. It was terrifying.

Soon, people began to drop like flies. To see them struck down so quickly was frightening. The creative and artistic industry, with its high quota of gay and bisexual employees, was hit particularly hard: throughout the mid-to-late eighties, it seemed everybody in film, theatre and television knew somebody with AIDS. I was devastated when my friend Julian Hosking, a Royal Ballet soloist, succumbed to the disease. He'd become infected after his first affair with a gay guy, having just come out of the closet, and died at the tender age of thirty-six. It became evident that AIDS had no mercy. Someone like Julian could fall victim after one single encounter, while others who'd enjoyed gay affairs for years managed to escape the virus. It was a lottery; the luck of the draw.

At that time, I was under the care of a private GP in Harley Street, Dr Vance, an eccentric chap who wore a pince-nez, a high-collared shirt and a tailcoat, with a silver vial of water pinned to his lapel containing a yellow rose. One day, while I was providing him with a routine blood sample, he gently suggested I take a simultaneous HIV test. Many people

preferred not to, as they were fearful of testing positive and living with a death sentence, but I had no such qualms. I needed to know either way. If I was a carrier, the last thing I wanted to do was spread the virus to somebody else. If that was the case, I wouldn't go near another man.

'I'll have to book you in under another name,' said Dr Vance. 'A sign of the times, I'm afraid.'

It seemed there had been instances of nurses and lab technicians leaking celebrities' HIV test results to the press, so he chose a suitably exotic pseudonym as cover. Wayne Sleep became Omar Khayyam. I liked it. It made me sound like a Middle Eastern prince.

Much to my relief, the test came back negative. But it did make me pause for thought. Had I relocated to America in the 1970s, I wondered – maybe living the dream as a New York City Ballet principal – would I have put myself more in harm's way? Was remaining in Britain one of the best decisions I ever made?

'Goodness me, how you're still alive I'll never know,' said George when I put him in the picture about the HIV results.

'Charming,' I replied. By now I was well-accustomed to his dry humour.

George had settled down with a rock music critic and publicist called Nick, a lovely guy with angelic looks and a great personality. They'd met in the early seventies at the first night of an avant-garde musical called *The Point*, created by my songwriting friend Harry Nilsson. After some cajoling, I'd taken on the leading role during its short run at London's Mermaid Theatre. I'd been terrified about singing in front of this hipster audience – I'd had recurring nightmares about

opening my mouth and just a squeak coming out – but after a few sessions with a voice coach, I found my voice.

After the show, my match-making instincts led me to introduce Nick and George to one another and, sure enough, they hit it off immediately and soon fell deeply in love. I felt an element of relief, to be quite honest. I'd been burdened by guilt since our break-up – George was a decent man who deserved romance in his life – and it was great to see him finding happiness with a new partner.

However, in the early 1980s, his beloved Nick fell ill. His constant nausea and fatigue led to an eventual diagnosis of terminal leukaemia and he was admitted to a London hospital. George was devastated, as were we all. But when Nick's bloods were taken it was discovered that he was HIV positive. Attitudes towards him changed overnight. He became a pariah. He was quarantined in a side ward with makeshift 'Do Not Enter' notices slapped on the locked door. Suddenly, all the nurses wore scrubs, masks and rubber gloves, some even refusing to go near him. Granted, there was so much confusion and misinformation at that time. Was the virus transmitted via touching, via kissing, via breathing? But this behaviour at the hospital seemed cruel and extreme. The tender loving care had disappeared in an instant and I was beyond incensed.

'He's dying of cancer, not AIDS,' I remember yelling at one of the nurses, when they ordered George and me to gown and mask up prior to a visit.

'We're just following procedure,' she replied with a shrug.

Poor Nick spent the last ten weeks of his life being treated like an outcast. Adding to his anguish was that tabloid

reporters had somehow discovered his HIV status – a leak from a supposed 'close friend' – and, using Nick's showbiz connections as their angle, had run with a front-page splash. Hard though it was, I had to tell him. If I hadn't, someone else would have done. But it was a disgusting intrusion by the gutter press. The media was a cesspit back then. One day, they would try and come for me, too.

Nick wasn't the only young man I visited in hospital during this period. One Christmas, I learned that a friend of a friend of mine, a young man in his twenties, had been admitted to a central London hospital, dying from an AIDS-related illness. His entire family had disowned him (many gay men with HIV were ostracised by their so-called loved ones, sadly) and as our mutual friend was staying in Scotland, the poor boy was on his own. I couldn't bear the thought of him lying there, without any company, and even though I'd only met him once before, I went to see him on Christmas Day. I wasn't enjoying any family festivities myself, of course, since my mother chose not to celebrate. As I walked into his side room, a kindly nurse (some did exist, thank goodness) was bathing a large sore on the young man's cheek, most probably a sarcoma. She allowed me to sit down on Robert's bed. He was spindle-thin, deathly pale and was having difficulty breathing.

'Hi there,' I said. 'I just thought I'd pop by to say hello.'

'That's so kind of you,' he whispered, with a faint smile. That poor boy. It took all my might to stem the tears.

I chatted to him for an hour or so, holding his hand and giving him hugs. I didn't think twice about touching him. Too many people treated AIDS sufferers with fear and loathing, sucked in by all the scaremongering and scapegoating, and

I refused to go down that road. It was so damaging to our community. Much of society persisted in viewing HIV/AIDS as a 'gay disease', which we somehow deserved, and for this reason, it didn't initially receive much scientific attention. Only when straight and bisexual people became infected did the medical world sit up and take notice. Until then, AIDS had been a low priority. Compare that with the Covid epidemic, if you will, which prompted governments to pour billions into research without hesitation.

All in all, it was a hideous time to be gay. Everywhere you turned, you were made to feel dirty or dangerous. But some people went against the grain – most famously Princess Diana. In the late-1980s, she began to pay official and unofficial visits to Mildmay Hospital in Shoreditch, a charitable institution that became a hospice for AIDS sufferers. And in 1987, she opened the UK's first specialist HIV/AIDS Unit at Middlesex General Hospital. Images of this worldwide icon treating dying patients with compassion – sitting beside them and chatting, to prove they weren't contagious – not only helped to smash the stigma around the virus but also served to humanise the gay community.

'That's my girl,' I remember saying when I saw her in a TV report, shaking hands with an AIDS victim.

By changing the whole conversation, and being unafraid to swim against the tide, she prompted a huge shift in public awareness. I was so damn proud of her. My giggling, blushing dance protégée had, against all expectations, become a global humanitarian.

* * *

I'd kept in regular contact with Freddie Mercury throughout the eighties. I was able to watch Queen's show-stealing 1985 Live Aid performance from Wembley Stadium's VIP area, courtesy of an invitation from Elton John's manager, John Reid ('You're my date, Wayne,' he'd said). As Freddie belted out some of their greatest hits – including an electrifying rendition of 'Radio Gaga' – he had the 70,000-strong crowd enraptured. If I close my eyes, I can still see him now, punching the air, resplendent in his white vest and pale blue jeans. A superstar at the top of his game.

'How can anyone follow THAT?!' I said when I embraced him backstage afterwards.

'Oh, thanks very *much*, Wayne. I'm on in ten minutes!' responded a slightly miffed voice behind me, which belonged to none other than Elton John. *Oopsie-daisy.*

Freddie also invited me to his fortieth birthday party in Ibiza. He hired a private jet to transport forty guests to the island, where he treated us to a lavish weekend of gourmet food and vintage champagne, centred around the luxurious Pikes Hotel. His generosity knew no bounds. And there was never any sense of vulgarity or boastfulness when Freddie parted (and partied) with his money; he simply wanted to spread the love and make his friends happy.

Back in London, I continued to socialise with Freddie, whether it was clubbing at Heaven or theatre-going in Soho. Whenever a paparazzi photographer approached us, I'd habitually give my friend a cuddle or hold him aloft because it always made a fun shot for the following day's showbiz pages. On one such occasion, Freddie's doctor, who was part of our friendship circle, urged caution.

'Be careful, Wayne, I'd rather you didn't do that,' he whispered in my ear, as I went to lift Freddie up. So I did as I was told, assuming my friend had hurt his back. A few weeks later, however, I spotted a photo of a thin-looking Freddie with tell-tale sores on his face and everything fell into place. No wonder the doctor had been so protective – my friend was ill. Very ill.

As his health deteriorated, Freddie effectively withdrew from society. I tried to contact him but was politely informed by Peter, his personal assistant, that he only wished to stay in touch with his closest friends and family members. This state of affairs upset me greatly but I had to respect Freddie's wishes. He was an incredibly proud and private man who clearly didn't want me to see him so poorly. On 24 November 1991, I was heartbroken to learn that he'd died from AIDS-related bronchial pneumonia. Sadly, the tabloids had already got wind of his illness and, just a day before his death, he'd been forced to go public before these vultures beat him to it. But he left us with that iconic song 'Who Wants to Live Forever'.

Freddie's death deprived me of a friend – and the world of a genius – but my memories of him will linger forever. I'll never forget his kindness, his generosity and his zest for life. And I remain convinced that we'd have eventually created that Covent Garden rock-opera-cum-ballet, no doubt mapped out while sitting at his grand piano while fantasising about fifty-piece orchestras and first-class choreographers. Let's stage it up in heaven one day, Freddie my dear.

Sadly, Dame Margot Fonteyn passed away in the same year – she'd endured a long struggle with cancer – and two

years later we also lost Rudolf Nureyev. Rudi died in a Parisian hospital aged just fifty-four, yet another victim of that dreadful four-letter disease. We'd lost touch as time had passed, but that didn't make the news of his death any less upsetting. We'd experienced our ups and downs over the years – I'd often borne the brunt of his infamous temper – but no one could doubt he was a trailblazer. Men's ballet owed everything to him.

Kenny Everett would be another we lost to this disease, in 1995. I still lament the artistic talent that AIDS stole from us. For years, that awful epidemic caused a famine of new ideas and a desert of creativity, and I can't help but imagine all the dances that were never performed, all the parts that were never played and all the songs that were never written. Far too many bright lights were snuffed out and we must never, ever forget them.

In my early forties, I decided to put my *Dash* show to bed. There came a point where I felt it had run out of steam. The format had become a little tired, I reckoned – there were only so many sports that I could satirise – darts, snooker, horse racing, American football – and I'd covered every break-dancin', body-poppin' craze going. I'd tried to reinvigorate the show with new numbers (my Torvill and Dean ice-dance routine, alias Bournville and Cream, seemed popular enough) and brought in different musicians and choreographers to spice things up. I'd even refreshed the show's name: at various times, it became *Aspects of Dance, Wayne's World of Dance* and then, when inspiration for a title completely deserted me, simply *Dance*.

Adopting the roles of director, producer, choreographer and performer had started to take its toll. I'd had enough of the day-to-day dramas of managing a group of dancers and musicians. I'd had enough of threatening box office staff with the police because I'd caught them fiddling the ticket receipts. And I'd also had enough of having to give interview upon interview to TV, radio and newspapers – or posing for daft photographs – in order to promote my shows and tempt people into theatres.

I remember getting quite ratty and bolshie with journalists who'd ask daft questions – 'Isn't dancing just for girls?' 'What's it like balancing on your toes?' – especially when I was suffering post-performance fatigue. These same reporters would often obsess about my height, proceeding to write pieces about the 'diminutive Wayne Sleep', describing me as doll-like, pint-sized or (as someone once did) 'a manikin matchstick man of little over five foot'. Being defined by the way I looked rather than the way I danced used to irritate me no end.

One tabloid reporter got even more up close and personal.

'I hope this doesn't sound rude, Wayne, but my editor wants me to ask you something,' she said, reddening slightly. 'Are you gay?'

Is the sky blue? I laughed to myself. *Do chickens lay eggs?*

'Don't call me gay, call me happy,' I answered, with a knowing smile.

This off-the-cuff remark became the article's headline, of course, and some readers will have doubtless read between the lines and drawn their own inferences. But seeing these words writ large made me yearn for the day

that I could finally quit the euphemisms, come out of the closet and be my authentic self. But that wasn't going to happen for a long time. Certainly not while my mother was around.

This tabloid treatment, however, was mild in comparison with what happened in the aftermath of Freddie's passing, when I received a strange call from a London publicist. Connie Filippello represented the likes of George Michael, Mariah Carey and Donatella Versace, but had recently added me to her books. If you were in need of some positive PR, she was the best in the business, as she knew all the movers and shakers and got invitations to the glitziest showbiz parties. She'd often joke that I was her buy-one-get-one-free, though.

'If you want George Michael at your launch, you've got to invite Wayne Sleep too,' she'd say to her clients. I didn't mind one bit. It gave me access to all the best VIP events and allowed me to get my face in the papers, which meant free publicity for whichever show I was trying to promote (and extra ticket sales as a result). Once, she tried to get me some column inches by telling the media I was getting engaged to a woman (I can't even remember who she was). But this led to reporters ringing her back, saying, 'C'mon, Connie, pull the other one, we're not going that far!' They weren't daft. They knew the score.

One Thursday night, a couple of *News of the World* hacks turned up at my home, demanding a comment on a story they planned to run that I had AIDS. I slammed the door in their faces and stood letting this bombshell sink in for a few moments.

For the next twenty-four hours, a handful of journalists camped outside in their cars, occasionally venturing over to my letterbox to post abusive notes or to shout insulting messages.

'Come out, Wayne, we know you're dying!' one yelled.

Connie called when she heard what was happening.

'Let them f***ing print it, Connie, because I *haven't*,' I raged. 'And I've got proof. I've been tested. Tell those f***ers I'll see them in court.'

Their evidence, apparently, was a paparazzi photo of me looking haggard and unkempt on the way to rehearsals one morning – which wasn't unusual, as I could look like a bag lady. Add into the mix my close friendship with Freddie, my newsworthy status as 'Princess Diana's favourite dancer', plus a ghoulish tabloid fascination with 'the gay plague' and I was suddenly a story. But it was a total fabrication.

It was obscene, it was grotesque, but I wasn't going to rise to the bait. I just closed the curtains, switched off the lights and spent time with my Canadian choreographer friend Trudy Moffatt who was staying with me in London for a few days and didn't know what had hit her. I was determined to stick it out, sue and await the hefty compensation pay-out. Print and be damned!

But Connie ordered me to get legal – pronto – in order to block the story, once and for all. Mud would stick. Even when we proved that the article was an outright lie and a clear case of defamation, the story would already be in the public domain for everyone to see. If I wasn't careful, she told me, I'd become persona non grata in the entertainment world.

'Your career might be over if this goes to print.'

'OK, Connie. Point taken.'

I managed to locate a lawyer, a high-flying hotshot who knew my friend the socialite Lady Edith Foxwell.

He came straight to my house and fought his way through the paparazzi.

'What's the problem?'

'I don't have AIDS and the *News of the World* is threatening the story.'

I later found out that he had secretly asked Trudy if I was actually HIV positive because he didn't know how to represent me and thought I might be lying.

When I came back in the room, he asked if I had any proof. I replied 'Yes' and showed him my test results.

'But this isn't in your name, Wayne Sleep.'

To which I roared with laughter.

So he was still unsure.

He nervously grabbed the phone and called the *News of the World*, asserting that we had test results that could prove I was HIV-negative. The fact they were in the name of Omar Khayyam might have blown my case out of the water, as it happened. Luckily, the editor didn't demand proof.

'So are you going to print the story tomorrow, then?' asked the lawyer. 'Because we'll come after you if you do.'

'You'll just have to buy the paper and see,' came the reply.

It was so cruel and callous to keep me dangling like that. I was so sick with worry and I knew I wouldn't be able to sleep.

Just past midnight, my lawyer turned up at a Piccadilly Circus newspaper kiosk, awaiting the arrival of the first edition of the *News of the World*.

'D'you want to know the good news or the bad news?' he said when he phoned me. 'The bad news is you can't sue them so you're not going to be rich. The good news is that they've not printed the story.'

'I know which option I'd prefer,' I replied, with a huge sigh of relief.

This press intrusion had a massive impact on me. These reporters had wanted me to be at death's door, just to get their scoop about 'Diana's favourite dancer'. It was a terrible way to treat a fellow human being and it made me wonder whether the showbiz world was for me anymore.

For me, the early 1990s was full of bad news. My mother became unwell, developing chronic arthritis that badly affected the movement in her hands and wrists. To numb the pain, and to help her sleep, she took much more paracetamol than recommended on the packet. This gradually took a toll on her vital organs – she was slowly and unwittingly poisoning herself – and in the early hours of 2 June 1995, I received a distraught call from Joanne informing me that our mum had died during the night. An ambulance had been called after she'd collapsed, but it was all too late.

My reaction was a mixture of shock and sorrow – she'd been ill for a while but not gravely so – but I didn't cry. In fact, I rarely cry when people die. I've shed a tear at live recordings of Édith Piaf singing 'Milord', or Kelly Holmes winning an Olympic gold double, but not necessarily when convention dictates I should. Witnessing human beings at the peak of their ability is what makes me bawl, especially

if they've triumphed over adversity. It chimes with my own experience, of course. No psychoanalysis needed there.

But in the aftermath of my mother's death, I experienced another emotion that rather took me by surprise: relief. Finally, I no longer had to hide my sexuality. With no further need to protect my mother, I could live freely and happily as a gay man. At long last, I wouldn't have to lie to family, colleagues and journalists for my mother's sake.

The Princess of Wales, true to form, sent me a touching note. She wrote that she was thinking of me at this difficult time and told me that my mother was a wonderful lady who was full of life and who added sparkle to any occasion. She finished by assuring me that Mum was enormously proud of me.

The funeral took place in the local Kingdom Hall. Atop her coffin, I laid a bouquet of woodland fern, bracken and wildflowers – primroses, bluebells and foxgloves – that covered the entire coffin. I knew she'd have liked it, as it would have reminded her of the Devon countryside. I wasn't a fan of the service – I took exception to the minister's over-bearing and over-familiar references to 'Joan, our sister' – but I endured it, for her sake.

At the wake, which took place at my mum's house, I found myself sitting beside Stan in the bedsit room across the corridor, which in recent years Mum had rented to him for ten pounds a week. 'He's lucky he's still under the same roof,' she'd often said to me, referring to the fact that their marriage was virtually non-existent. 'A tenner is the least he can offer.'

Stan felt he needed to tell me the circumstances of my

mother's death – apparently, her last words were 'Barbara, I'm in trouble . . .' – although he was barely able to speak through his wheezes. I felt a rare pang of pity for my step-father. He hadn't had the happiest of lives. His career hadn't gone the way he had planned, having given up a decent job in Plymouth only to end up in a brickworks in Hartlepool. And his home life hadn't been brim-full of joy, either, with a relationship that had become more like a tenancy agreement than a marriage. And, as he dwelled upon my mother's dying moments – rather inappropriately, if you ask me – I was struck by the fact this was the first proper conversation we'd ever had. And it would likely be our last.

'Well, I'd better be off,' I said, when I'd had enough of his company.

'Alright then,' Stan replied, with his palms on his knees and his eyes downcast.

That was it. No 'take care' or 'see you soon' from either of us. I knew, and he knew, that we wouldn't keep in touch. We knew we had nothing left to say to each other. He died a year later.

So, following my mother's death, and the winding up of *Dash*, I felt a little rudderless. My friendship circle had diminished (more had died of AIDS, such as filmmaker Derek Jarman) and, ever since I'd split up with a recent boyfriend, I'd had no love in my life. Whenever I came home to London during a break in my schedule, I suddenly found I had few friends to go out with. *Where is everybody?* I'd ask myself. The truth was that I toured so often; people had just stopped bothering to phone me at weekends because I was never home. The only constant in my life was George, with whom

I often shared a refined meal à deux. My best friend was always there for me, through thick and thin.

To fill the social void, I'd often seek the company of other people (one night, I even persuaded the builders working on my house in Queensberry Mews West to have a night out on the tiles). It was all rather shallow. I had a wild time with actor Oliver Reed, too. I'd first met Oliver back in the late 1970s, while sharing a dressing room in a Royal Gala performance.

'What are you putting on tights for, Willie?' he'd asked, as I'd got myself ready. He continued to address me as Willie Carson, and even went as far to ask what happened in the 2.30 race yesterday.

It was easier just to go along with it, so I said, 'Oh, the horse went lame.'

(He wasn't the only small celeb I'd get mistaken for. People often confused me with singer Leo Sayer, who shared my height as well as my curly hair. He confirmed the opposite was the case, too, when we finally met at a function and compared notes. Out in public, I'd often hear shouts of 'Give us a tune, Leo,' and he'd hear 'Give us a twirl, Wayne'. I told him that I was so fed up of being asked for his autograph and he said that he was so fed up of being told how well he had danced in *Swan Lake* the night before.)

My night out with Oliver Reed involved consuming copious amounts of alcohol and reciting Shakespeare in the Groucho Club (where women literally flung themselves at him). One of the women said, 'Oh, you're so small, Wayne Sleep.'

'Stop calling me small! Come on, Oliver, we're leaving.'

And as I left, somebody shouted: 'Goodnight, Shorty.'

We then went out to dinner at Bentley's fish restaurant in Mayfair and I had to call his wife in Guernsey and tell her: 'Don't worry, I'll look after your husband.'

I kind of became his minder. It was like a St Bernard and a Jack Russell going out on the town.

This concluded with an after-hours visit to his aunt's grand apartment in Knightsbridge, supposedly, which went a little haywire when he banged on the wrong door and woke up a completely different household.

I said, 'Hello, Oliver's auntie.'

She looked in horror. 'I don't know either of you,' and slammed the door in fright.

I suppose I was in danger of veering off the rails. Not only did I begin to suffer with terrible hangovers, I also experienced memory blackouts. George would often have to remind me of the things I'd got up to the night before, which came and went in a blur. At one point, he and I both realised we were drinking too much and made a joint appointment to see a Harley Street specialist. It didn't do us much good. Forty-five minutes talking about alcohol intake gave us the thirst, and as soon as the consultation finished, we headed for a nearby hotel and ordered two bloody Marys.

But never before had I felt so low. I had fame, success and solvency, but with no one to spend my time with, or share my life with, everything felt utterly meaningless. And that's when it suddenly dawned on me. I remember dragging myself out of bed (probably to grab something to eat) and

immediately falling back onto the mattress, feeling as weak as a rag doll.

'You're *lonely*, Wayne Sleep. You're very, very lonely,' I said to myself.

And then I went to Spain, and everything changed.

In the late 1980s, I'd bought a small, one-bedroom apartment in the resort of Aguadulce, south-west Spain, with George and a very good mutual friend of ours, Ilona Herman. A Czech make-up artist who worked in the film industry, she'd discovered that Sean Connery's stunt man was selling his holiday home at a bargain basement price. While the flat had had lovely, unobstructed views of North Africa and the resort was guaranteed rain for only eight days of the year, the place itself had little character, and wasn't particularly pretty or glamorous. There had been rumours that a beach was to be built using red sand from the Sahara, triggering the construction of a big yachting marina, but neither had materialised. Thus, Aguadulce hadn't become a honeypot for British sunseekers, as initially planned, and was largely visited by vacationing Spaniards.

In October 1995, in desperate need of a restorative getaway, I decided to escape to my bolt-hole for a week. I also needed somewhere quiet to research a new show, *History of Dance*, which ran through dance styles, from the Lindy Hop to the can-can. I'd been unable to resist a thirty-two-week tour, despite putting *Dash* to bed; part of the appeal lay in the fact that I was just being asked to perform and choreograph, with the producing responsibilities being delegated elsewhere.

On the second day of my trip, I visited my favourite eatery,

a seafood beach hut. It was owned by a German woman called Michael (yes, the male spelling) and her Spanish husband. As I enjoyed a nice platter of fresh sardines for lunch, while scribbling a few notes, a young man came over and plonked himself down at my table. With his deep tan, dark eyes and wavy brown hair with blond flecks, he reminded me of George Michael. *Gorgeous.*

'*Hola,*' he said, with a cheeky grin.

It was then that I recognised him. The previous night, Michael had taken me to a new cocktail bar that a pair of twenty-somethings had opened in the town. It was a stylish little place, with rock music on the stereo and fashion mags on the tables. My margarita was so good that I left one of the bar-owners a pretty generous tip. Twenty-four hours later, the man himself was now sitting beside me in the beach hut.

He introduced himself as José Bergera, although his English was as basic as my Spanish. Through a mixture of sign language and scribbled doodles, I gathered that his family were from the Basque country, in northern Spain, but had relocated to the south when he was young. The attraction between us was instant – it spoke louder than our words – and I took the liberty of inviting him back to my place for the afternoon. In spite of the language barrier, I found him very kind, warm and funny, and the fact he clearly had no idea who I was made me like him even more. My *News of the World* encounter had made me paranoid about meeting new people – I always questioned their motives – but I had no such qualms with José.

At one point, my housekeeper knocked on the front door, chatting away in my hallway about some errand or other.

When she left and I returned to the bedroom, José was nowhere to be seen. I thought he'd sneaked out. But then I found him hiding in the wardrobe, hugging his knees, petrified that he'd be spotted by my cleaner. He didn't have to explain. His body language said it all. Homophobia was still rife in Spain, and being seen in another man's flat would have got the whole town talking. In that moment, he seemed so sweet and vulnerable, and my heart ached for him. I'd spent decades hiding my true identity, for fear of upsetting my family, so I knew exactly how he felt.

That night, José invited me to a restaurant with a group of friends. Amid these fresh-faced twenty-somethings, though, I felt like the oldest swinger in town. Being two decades their senior felt all too apparent and I found myself gripped with anxiety.

This boy is far too young and pretty, said a voice in my head. *He won't want to waste his time with an old fart like you. Don't do it to yourself. You'll only be disappointed . . .*

I hadn't gone to Spain looking for love; in fact, it had been the last thing on my mind. I'd been so scared of rejection – and I was still worried about AIDS, despite recent (and hugely welcome) news of breakthrough anti-HIV drugs. I'd simply given up on the idea of meeting someone. I'd resigned myself to the fact that I was too old to fall in love and would live the rest of my life as a singleton.

I decided to nip things in the bud, there and then. Pursuing this Spanish boy was futile – I'd only end up getting hurt – so I slipped out of the restaurant and headed out into the night, back home to my apartment. But two minutes later, I felt a hand grabbing my shoulder.

'Wayne, no, no, no!' said José, breathless from running after me.

'Are you sure about this?' I replied, as my heart pirouetted.

Within a day or so, José had sussed out who I was. Someone had recognised me and unearthed an old *Hola!* magazine featuring photos of me with Princess Diana. Once I bowed to popular demand in José's bar and showed off a few steps – a bit of ballet, a bit of tap – my cover was well and truly blown. My beau seemed impressed but not remotely awe-struck. A good sign, I thought.

When the time came for me to return to England, following an idyllic week in Spain, José promised to keep in touch. Once I was back home in the UK, he and I had many conversations courtesy of his English–Spanish dictionary, the pages of which I could hear him rustling down the line. What became clear was that he wanted to come over and see me in London and was planning to buy a plane ticket.

So, a fortnight later, I found myself in Gatwick Airport, virtually jetéing my way through the terminal, such was my excitement to greet him in arrivals. I hadn't felt this head-over-heels for a long time. When mine and José's eyes met, we beamed at each other, and he uttered just one word: 'Wayne'. At that moment, I wondered whether my mother had sent this beautiful boy to me, as a gift from God. Maybe she wanted me to be happy, even if it was with another man.

The poor bloke had a baptism of fire, though, because his first evening in London was spent at Kensington Palace, in the company of Princess Margaret. I'd been asked to direct a gala for the royal family, not dissimilar to the *History of*

Dance, and had a committee meeting scheduled in the diary. This was our first meeting about it, and since José had only just arrived in this big, strange city I didn't feel I could leave him on his own, so I brought him along. Much to my chagrin, he refused to let me buy him a pair of Russell & Bromley slip-ons, and rocked up to 'KP' in Doc Martens, rolled-up jeans and a silver nose ring. *What on earth will Princess Margaret think?* I asked myself.

I needn't have worried. The Princess was remarkably nonchalant about José's casual appearance and was genuinely pleased to meet him.

The rest of the committee were extremely kind to José, too with royal aide Roger Bramble attempting some Spanish by cheekily suggesting I was *'poco loco, poco loco'* (translation: a little bit crazy).

Within a few weeks, the work had been completed on the Mews and, after nearly twenty years of living alone, I now had a new housemate. Not long after José's arrival, it had become clear that he'd bought a one-way plane ticket, so it looked like he was here to stay. Credit to him, he was very keen to learn the language and become self-sufficient – he'd eventually secure a good job at Pret à Manger – but for a while, I employed him as my dresser while touring *History of Dance.* His temperament could be as volatile as mine – there was a reason his family nickname was 'TNT' – so there'd often be fireworks backstage between the acts. My quick changes were often more exhausting than the skits themselves.

'The trousers first, NOT THE F***ING JACKET!' I'd scream as I climbed into my Charlie Chaplin suit with seconds to spare.

'That's what I'm F***ING DOING!' he'd yell back, displaying a new-found knowledge of English expletives.

It was utter chaos. We'd be spitting venom at each other as props, garments and accessories went flying. And then moments later, I'd skip back onto the stage, more often than not with a cock-eyed bowler hat and a skewwhiff moustache.

Once, when he was helping me out at a gala, he saw a dancer propping up her legs on my designated chair while she put on her pointe shoes.

'That's Wayne's chair, *get off!*' he hissed, having no idea who she was.

'Oh, I do apologise,' said prima ballerina Darcey Bussell, the most famous British ballerina since Dame Margot Fonteyn. *Oh, José.* Luckily, I was able to smooth things over.

But despite the odd row and quarrel, and the language barrier, and the twenty-year age gap, my partner and I were exceedingly happy. José felt far more relaxed about his sexuality in cosmopolitan, liberal London and, for the first time in our lives, we were both happy to be ourselves in public. It was official: we were an out-and-proud gay couple. José even felt strong enough to tell his family back in Spain that we were an item and received the most beautiful letter from his father, assuring him of his parents' unconditional love. We were both in floods of tears when we read these heartfelt words. They meant the world to us.

José never had the pleasure of meeting Princess Diana, sadly. Following her separation from King Charles, in 1992, I hadn't seen much of her either, owing to the fact that she'd loosened many of her charitable links with the arts world, which meant

our paths rarely crossed at first nights and galas. And I had to be brutally honest with myself: now that she wished to be taken more seriously for her humanitarian work – particularly with a landmines charity – she probably thought it unwise to be associated with a court jester like me. Indeed, I'd already got the distinct impression she was becoming rather irritated with the 'Diana's favourite dancer' tagline. I remember her once asking me rather pointedly if I was ever planning to retire, the implication being that it was high time that I did. It was a legitimate question, though, and one that I'd also been asking myself. Dancers usually retire from principal roles at the age of thirty-five and she'd obviously been told that I was past my sell-by date, but I was doing something completely different, working in a world where retirement wasn't necessary.

Looking back, however, I suspect she'd been fed lines by certain members of the English National Ballet (of which she was patron) who turned their noses up at me for being a commercial artiste. I imagine they'd advised her to disassociate herself with a has-been who no longer danced with the Royal Ballet. Whatever the truth of it, over time, our giggly lunches, chatty notes and jokey cards petered out. But I bore her no ill will. I totally appreciated that her priorities had changed.

But I believe there was another factor, too. With all manner of anti-Diana stories being planted in the press, she'd become paranoid about who she could and couldn't trust. In point of fact, one of her last notes to me, thanking me for a birthday gift, alluded to her every move being followed by the press. Then, in 1995 – and much to my horror and

surprise – twenty-one photographs of our 'Uptown Girl' pas de deux were published in a British newspaper, to great fanfare. Previously unseen, these atmospheric black and white images showed the Princess and I striking various poses on the Royal Opera House stage, she in her lovely white dress, me in my shirt and slacks. With no video footage in existence, these snapshots gave the world its first ever glimpse of our famous dance.

The tabloid chequebooks had been opened to someone, quite obviously, but that someone wasn't me. I wouldn't have dreamed of betraying her confidence. Though Diana will have known I wasn't the culprit, from that day onwards, I sensed I was being given the cold shoulder. Though it was a shame that our relationship had changed, my respect for the Princess remained undimmed. I'd always treasure those wonderful memories we made together, particularly on the stage of the Opera House.

On Sunday 31 August, 1997, I'd gone to bed in the early hours, having had a late night out in the West End with friends. I remember my phone ringing around 4am but I just ignored it, assuming it was either a wrong number or an issue that could be dealt with later in the day. But then, a few hours' later, I heard someone hammering on my front door. Standing on the step, in floods of tears, was a PR consultant I was working with at the time. And that's how I learned of the death of Diana, Princess of Wales.

I spent the rest of the day in a daze. I was too dumbfounded to cry. I simply couldn't believe that she'd gone and that those poor boys had lost their mother.

The following week, I attended the state funeral. Prior to

the ceremony, I was privileged to be interviewed by dozens of television networks, from all corners of the globe, about my unique friendship with the Princess. As I explained how she'd championed ballet with such passion and dedication, I felt I was speaking on behalf of the entire dance world. We would be forever indebted to Diana, and it was our duty to preserve and celebrate her legacy.

The most surreal part of the day, perhaps, came as I made my way to Westminster Abbey. Each step of the way, I found myself being kissed and hugged by members of the public, most of them sobbing uncontrollably as they expressed their grief. Others grabbed hold of my hands or arms, as if – being Diana's former dance partner – I somehow embodied a physical connection between them and her.

But what touched me most deeply was the poignant sight of tiny pink ballet shoes nestling among the mountains of flowers, placed there to pay tribute to the Princess's love of dance. Oh, how she'd have adored that.

CHAPTER TWELVE

Reality and Reinvention

I OFTEN THINK about Diana, and about what she might be doing now. What plagues me the most is that she never saw her boys grow into adults. To me, that was the real tragedy of her untimely death. She loved them both to bits.

'My boys can be very mischievous,' she once said to me, while were having lunch at my house. 'And d'you know what I tell them when they're being naughty, Wayne?'

'What's that, Ma'am?'

'If you don't be good, boys, I'm going to send you next door to Auntie Margaret!'

She had such a fabulous sense of humour. I miss that so very much.

Doubtless, the Princess would have been quite amused to see me getting my Order of the British Empire in 1998. I was rather concerned about the reception I'd get on the day. Whenever we'd met socially, King Charles had been perfectly courteous, but I suspected the famous dance – and my association with 'Team Diana' – had blotted my copybook. This was born out by a conversation I had with the policemen at the Buckingham Palace gates, prior to the investiture.

'We've been having some fun with you, Mr Sleep,' they said, admitting they'd had bets among themselves about how long His Royal Highness would converse with me. 'We reckon twenty seconds, maximum.'

'Let's see, shall we!' I laughed.

When I finally came face-to-face with the Prince for the formal investiture, I was so thrilled to be in his presence that I could hardly let go of his hand. He was very charming. I definitely spoke to him for longer than twenty seconds, ignoring the protocol which dictated I had to step back once His Royal Highness relaxed his handshake. Outside the palace, I gleefully informed the policemen that they'd lost their bet.

A far more important ceremony in my life (but on a less grand scale, perhaps) took place almost ten years later at Chelsea town hall, where José and I celebrated our civil partnership. Just three years before, it had become legal for same-sex couples to tie the knot, a remarkable milestone that ended a history of intolerance and inequality. Having lived together for over a decade, we felt ready to make things official. We joked that José was marrying for love and I was marrying for money, but it wasn't too far from the truth. I was thrilled to make a lifelong commitment to my beau, of course, but was also conscious that a civil partnership bene-fitted us legally and negated costly death duties. Who says romance is dead?

Our 'wedding' day was a very simple affair. We only invited a dozen or so close friends to the ceremony, including George and his partner Jamie. I didn't ask any of my relatives – a gay wedding really wasn't their thing – but, in all fairness, I never received any kick-back from them in the aftermath.

I still don't today. Their tolerance, albeit stopping short at acceptance, is good enough for me.

While it was lovely to tie the knot, it happened slap-bang in the middle of a tour of a new production of *Cabaret*, directed by Rufus Norris, and I remember being absolutely shattered on the day. And such was my organisational ineptitude, outside of my work zone, that José confiscated my golden wedding band, just moments after we'd performed the exchange.

'You'll only lose it, Wayne,' he said, quite correctly.

I'm forever leaving things in bars and on the back seats of taxis, and my precious ring would have probably ended up down a grate.

In all honesty, I'd just wanted to get the ceremony done and dusted. I'd approached it in a very low key, no-frills manner, and hadn't wanted a big, showy declaration of love. José would have preferred a more celebratory occasion, maybe something involving his wider family but – because I was so busy with work – I knocked this back and reined him in. I regret that now. I could have (and should have) made a bigger deal of it. I'm hoping to make amends one day, perhaps a renewal of our vows in Ibiza or the Seychelles.

As I write, José and I are months away from celebrating our thirtieth anniversary together and are still very happy. We disagree about everything, like most couples (we argue most about the house and the garden, as his modernist style clashes with my traditional ways), but we have a very safe and secure relationship. And my ballet and theatre friends adore the bones of him.

'Oh no, where's José?' is often the first thing they'll say if I arrive at an event without him.

'On shift today,' I'll smile. 'He's got a proper job, not like us!'

Speaking from mine and José's own lived experience, I believe the civil partnerships legislation ushered in a bright new dawn for gay people. I've never claimed to be a campaigner – other activists do it far better than me, like the wonderful Sir Ian McKellen – but I believe that in most areas of life, we now have parity and equality, and can go about our daily business without fear of prejudice or persecution. I hardly ever witness homophobia these days (in the UK); I don't feel unsafe or under attack and everywhere I go I'm treated with respect and kindness. A rare exception occurred when José and I received a nasty letter from an elderly lady claiming we were 'turning the area gay' when we moved into our cottage. We found this hilarious – this old biddy clearly thought we were contagious – and we merely ramped up the camp every time we passed her in the street.

I'm so glad that times have changed and society has moved on. I cherish the fact I'm now able to live honestly and openly as a homosexual man, having spent years suppressing my sexuality from the gay-bashing prejudice of the 1960s through to the AIDS-related bigotry of the 1980s. London taxi drivers used to purposely drive past me, shaking their heads – they clearly didn't want 'one of them' in their back seat – but now the opposite is the case; most cabbies talk me into oblivion, asking me about my dancing career and (perhaps inevitably) my memories of Diana. (Although, now I think about it, funnily enough, back in the day, if I walked past a building site I'd quite often hear shouts of 'Hey, give us a twirl', and even now when I hear a wolf-whistle, I think it's for me.)

When I was a young man, I was terrified of police officers – some behaved abominably towards gay men – but, as I walk through London today, the only reason they apprehend me is to say hello and shake my hand. Only recently, I found myself teaching all five ballet positions to a couple of bobbies on the beat in Earl's Court, as people on their way to a football match surrounded us and took photographs. For someone who lived through the dark days, this atmosphere of inclusion and acceptance is truly exhilarating.

The integration of gay people and gay culture has been fantastic to witness. I honestly don't think we've had it so good. Things happen nowadays that would have been simply unimaginable in my youth. First and foremost, and thanks to pioneering organisations like the Terrence Higgins Trust, AIDS and HIV-related healthcare is now discussed openly and sensitively, without the fear and misinformation of yester-year. In the world of medicine, business, politics and sport – and most other employment sectors – gay and lesbian people are not only represented but also have a voice. And when a primetime TV show like *Strictly Come Dancing* features a same-sex pairing, which performs a routine cele-brating love and romance between two men, I know that the landscape has changed and we're living in enlightened times.

While I'd never officially retired from the Company, back in the 1990s, there'd been some signs that we were further drifting apart. After nearly twenty years, my status as senior 'principal' had been quietly removed, although I'd occasion-ally return to Covent Garden as a guest artiste. In 2003, I performed in a revival of Ashton's *Cinderella*, taking on

his Ugly Sister role alongside Anthony Dowell. The reviews were a little patchy, sadly. In hindsight, we should have known better that to try to follow in Ashton and Helpmann's footsteps, as that partnership was beyond compare – they were like ballet's version of Morecambe and Wise, able to feed off their natural affinity and affection for each other.

'I always thought we'd finish up at the end of the pier, Wayne, and here we are . . .' I remember him saying to me, with a grin.

So as my professional relationship with the Company began to ebb, there came a day when I no longer needed to seek permission to appear in other productions and programmes, which was telling in itself. In the past, every appearance had required their consent, with an appropriate credit 'by kind permission of the Royal Opera House, Covent Garden', but now it seemed I was at liberty to do what I wanted. It felt exciting and terrifying in equal measure. And as I faced a whole new world of uncertainty, the sage advice of two great women rang around my head:

'Tenacity, dear Wayne, tenacity.' (Dame Margot Fonteyn).

'Now, get on with it!' (Dame Ninette De Valois).

In the mid-2000s I returned to the wonderful world of Shakespeare and signed up for a few seasons with some touring theatre companies, including the British Shakespeare Company. I was cast in a variety of roles – including Puck in *A Midsummer Night's Dream* (who felt like my alter-ego, I'd danced him so often) and *Twelfth Night*'s Feste the fool – as well as the requisite ensemble cameos. My pay packet was meagre and the production budgets were low, but that didn't deter me. I was quite happy to tread the boards in

moth-eaten monks' habits and charity shop sandals if it meant enjoying regular and rewarding work.

Moving out of my comfort zone wasn't easy, though. Dancing came naturally to me, of course, but acting demanded more blood, sweat and tears. Delivering my lines while controlling my movements required incredible focus, but my experienced cast-mates offered me lots of help and guidance. I very much appreciated their support and almost forgave those who insisted upon referring to the most revered playwright of our times as 'Shakey'. Ugh.

In the summer season, we held a number of open-air performances, usually in the grounds of abbeys, castles and stately homes. The glorious backdrops, coupled with nature's elements, made for a truly magical experience. Oddly enough, the rain-soaked performances were among my favourites. The other cast members would moan and complain about the conditions, but I positively gloried in them, sliding in the mud and sploshing in the puddles as Puck.

Sometimes people in the crowd would recognise me – perhaps unaware I'd branched into acting – which would often disrupt proceedings.

'Eh, isn't that Wayne Sleep?' a woman once yelled in a broad Yorkshire accent during a production of *Romeo and Juliet* at Kirkstall Abbey, just as my cameo character, a monk – sporting an oversized habit and sandals, looking like Dopey in *Snow White and the Seven Dwarfs* – had slowly and solemnly entered the stage to deliver an important message to Juliet. This moment of high Shakespearean drama ended up descending into farce as my fellow actors – including Juliet, who was laid on the tomb – shook with laughter.

I'm sure the Bard, who liked the odd joke himself, would have appreciated the comedy value.

Around the same time, I heard on the grapevine that a movie had been released telling the story of a young, male, working class ballet dancer seeking to escape the constraints of a north-east mining town.

At last, someone's been given the green light to produce that kind of movie, I remember thinking to myself. For some years, I'd toyed with the idea of creating a play about the life of a boy who wanted to be a dancer, but the feedback I'd received from potential backers was along the lines of 'Who wants to watch a play about a gay dancer?' so I'd shelved it. But it seemed that the film's scriptwriter, Lee Hall, was working along similar lines. And while *Billy Elliot* wasn't based on my life per se, further along the line, Hall admitted that he'd gained some inspiration from my story.

I watched the film on DVD and adored it. The scene depicting Billy dancing down the cobbled street, leaping and spinning with unfettered joy, chimed with me so much. I'd done exactly the same as a kid in Hartlepool, darting and skipping along the pavement, challenging myself to avoid stepping onto the gap and lines. And I could definitely detect the influence of my own saga – the working-class setting, the all-important letter arriving from the Royal Ballet School – although the hostility displayed by Billy's family didn't strike a chord, since mine were largely supportive, and my mother was still alive, unlike the mother of the film's protagonist. I even received two or three namechecks in the screenplay, including one where a young friend of Billy's, in an attempt to counter those negative 'ballet-is-for-cissies'

stereotypes, comes out with a memorable (for me!) line: 'What about Wayne Sleep? He's no poof.'

I had to laugh. 'Thank god my mother wasn't alive to see this,' I remember saying to José.

Billy Elliot the Musical followed too, of course, and was a hit around the world (although on Broadway, my namechecks were altered to reference Rudolf Nureyev instead; totally understandable, of course). When the show celebrated its tenth anniversary, I was invited to a special event at London's Victoria Theatre, which saw twenty past and present Billy Elliots sharing the stage in a terrific finale. When the director spotted me sitting in the stalls, he beckoned me up to the stage before introducing me to the cast and the audience.

'Some people might say that Wayne Sleep was the first Billy Elliot,' he said, which was met with rapturous applause. It was a lovely thing to say and it meant a lot.

At the other end of the acting spectrum, I could always rely on the festive pantomime season to keep me busy. I loved the whole panto experience – for me it was a joy, not a chore – and, from my thirties to my sixties, it was an annual ritual. Some snootier sections of the classical world liked to denigrate pantos – *low art, darling* – but I was a big fan, for a variety of reasons. It paid well, for starters, and the box office receipts also helped to keep provincial theatres afloat. It taught me a great deal about acting for family audiences, especially the best way to corpse, ad lib and deliver a double-entendre. And panto classics like *Mother Goose* and *Dick Whittington* provided such marvellous value-for-money entertainment for thousands of kids, parents and

grandparents, many of whom only visited the theatre at Christmastime. It was a win-win all round.

In the early days, I remember being reluctant to admit I was doing panto. I once bumped into Dame Ninette De Valois at a charity Christmas lunch and presumed that, like many of her contemporaries, she'd think I was scraping the barrel and wasting my talent.

'I'm performing *Aladdin* twice every day,' I remember telling her, rather bashfully, when she asked me what I was up to.

'Oh, in my day I did *three* a day,' she replied, 'and Dame Alicia did plenty, too.'

I couldn't believe that this great Dame had performed in panto. Dame Ninette explained that since there were no ballet companies around back then, panto was a way to make a living and the only place they could perform where the ballet section was taken seriously. So if it was good enough for Madam and Markova, it was good enough for me.

Aladdin was my first panto, back in 1978, when I played Genie of the Ring (no sniggering at the back, please) alongside Danny La Rue's Widow Twankey at the London Palladium. It was an early foray into the world of panto for Danny, too, who'd go on to become a brilliant panto dame – the best in the business, I'd argue – with his white bouffant hairdo, his elaborate frocks and his impeccable make-up. Other dames tended to be more masculine-looking (like Les Dawson, whose stubble, pot belly and hairy legs added to the joke), but Danny was an out-and-out glamour-puss. He was a magnificent performer and a delightful person, with a generosity of spirit that I really warmed to. At the peak of

his fame, he preferred to keep his audience guessing. It would have been a professional as well as a personal decision, something with which I could identify.

For fourteen weeks, we had twelve shows per week (mid-November right through to March). But it's harder now for dancers than it has ever been. Previously it was easier, as after the long panto run, there would be a month off for holiday, then straight into rehearsals for the summer season. Performers were always guaranteed work because panto-mimes would start rehearsing in November and would then perform all the way through to March. Now the season is much shorter at Christmas and there is a lack of all-year-round work. So many have reverted to working on cruise ships or as backing dancers for pop groups. Once, I tackled a panto dame role myself. Aberdeen theatregoers were treated to my Gertie, Queen of the Circus in *Goldilocks* – I sang about having 'the biggest pair of bagpipes in the land' – but I wasn't much good. I was much better suited to cheeky-chappy laddish roles like Buttons and Dick Whittington. Hilariously, there were occasions when José got involved in the act. When a cast member dropped out at short notice, I roped in my husband to play the front half of Daisy the Cow in *Jack and the Beanstalk*.

'You want me to do *what*?' he asked. Like most foreigners, the concept of the Great British Panto was completely alien to him.

'Do it as a favour for me, José,' I said. 'You'll be brilliant . . .'

He was, as it happened. His zany antics nearly stole the show. So brilliant was his performance, he was later cast as Dobbin the Horse in *Cinderella*. As the run went on, he

gained confidence and, when leaving the stage, I heard unexpected whoops and cheers from the audience: Dobbin the Horse was performing an impromptu elaborate dance routine.

What many people don't realise, however, is that most pantomime performers seek out very cheap accommodation to make their wages stretch as far as possible. Staying in a hotel or apartment for the whole six-week run, including rehearsals, just eats up your pay cheque. Over the years, I've stayed in a whole host of grotty B&Bs and student halls of residence. When I was starring in Cardiff, I bedded down in a caravan at the bottom of an elderly lady's garden. On another occasion, I found myself seeking a room in Windsor and, not having much joy, I got chatting to a friendly twenty-something, Mark, in a local pub. It turned out he was a big fan of mine – I'd signed some of his ballet certificates when he was young. Unfortunately, Mark had had to give up dancing, but had since become a professional rugby player. As the wine and conversation flowed, he said I could stay in his family's attic room for the duration of the panto run, and at no cost. How could I refuse that kind offer? I'd always loved a freebie and the young lad seemed genuine enough.

So we went back to his house where I met his parents, Richard and Wendy. He then took me up a removable ladder to the attic, where there was a model railway and assorted children's toys, and a lovely double mattress on the floor, which suited me perfectly.

He left and said goodbye, and I remember feeling stuck in this attic. So I phoned José for a bit of comfort, and said,

'I've got free digs, yippee! And the family are such big fans of mine.'

To which José said: 'Don't forget the film *Misery*.'

I couldn't sleep all night.

In the morning (bearing in mind this was December), I looked out of the window and the trees were full of bright green leaves. I thought I was hallucinating, but it turned out that it was hundreds of parakeets, waiting for their early feast of walnuts.

As it happened, the whole family was delightful, and the time I spent in their household was a joy. In fact, to this day, I'm still in touch with Richard and Wendy, who now run a young people's charity on Hayling Island, and have formed a boxing club in the gym, which is proving to be a success. They call themselves the 'Misery Family', which always makes me laugh. Fate is a wonderful thing sometimes.

Pantomime allowed me to entertain children and their families, which I loved, and I was able to repeat the experience (well, frighten them out of their wits, more like) when I joined the London Palladium cast of *Chitty Chitty Bang Bang*, playing the part of the Child Catcher. 'Too Scared to Go to Sleep?' said the publicity posters on the Tube – very clever – which featured a shot of me looking suitably malevolent, with my pale face and pointed prosthetic nose.

With this role, I was following in the footsteps of the great Robert Helpmann, of course. The choreographer, my old friend Gillian Lynne, was delighted that I'd been cast in the role, since I could easily reprise Helpmann's sinister hops and eccentric gestures – previously, the role had been played by non-dancers. The poor kids in the audience were

scared witless. Towards the end of the show, I'd be captured in a net and hoisted on a wire towards the auditorium roof and, as I rose higher and higher, I'd pass within inches of the upper circle. It gave me plenty of time to ad-lib for all I was worth.

'I know where you live, kiddie-winkies,' I'd snarl. 'I'll be under your bed tonight, while you're sleeping . . . so WATCH OUT!'

After each show, without fail, there'd be at least one mother or father awaiting my emergence at the stage door. They'd beg me to reassure their traumatised son or daughter, who was often clinging to their legs, that the Child Catcher was just a role and wasn't real, and that this nasty baddie wouldn't in fact be hiding under their bed that night. But even though I was out of costume, the tone and timbre of my voice would set these kids off again, and they'd burst into tears as their parents glared at me. And forgive me for sounding callous, but I revelled in it! It proved I was doing my job properly.

In my fifties and sixties, I continued to make more appearances on the television than on the stage. TV loved a good sport who didn't take themselves too seriously so I often got invited onto primetime weekend shows like *Family Fortunes, The Generation Game* and *Noel's House Party*. Indeed, I'm proud to be one of the first recipients of Noel Edmonds' infamous 'Gotcha Oscar', having unwittingly been driven to the point of insanity during a prank involving teaching Mr Blobby to dance *Swan Lake* (this oafish pink and yellow character was being introduced to British viewers for the first time, so please accept my apologies for playing a part in the phenomenon).

Chat shows continued to be good profile-raisers – I can talk for Britain, as anyone who tries to get a word in edgeways will confirm – although there came a point when I stopped receiving invitations onto a certain programme, having made a handful of appearances previously. I've since found out from one of his make-up artists that the host had a blacklist of celebs who were effectively barred from his sofa, never to be invited again. Maybe I was a little too gay for his liking.

I also started to use my height to my advantage. As a young dancer, my stature had always been such a sore subject – I blamed it for limiting my opportunities – but as I got older, I began using it to my advantage, as a positive rather than a negative. My height was my calling card (no other male celebrity was smaller than me, other than Ronnie Corbett, perhaps) and I could so easily play for laughs in a comedy sketch. The ribbing and ridicule never stopped, but now I wasn't so sensitive and could more easily laugh it off.

But the whole television landscape underwent a revolution at the turn of the millennium when a new fly-on-the-wall show, *Big Brother*, was aired on Channel Four. On the face of it, live footage of a group of housemates twenty-four hours a day every day for six weeks didn't sound like a ratings winner ('As if I'd ever go on that!' I remember telling José at the time). But all the real-time rows and romances made it an instant hit – the viewing figures were phenomenal – and the reality show format was born in the UK.

A celebrity version soon followed, as did a host of other similar personality-driven programmes. ITV's *I'm a Celebrity, Get Me Out of Here* was my first venture into this new

territory, in 2003, along with nine other camp-mates. Roughing it in the Australian rainforest really appealed to me – I hoped it might be like my childhood camps in Devon, but with warmer weather – as did the appearance fee. But the main motivation was that I could donate proceeds of the telephone votes to my nominated charity, the Wayne Sleep Foundation. George and I had established it on my fiftieth birthday – the year after Diana died – to help performing arts students with fees and expenses. The charity was in part a tribute to the Princess, as helping budding artists from all backgrounds to flourish had been a shared passion of ours. I'm glad to say that the charity is still going strong, largely down to the hard work of George (who's since retired as a trustee) and my fabulous assistant, Matthew Ryan, who's now directing the charity. This year, we held open submissions and, from a total of 250 applicants, auditioned fifteen students – ranging from classical pianists to musical theatre performers – and bestowed twelve grants. Setting up the foundation remains one of my proudest achievements.

Appearing on *I'm a Celeb* taught me a lot – primarily how to keep my mouth shut and tolerate idiots. My first Bushtucker Trial was hellish. I was dumped into a literal rat-run and tasked with finding keys to unlock combinations, crawling around on all fours with sugary waffles taped to my body as bait (those producers were truly sadistic). Only baby rats were unleashed, thank goodness – adults would have eaten me alive – but feeling them nibbling my ears and gnawing my goggles was still pretty horrific. I squirmed my way through the ordeal – I gave up in the end – returning to

base camp with a paltry two stars. That meant slim pickings for that evening's dinner; most probably one ostrich egg or kangaroo tail between the ten of us. It was mortifying.

'It doesn't matter, Wayne,' they all said.

'Oh, yes it does,' I replied, convinced they thought otherwise.

I'm a Celeb took a toll on me, mentally and physically. A few weeks prior to the show, I'd torn my rotator-cuff joint in my shoulder (my cartilage was virtually hanging off the bone). All the daily camp duties, whether it was collecting logs or cleaning saucepans, caused me excruciating pain.

'Wayne, can you help me pump some water?' Toyah Wilcox would ask every morning. 'Yes, of course,' I'd say, wincing my way through the whole exercise.

Mid-way through my stint, I also fractured my foot, cracking a bone while bouncing on my bed as though it were a trampoline. Moving around became problematic and one day, I got stuck on our communal toilet, the infamous 'dunny', which constituted a highly positioned bucket topped with a plank of wood. Fortunately, ex-footballer John Fashanu came to the rescue and lowered me down.

I'm a Celeb led to a succession of reality TV appearances over the following decade that ranged from *Celebrity Masterchef* to *Celebrity Big Brother*. *Masterchef* in particular was an emotional rollercoaster. In one of the challenges, the contestants were asked to prepare a dish that reminded us of a loved one, so I chose José's traditional paella. The recipe had been passed down through generations of the Bergera family and, whenever my husband cooked it at home, those familiar ingredients and aromas created a deep connection to his homeland and its people. Judges John Torode and

Gregg Wallace were surprised by my offering (I'd done really badly the day before) and loved the story behind the dish. We all ended up in tears. It's amazing how food can make you feel emotional.

When I first received the call to go on *Celebrity Big Brother*, in 2018, I thought I was being asked to do a children's show – I confused 'CBBC' with 'CBB' – and couldn't quite believe that dancing around a studio for kids merited a six-figure fee. When I was put straight, I didn't hesitate. Entering the famed house, alongside the likes of actress Amanda Barrie, singer Shane Lynch and politician Anne Widdecombe was an experience I won't forget easily, and not always for the right reasons. The show relied on creating conflict and stoking division – that was the secret of its success and its stratospheric ratings – but I didn't always play ball. Some housemates goaded me to challenge Widdecombe about her strident views on gay marriage – she'd voted against it in Parliament, apparently – but I refused to be drawn into a debate. It had already been aired and I didn't want to rake over it again. As far as I was concerned, the subject was over. People had the right to have their own opinion, whether I agreed with them or not. I hugely enjoyed the *CBB* experience – I ended up in the final four, thanks to the voting public – and I felt very grateful to be part of it.

The *Real Marigold Hotel* however, which the BBC had first invited me onto in 2015, was a totally different proposition. More documentary than reality show, it planned to follow a group of pension-age celebrities, including chef Rosemary Shraeger, singer Patti Boulaye and darts legend Bobby George, as we travelled through India, comparing and contrasting

how their elderly population was treated to the norm in the UK. This public-spirited, socially conscious programme, filmed in a land I'd always wanted to visit, sounded right up my street.

However, my preparations for the show were dealt a huge and unexpected blow when, just two months before the departure date, I was diagnosed with prostate cancer. As I had no obvious signs or symptoms – apart from my pee becoming more or less a trickle, which I'd put down to old age – this came as a bombshell. I'd visited my GP for a routine blood test and he'd suggested, since I was in my late sixties, I should also have a precautionary prostate blood test (in fact, I was quite surprised to learn that this wasn't automatically part of the package). And, much to my shock, the results showed abnormally high levels of prostate specific antigen (PSA). A subsequent biopsy confirmed the presence of cancer cells and I was advised by the urologist that a procedure would be necessary in order to reduce the risk of the disease spreading. Radiotherapy would take weeks, if not months, so I opted instead for a shorter-term treatment known as brachytherapy, which involved the implantation of tiny radioactive pellets close to the cancer cells.

I felt weirdly calm when I first heard the doctor utter the c-word. Rather than cry or panic, I just told myself that I was in very safe hands, and that the clever consultants would see me right. Rightly or wrongly, I kept my diagnosis from José until the morning of my surgery, simply because I hadn't wanted him to worry himself silly beforehand. He was devastated when I told him, his own reaction far worse than mine.

Filing my cancer diagnosis under the same category as the many knocks, sprains and injuries I'd suffered over the years proved to be a help and a comfort: it was just another of life's little hurdles, a challenge that would be overcome. I got on with the daily business of living and didn't plague myself with bleak thoughts of death and dying. Living through the AIDS epidemic and seeing so many people fade before my eyes had provided me with a certain armour. I'd felt compelled to transmit hopeful and positive vibes to these people, to help them cope with the tragedy, and now was the time to apply that fortitude to myself.

Ever the professional, what worried me most was the prospect of missing out on the *Marigold* experience. For this reason, I chose to tell neither my doctors that I was due to travel to India soon after the operation, nor the BBC about my cancer diagnosis. This was very, very naughty of me, in hindsight, but nothing was going to prevent my trip to India. Not even cancer.

The procedure went well but, four days after the op – and a week or so before my flight to Delhi – I was still laid up in a hospital bed, for reasons beyond my control.

'Until you can pee a certain amount, we can't discharge you,' the nurse told me, brandishing a urine sample bottle. 'You need to reach this measure, here.'

'But I've tried, Nurse, and I can't!' I wailed. 'I don't want to be here anymore . . .'

She gave me a 'not-my-problem' shrug and left me to it. It was so stressful and frustrating. Not until 5.30am the next morning (yes, that glorious moment is still etched on my psyche) did I manage to reach the target. In the early hours,

I'd suddenly recalled my mother's childhood advice to 'whistle if you can't trickle' so I lay there for hours, warbling *I'm leaning on a lamp-post but I'm dying for a pee, until a certain little trickle comes by . . .*

But it did the trick, prompting me to call the nurse immediately to tell her I'd done a wee-wee, like a triumphant toddler. The hospital staff couldn't discharge me fast enough. I hated being inactive and incarcerated and I wasn't the easiest patient to manage.

Looking back, it was highly reckless of me to go to India so soon after my cancer treatment. The three weeks' filming was torturous in places, partly due to running out of my medication and partly due to constant abdominal pain (which, I'd later find out, was an undiagnosed hernia). Indeed, I was struggling with my health so badly as we travelled from town to city – especially in the scorching temperatures – that I felt I had to come clean to my cast-mates. With the cameras rolling, I decided to reveal all about my prostate cancer.

Discussing my diagnosis on mainstream TV had a huge knock-on effect. Within weeks of *Marigold* airing, I became an ambassador for Prostate Cancer UK, helping to break the stigma of this disease by speaking to the press and the public about symptoms like painful urination and erectile dysfunction. In the summer of 2017, I appeared in ITV's *The Real Full Monty*, stripping off to raise funds for the charity along with other celebs like McFly star Harry Judd and Olympic swimmer Mark Foster.

And I know of at least one person whose life I may have saved. At a Buckingham Palace garden party, I got chatting to an elderly couple, our conversation prompted

by my silver man-shaped Prostate Cancer UK lapel badge. It ended with the husband agreeing to go for a prostate check. A few weeks later, I received a letter from his wife, informing me her husband had tested positive for cancer but was responding well to treatment since it had been caught early. I felt so pleased to have been able to help in some way.

Recovering from prostate cancer brought my health and wellbeing into sharp focus. Looking after myself and listening to my body was paramount if I wanted to live long and prosper. Because not everyone is afforded that privilege. Around the same time as my cancer diagnosis, my beloved George was diagnosed with a life-changing disease. For a while, I had been noticing that he was struggling with his mobility; when we went for lunch in Soho, we'd try to cross the road and he'd suddenly stop rigid at the kerb, physically unable to move, and I'd have to help him over. It would then take us twice as long as normal to walk to the restaurant as George slowly regained his movement.

George, David Hockney and I recently had a delightful reunion at my cottage (David and I are still great friends and catch up as often as we can). George travelled by private ambulance, in his wheelchair, and we spent a lovely after-noon in the garden, eating fish and chips and drinking champagne. David and I reminisced about the old times while George – whose brain and intellect is still as sharp as ever, despite his physical impairments – either smiled, grimaced or raised his eyebrows, depending on the story being recalled. Despite the passage of time, our friendship hadn't waned. It was one of the best afternoons I'd ever had.

As George was being taken to the ambulance to leave, David said to George:

'We must do this again.'

To which George wittily replied: 'Do we have to?'

We all roared with laughter.

I didn't regret doing *The Real Marigold Hotel*, despite my physical discomfort. It was while in India – specifically in Jaipur, the Pink City, a place with temples on every street corner – that I rekindled my faith. Something about the vibrancy of my surroundings and the serenity of the people prompted a kind of spiritual reawakening. Despite the poverty and hardship, I felt an underlying sense of peace and contentment among the locals. Everywhere I went, I met happy people, whose faith in a better afterlife helped them to accept their earthly existence. This hope and conviction had such a profound effect on me.

Each morning in Jaipur, I'd get out of bed at 6am to watch the sun rise from the balcony of my hotel room, and would be overwhelmed with wonder and gratitude. Throughout my life, I've felt some kind of godlike presence – like a guiding light, especially on stage – but not since my Church Army and Scripture Union days, when I was ten or eleven, had I felt so . . . connected. It was my own little epiphany.

When I returned home to London, one of the first things I did was dust off the *Bhagavad Gita* that Madam had given me for spiritual guidance all those years ago. This ancient Hindu text had lain untouched on my bookshelf since then, but reading the profoundly beautiful verse – about how you should love yourself and others – immediately calmed and

soothed my soul. It also reminded me of my beloved friend and mentor. Madam had died in 2001 at the ripe old age of 102, yet her kindness and wisdom continued to inspire me.

My fifty-year-old edition may be getting more dog-eared by the day – the pages have browned and frequently fall out – but it still shapes and guides me. Whenever I need to relax and centre myself – perhaps after bickering with José, usually over something trivial – I'll retreat to my bedroom and read a line or two at random. With the *Bhagavad Gita* by my side, I've become a far more mellow, mindful and reflective person. It's changed my life.

Learning about elderly people's wellbeing, which I was able to do in *The Real Marigold Hotel* and its follow-up, *The Real Marigold on Tour*, was a real eye-opener. I'm not a party political person – current affairs isn't my thing – but, from my standpoint, I think senior citizens currently get a raw deal in the UK. Compared with the countries I visited for *Marigold*, our over-sixty-fives don't receive the care and attention from the government that they deserve. And I'd really like that to change.

In China, for example, I saw how the nation's Seniors University provided elderly people with free skills training, enabling them to study for degrees in arts and sciences. This added huge value to their lives, instead of feeling they were on the scrapheap and past their sell-by date. In Japan, businesses were encouraged to recruit the older generation; in shops and restaurants, we were often served by these people, who told us how re-entering the workplace had massively benefited their wellbeing and self-esteem.

And in Cuba, I looked on in envy at the multitude of outdoor activities laid on for elderly people, many of them

reconnecting with old school friends who'd returned to their mother country after decades of living and working abroad. And when the rainy season arrived, these groups were able to convene in custom-built meeting places (often derelict mansions, renovated on the orders of Fidel Castro) where they could play bridge and board games. It was all so heartening and inspiring, and it gave me much food for thought.

Over the past decade or so, and prompted by my *Marigold* experience, I've become a great advocate for senior citizens in the UK. In honour of my mother's memory, who volunteered with the Royal Voluntary Service many years ago, I have worked with the RVS, which has given me a real insight into the problems the older generation face. On the whole, they're neglected, in my opinion. I agree with the actress Patricia Routledge, who once told me that while medical care has advanced, social care hasn't.

'You can give us the means to live longer, but you don't know where to put us,' she said, quite rightly.

But the RVS (with Queen Camilla as its patron, who I enjoyed meeting and sharing with some lovely stories about India) is doing great work to tackle this issue, and I've had the privilege of visiting village halls, sheltered accommodation and retirement homes that appreciate the importance of keeping elderly people mentally and physically active. Movement is key to good health. Simple steps and gentle motions help improve their balance and flexibility, which increases confidence and can prevent tumbles. Falls are commonplace among older adults – even I have suffered a few wobbles – and they can be extremely serious, especially if someone is very frail or has osteoporosis.

I'm biased, naturally, but dance is the perfect form of movement, whatever your age, because it exercises every faculty. It's a low-impact activity, unlike jogging on concrete, and it requires you to use your mind and memory. And it can be wonderfully sociable, of course. Indeed, I love joining in the RVS dance sessions, whether it's the conga or the cha-cha-cha – and will often throw in the odd cheery anecdote or two about my career. Laughter and conversation, with a bit of nostalgia thrown in, can be the best spirit-lifter.

As for my own future in the twilight zone, I have no plans to retire. I intend to work until I drop. I can't bear the thought of being idle and am forever seeking fresh projects and creating new ideas to keep me busy. Optimism is such an underrated quality – I wouldn't have enjoyed success without it – so I like to stay upbeat and positive. I can't put my feet up. I can't potter around the house. I need to be active in mind and body and to maintain that structure and discipline I've had since my teens, whether that's organising a gala, laying on a workshop, appearing on TV and radio, or being active as a patron. Most recently, I have become patron of London Youth Opera and a fellow of the Worshipful Company of Wheelwrights, and intend to help raise awareness of these wonderful institutions.

I recently had the pleasure of being invited onto BBC Radio 3's *Private Passions*, which allows public figures to select their favourite classical or traditional pieces. I happened to mention that I had a deep longing to hear my mother's original rendition of 'Dancing in the Dark', the one record that she'd made in the 1940s, which had since been found in an attic by Joanne, but was so scratched and crackly her voice was virtually inaudible.

'Bring it into the studio,' suggested a BBC producer. 'We'll see what the engineers can do.' They worked wonders on the record, bless their hearts, cleaning it and digitising it with such diligence that I was able to use it as one of my chosen tunes. My eyes brimmed with tears as Mum's velvety vocals filled the studio during the broadcast, singing the song that had entertained Plymouth cinema goers during the intermission. It was truly remarkable. Until that moment, I'd not realised how beautiful her voice was: she was pitch-perfect, hitting those high notes with operatic precision.

The deep poignancy of the occasion wasn't lost on me. Back in the 1950s, a young mother had declined the offer of a BBC contract, and a potential career in the spotlight, to focus on raising her toddler son alone. The boy grew up to be as natural a dancer as his mother was a singer. And seventy years later, that same son found himself back at the BBC, giving his mother the airplay that she'd always deserved. Because a performance without an audience is nothing, as he knew only too well.

Covent Garden, July 2023

CELEBRATING MY SEVENTY-FIFTH birthday at the Royal Opera House, the site of so many memories and milestones, was a dream come true for me. My dear friend Janie Dee, as a birthday present, had offered to put on a gala performance to mark the occasion, to be attended by my closest family, friends and colleagues which, with the help of some special guests, would showcase my career highlights. It all sounded fabulous and Janie and I were thrilled when the director of the Royal Ballet, Kevin O'Hare, agreed to let us use the Opera House's Linbury Theatre.

I'd already experienced Kevin's generosity and kind-heartedness. He'd been instrumental in welcoming me back to Covent Garden for the first time in fifty years to coach some of the roles that I danced or were created on me at the Royal Ballet. By appreciating my contribution to the world of ballet, Kevin had made me feel valued. At last, I was being congratulated, not castigated, for popularising dance.

Returning to Covent Garden gave me an insight into the phenomenal progress of modern-day male dancing. What I witnessed bore testament to the quality of the current curriculum and the teachers now delivering it, to both boys and

girls. Under Kevin's tenure, this new generation were being directed and developed with such care, in and out of the studio. And it was equally heartening to discover that boys now accounted for 50 per cent of the Royal Ballet School intake, compared to a paltry 10 per cent when I was there.

One summer, I was in the Royal Ballet studios, giving a seminar for ninety dance teachers. They came to me in the lunch break, informing me that they had looked for but failed to find my portrait among the photos that lined the walls of senior principals, as they wished to take a photo of me next to it. 'Where's yours?' they asked. I realised then that I was the only senior principal not included. This can't have been a mistake. I was Just Different, I suppose!

In the spring of 2023, Janie started the ball rolling with rehearsals for the gala performance – her intention being to direct the entire proceedings in order to take any stress or pressure off the birthday boy. This was a completely unfamiliar experience for me, not to direct my own show, and I couldn't help but tweak and interfere – but when I realised Janie wanted this to be a birthday present, I decided to sit back and not get involved. I knew that, as a consummate professional and producer of the highest quality, she would create something special. Which, when the big day arrived, she had. The Linbury Theatre audience – which included my family, including my husband, José, my sister Joanne and her husband Mike, my auntie Sybil and my friends Lady Anya Sainsbury, Lillian Hochhauser (but sadly not George), Debbie Moore and David Gayle, to name but a few – were treated to a topnotch, hour-long celebration of my life.

The show opened with a lovely speech from Kevin, explaining how I'd made an indelible mark on ballet, dance and theatre, and how my 'boundless enthusiasm' for the art form had touched the lives of countless individuals. An on-stage Q&A between myself and presenter Alan Titchmarsh was interspersed with big-screen film footage of my career as well as short routines by the team that Janie had produced and directed.

My emotions began to wobble as the gala got under way and the significance of reaching my three-quarters of a century hit home. My eyes brimmed with tears as the great opera singer Dame Felicity Lott performed 'Dancing in the Dark', accompanying the recording of my mother's voice. Then, former Royal Ballet principal Marguerite Porter read out a letter that Dame Ninette De Valois had sent me after her one-hundredth birthday celebrations.

'If I had invented an honorary award, you would be the first one to receive it, as I realise how very, very much we in the dance world owe to you,' Madam had written. 'Your name is the one connected with dance that the whole country recognises.'

And, in what was a brilliant coup, Janie used the occasion to reunite the Kit Kat girls and boys from the 1986 revival of *Cabaret*. They walked on stage, looking amazingly youthful, and performed a sensational routine of the show's opening number, 'Willkommen', which enabled me to reprise my role of Emcee. It felt marvellous to share the stage once again with my old cast-mates.

One of the show's highlights was Janie's superb performance of 'The Boy From . . .' This Mary Rodgers and Stephen Sondheim composition parodies 'The Girl from Ipanema' and

is sung from the viewpoint of a woman who is comically unaware that the man of her dreams is most probably gay. I'd asked Janie to include it in the gala so I could dedicate it specially to José and allow him a share of the limelight. It was only right. My husband had stood loyally by my side for almost thirty years and, like many other partners of celebrities, doubtless felt a little overshadowed now and then. This was my way of expressing my love and gratitude.

The finale saw me performing a solo number which I'd carefully rehearsed for weeks, as I (quite literally) didn't want to put a foot wrong.

The presentation of a huge birthday cake brought the tribute to a close (as I blew out the seventy-five candles, I felt out of breath for the first time) and one hundred guests – my nearest and dearest – enjoyed a wonderful lunch in the Opera House rooftop restaurant. Afterwards, many of us made our way to the balcony to watch the sun setting over Covent Garden. As I did, though, linking arms with José and Janie, I felt a tap on my shoulder.

'Come with me,' said Kevin O'Hare. 'I've something to show you.'

He led the three of us along the main corridor, past the gallery of portraits of senior principals, until we reached Madam's. Beside it, much to my surprise, was a large, framed portrait of me. A black and white image taken in my prime, during a performance of *The Dream* – it showed me as Puck, in an ethereal position.

'It's the very least we could do, Wayne,' said Kevin, as José gently squeezed my hand. 'There you are, I put you next to Madam, where you belong.'

Acknowledgements

I WOULD LIKE to express my deepest gratitude to my family. To my husband, José Bergera Olmedo – thank you for entering my life unexpectedly and bringing over thirty years of joy, with so much more to come. My sister, Joanne, and her husband, Mike, who always remind me to look on the bright side of life. Auntie Ruth, Auntie Sybil, my cousin Diane, my late cousin Robert and, of course, my late grandmother, who (against the odds travelling all the way from Plymouth) have consistently made the effort to attend my performances over the years. My heartfelt gratitude goes to George Lawson, to whom this book is dedicated. Your unwavering friendship and the countless ways you've organised my life behind the curtain have been truly invaluable.

What would life be without friendship, and the laughter, love and support that come with it! I am fortunate to have so many wonderful friends and colleagues whom I have met throughout my career. From my Royal Ballet School days, I am grateful to Janine Limberg, Noel Proctor, Marguerite Porter, Antoinette Peloso and Pamela Scott. Among the esteemed choreographers and colleagues from the Royal Ballet: Sir Frederick Ashton, Jackie Barrett, Lesley Collier,

Leslie Edwards, David Gayle, Iris Lawe, Joe Layton, Sir Kenneth MacMillan, John Neumeier and Kevin O'Hare. From the worlds of television, theatre and musicals: Dave Arch, Clive Arrowsmith, Brenda Armstrong, Richard and Wendy Coates (aka The Misery Family), Jacquie Brunjes, Maddy Brennan, Liz Brewer, Lee Dean, Irving Davies, Angela D'Valda and Steve Sirico from Dance Teacher Web, Bill Drysdale, Ann Emery, Maina Gielgud, Howard Goodall, Gillian Gregory, Ilona Herman, Lilian Hochhauser, Ian Hay, Mary Hammond, Michael Jason, Gerard Kenny, Ed Kresley, Bonnie Langford, Gillian Lynne, Nigel Lythgoe, Sir Cameron Mackintosh, Sir Kenneth MacMillan, Norman Maen, Molly Molloy, Trudy Moffatt, Sir Trevor Nunn, Rufus Norris, Harry Nilsson, Ashley Page, Arlene Phillips, Robert Purvis, Wendy Roe, Brian Rogers, Richard Sampson, Elizabeth Seal, Dougie Squires, Ian Talbot, Anthony Van Laast and Andrew Lloyd Webber. Those who I have worked alongside to organise charity galas, including Johanna Adams, Janie Dee, Thomas Edur, Lady Diana Farnham, David Hockney, Jeanetta Laurence, Monica Mason, Elizabeth McGorian – who so bravely danced in a gold unitard through hundreds of men in the mud and rain at the Berkeley Square Ball – Peter Schlesinger, Lady Anya Sainsbury, Andrew Ward and Doreen Wells. And those involved with my first *Dash*: Anne Allen, Charles Augins (Bubbling Brown Sugar), Michael Beare, Anne Cox, Conchita del Campo, Jane Darling, Armand Gerrard, Jennifer Jackson, Don Lawson, Debbie Moore, Kim Robinson, Susan Roe, Kim Rosato, Peter Salmon, Marian St Claire and Tom Yang. From the world of opera, I have had the privilege of working with Thomas Allen, Josephine Barstow, James Bowman, John

Copley, John Cox, Plácido Domingo, Geraint Evans, Anne Howells, Dame Felicity Lott, Lucia Popp, Kiri Te Kanawa and Eva Turner. Many thanks to all those I have worked with along the way, both going up the ladder and coming down.

Sadly, there are many dear friends who are no longer with us, including Dame Beryl Grey, Princess Diana, Freddie Mercury, Graham Powell, Diana Roberts and Nick Underwood. Each of them left an indelible mark on my life.

I would like to express my sincere thanks to Tom Perrin, my publisher at Hodder & Stoughton, my wonderful co-writer, Jo Lake and my agent, Jane Compton, for their support and guidance throughout this process. A special thank you goes to my dedicated assistant, Matthew Ryan, and his partner, Alastair Chilvers, for the countless late nights spent helping to meet deadlines – they were true lifesavers.

There are two extraordinary women who are no longer with us, without whom I wouldn't be who I am today: my mentor, Dame Ninette de Valois, and my beloved mother, Joan. Their influence and love continue to guide me every day.

Finally, to my audience who have supported and sustained me throughout my career, thank you from the bottom of my heart. Your warm receptions and unwavering enthusiasm have brought me endless joy over the years.

Picture credits

Picture Research by Jane Smith Media

Photo Section 1-
ArenaPal: page 3 (below right) and page 6 (top) – Leslie E. Spatt
Camera Press: page 1 and page 4 (below) – Clive Arrowsmith
Getty Images: page 5 (top) – Evening Standard / Hulton Archive
Karl Bowen: page 6 (below)
Keystone: page 3 (below left)
Mary Evans Picture Library: page 8 (top) – Image courtesy Ronald Grant Archive
Open Road Films Ltd / Highroad Presentation / Columbia Pictures – page 8 (below)
Roddy McDowall: page 7 (top left)
Roland Bond: page 7 (top right)
Shutterstock: page 7 (below) – James Gourley
Stephen Tolley: page 4 (top)
Victoria and Albert Museum, London: page 5 (below) – Anthony Crickmay

Photo Section 2-
Andra Nelki: page 7 (below)

Catherine Ashmore: page 3 (top)

Chitty (UK) Ltd: page 8 (below) – By kind permission of Chitty (UK) Ltd / Dewynters

Getty Images: page 7 (middle) – Princess Diana Archive

Mirrorpix: page 4 (top) – John Downing / Daily Express

Peter Schlesinger: page 1 and page 2 (top)

Shutterstock: page 3 below – Steve Back / ANL; page 5 and page 6 (below) and 6 (top right) – Richard Young; page 6 (top left) – Alan Davidson; page 7 (top) – News group; page 8 (top) – Brian Bould / ANL

Stephen Pover: page 4 (below) – with thanks to the Royal Academy of Dance

Tony McGee: page 5 (top)

All other photos are personal photos from the author's collection.

Support the Next Generation of Performing Artists with The Wayne Sleep Foundation

Registered Charity No: 1070547

Since its inception in 1998, The Wayne Sleep Foundation has been a source of support for young, aspiring performing artists. Founded by Wayne Sleep and George Lawson, the charity's mission is to support students who have secured a place at some of the most prestigious arts institutions across the UK. By alleviating some of the financial burden, the Foundation allows these talented individuals to focus fully on their craft.

"I am enormously grateful to The Wayne Sleep Foundation for generously supporting my training. The Foundation's support and generosity to emerging dance talent is transforming the lives of many young people, and I am honoured to be a part of that. Thank you."
Matthew Potulski, Dancer, Rambert School

As we look to the future, we invite you to join us in making a difference. Your donation, no matter the size, will help ensure that these gifted students can pursue their dreams without the barrier of financial hardship.

To learn more about our work please visit: **waynesleepfoundation.org**

To make a donation, simply scan the QR code below

Matthew Ryan
Director of The Wayne Sleep Foundation

The Wayne Sleep Foundation
31 Long Acre, Covent Garden, WC2E 9LA
Charity Registered in England No 1070547